KOREN SHADMI

LUGOSI

THE RISE & FALL
OF HOLLYWOOD'S DRACULA

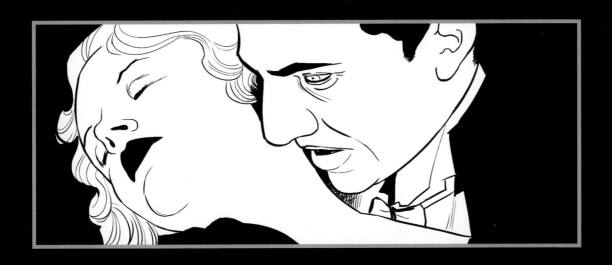

Life Drawn
by Humanoids

KOREN SHADMI
Story & Art

•

TOM NAPOLITANO
Letterer

•

ROB LEVIN
Editor

JERRY FRISSEN
Senior Art Director

FABRICE GIGER
Publisher

Rights and Licensing - licensing@humanoids.com
Press and Social Media - pr@humanoids.com

Dedicated to Aviv Shadmi

The author would like to thank Mary Abramson,
Yaron Kaver, Oren Shai, and Fabrice Sapolsky.

LUGOSI: THE RISE & FALL OF HOLLYWOOD'S DRACULA
First Edition. This title is a publication of Humanoids, Inc. 8033 Sunset Blvd. #628, Los Angeles, CA 90046. Copyright © 2021
Humanoids, Inc., Los Angeles (USA). All rights reserved. Humanoids and its logos are ® and © 2021 Humanoids, Inc.
Library of Congress Control Number: 2021935029

Life Drawn is an imprint of Humanoids, Inc.

Foreword by Joe R. Lansdale

He was the ultimate Count Dracula for many years. A standard bearer for Universal Pictures. He performed on stage, became a star, and eventually was so typecast that he devolved into acting for minor film companies in less interesting roles.

But for those of us who grew up with his dramatic, cape-and-tuxedo-wearing Dracula, no matter how we may feel about other performers who have inhabited the role, there's always a place in our minds and hearts for the man who introduced us to vampires and creeping terror.

His depiction of the nefarious count has influenced generations of Halloween costumes, breakfast cereals, films, books, and plays. Even *Sesame Street*, an educational program designed for children, had a not-so-veiled version of Lugosi in puppet form, known as The Count, who is more interested in math than blood. Other incarnations are too countless to name.

Less known is how Lugosi, a Hungarian immigrant with a grim past and a soul full of tragedy, ended up as a stage and film actor and, finally, a sex symbol of dark and forbidden desire. And what came after.

This wonderful graphic novel gives us the whole biographical banquet, from soup to nuts. The triumphs, the misfortunes, the oddities, as well as the wonders and high points of Lugosi's life. From Hollywood star to an addict struggling with drug addiction to his final attempt to put his floundering health and life back on track, this graphic novel covers it all.

If you're a dyed-in-the-wool fan of Lugosi's life and career, this is the book for you. If you are coming for the first time to Lugosi the man, this is the book for you. If you know of him only through the borrowed images from his classic role, then this is certainly the book for you.

It's a beautiful visualization of Lugosi's life in a digestible package made of the blood and bones of a real life, depicted by smart writing and perfect artwork for the form. It's a marvelous deep-dive into the soul of an immigrant who became an American icon.

Joe R. Lansdale is the author of over fifty novels and numerous short stories, writing for comics, television, film, newspapers, and Internet sites. His stories have won ten Bram Stoker Awards, an Edgar Award, and a Raymond Chandler Lifetime Achievement Award. Several of his works have been adapted for film and television, including the Hap and Leonard *novel series and* Bubba Ho-Tep.

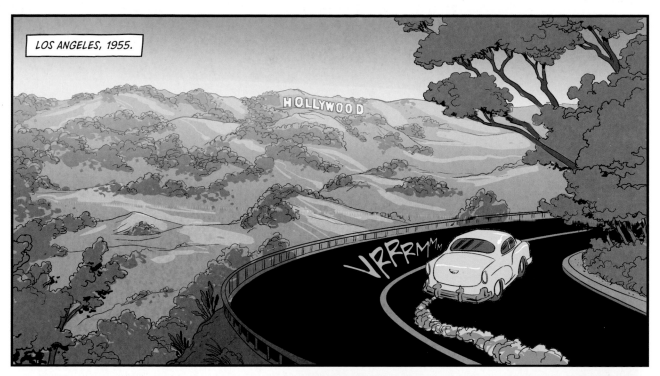

LOS ANGELES, 1955.

HOLLYWOOD

VRRRMMM

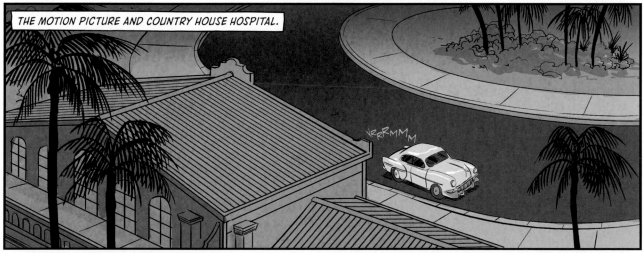

THE MOTION PICTURE AND COUNTRY HOUSE HOSPITAL.

VRRRMMM

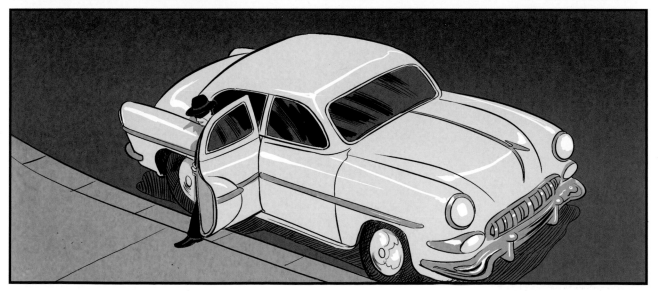

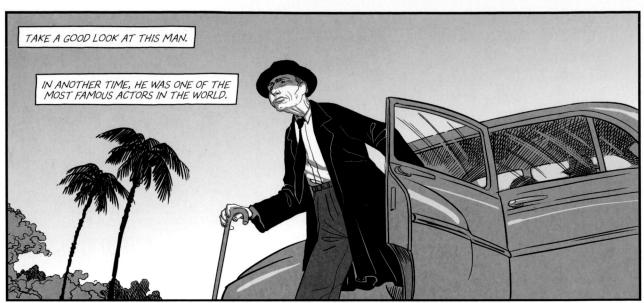

TAKE A GOOD LOOK AT THIS MAN.

IN ANOTHER TIME, HE WAS ONE OF THE MOST FAMOUS ACTORS IN THE WORLD.

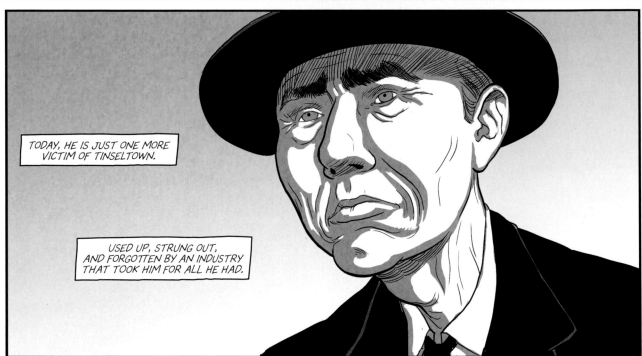

TODAY, HE IS JUST ONE MORE VICTIM OF TINSELTOWN.

USED UP, STRUNG OUT, AND FORGOTTEN BY AN INDUSTRY THAT TOOK HIM FOR ALL HE HAD.

THIS IS HIS LAST ACT OF HOPE, LAST CHANCE OF SALVATION.

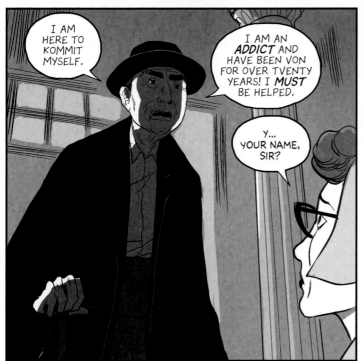
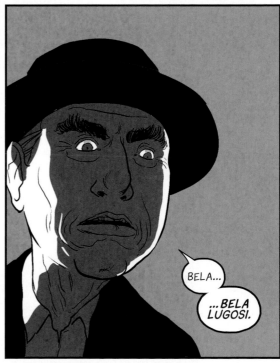
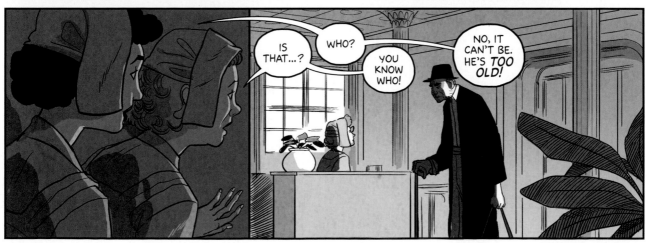

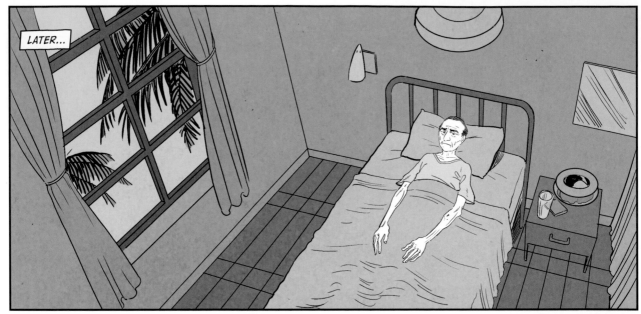

LATER...

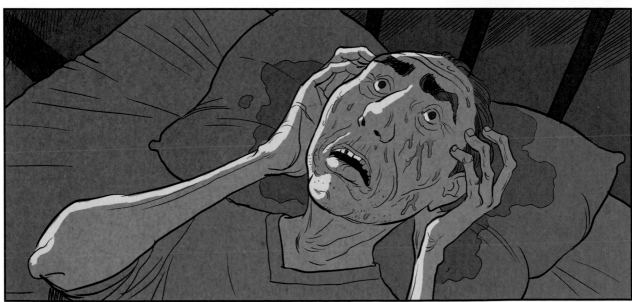

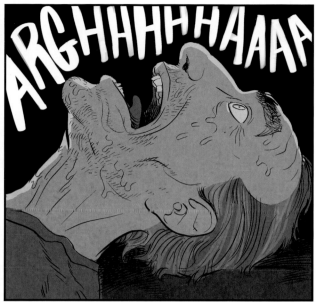

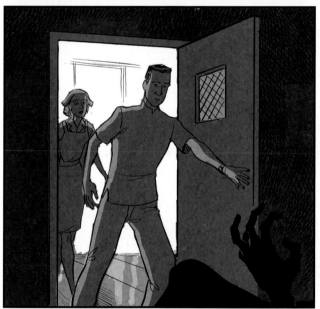

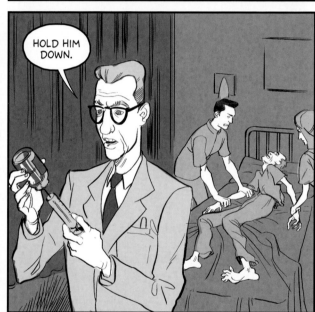

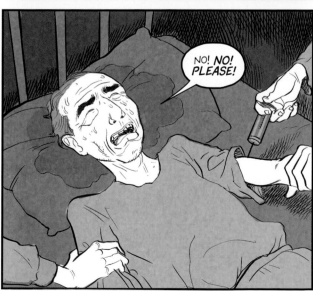

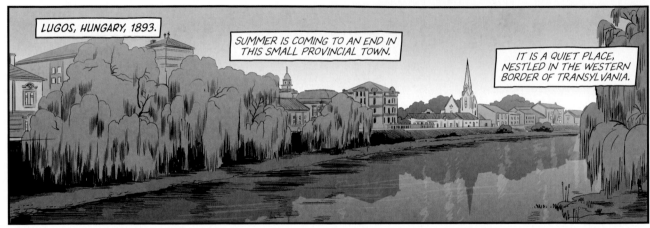

LUGOS, HUNGARY, 1893.

SUMMER IS COMING TO AN END IN THIS SMALL PROVINCIAL TOWN.

IT IS A QUIET PLACE, NESTLED IN THE WESTERN BORDER OF TRANSYLVANIA.

A TRAVELING TROUPE HAS JUST LEFT TOWN AFTER PERFORMING TO THE PLEASURE OF ITS RESIDENTS.

BUT FOR ONE BOY, THEIR SHOW WAS MORE THAN JUST A PASSING SPECTACLE.

THIS BOY--BÉLA BLASKÓ-- HAS BECOME POSSESSED.

HE'S DECIDED TO BECOME AN ACTOR, AND NOTHING WILL STAND BETWEEN HIM AND HIS NEWFOUND DREAM.

<HARK! THUNDER RUMBLING!>*

*TRANSLATED FROM HUNGARIAN.

<DO YOU HEAR IT, GROWING STRONGER IN THE DISTANCE?>

<I MUST ROUSE MY HORSE AND RIDE AWAY BEFORE IT IS TOO LATE.>

10

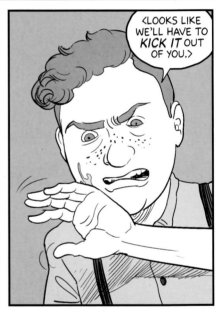

LATER, AT THE BLASKÓ FAMILY HOME...

BÉLA WAS ALWAYS THE PARIAH OF THE FAMILY, BUT HIS NEW OBSESSION WITH ACTING WAS TROUBLING NEWS FOR HIS PARENTS.

ding dong

SQUEEEEEK

<HELLO.>

\<S-SORRY FOR BEING SO LATE.\>

\<WELL, DON'T YOU WANT TO KNOW *WHAT HAPPENED* TO ME?\>

\<DEAR, WOULD YOU PLEASE PASS THE SALT.\>

\<HMMF, SINCE YOU ASKED--\>

\<--I HAD AN *INCREDIBLE* TEST RUN OF MY ONE MAN SHOW TODAY.\>

\<MATYAS SAID I WAS *SIMPLY BRILLIANT.*\>

\<BUT THEN WE HAD A RUN-IN WITH THE ROMANIAN BOYS.\>

\<THEY CORNERED US IN A DITCH.\>

\<DON'T YOU WANT TO KNOW HOW I GOT AWAY?\>

\<I'M WASTING MY TIME!\>

\<YOU WOULDN'T CARE IF I *NEVER* CAME HOME! IF I LAY DEAD IN THAT DITCH!\>

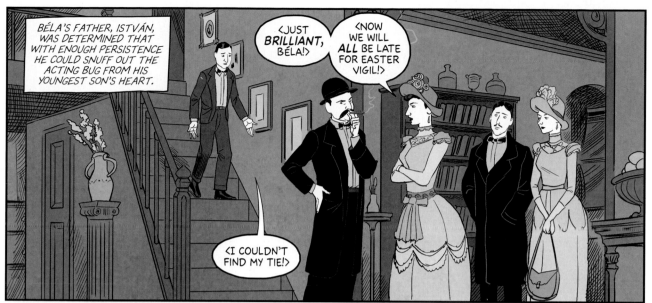

BÉLA'S FATHER, ISTVÁN, WAS DETERMINED THAT WITH ENOUGH PERSISTENCE HE COULD SNUFF OUT THE ACTING BUG FROM HIS YOUNGEST SON'S HEART.

‹JUST **BRILLIANT,** BÉLA!›

‹NOW WE WILL **ALL** BE LATE FOR EASTER VIGIL!›

‹I COULDN'T FIND MY TIE!›

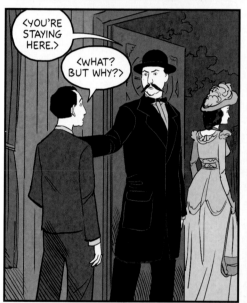

‹YOU'RE STAYING HERE.›

‹WHAT? BUT WHY?›

‹SON, ARE YOU AWARE OF HOW LUCKY YOU ARE?›

‹Y-YES...?›

‹I GREW UP **EATING GRUEL AND WEARING RAGS.** I WAS ALWAYS COLD AND HUNGRY.›

‹BUT I WAS DETERMINED TO **RISE UP** FROM POVERTY.›

‹AND NOW--I AM AN ESTEEMED BANKER.›

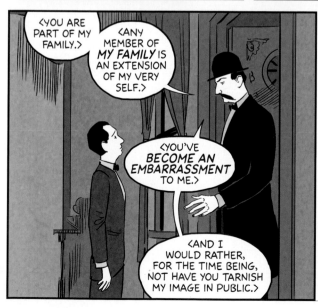

‹YOU ARE PART OF MY FAMILY.›

‹ANY MEMBER OF **MY FAMILY** IS AN EXTENSION OF MY VERY SELF.›

‹YOU'VE **BECOME AN EMBARRASSMENT** TO ME.›

‹AND I WOULD RATHER, FOR THE TIME BEING, NOT HAVE YOU TARNISH MY IMAGE IN PUBLIC.›

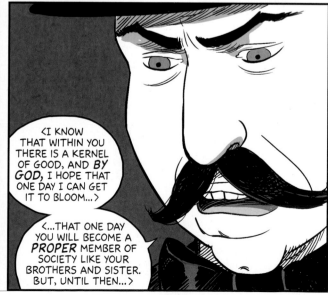

‹I KNOW THAT WITHIN YOU THERE IS A KERNEL OF GOOD, AND **BY GOD,** I HOPE THAT ONE DAY I CAN GET IT TO BLOOM...›

‹...THAT ONE DAY YOU WILL BECOME A **PROPER** MEMBER OF SOCIETY LIKE YOUR BROTHERS AND SISTER. BUT, UNTIL THEN...›

<COME ON, LET'S GO.>

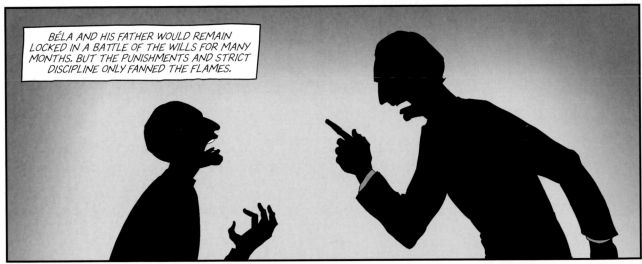

BÉLA AND HIS FATHER WOULD REMAIN LOCKED IN A BATTLE OF THE WILLS FOR MANY MONTHS. BUT THE PUNISHMENTS AND STRICT DISCIPLINE ONLY FANNED THE FLAMES.

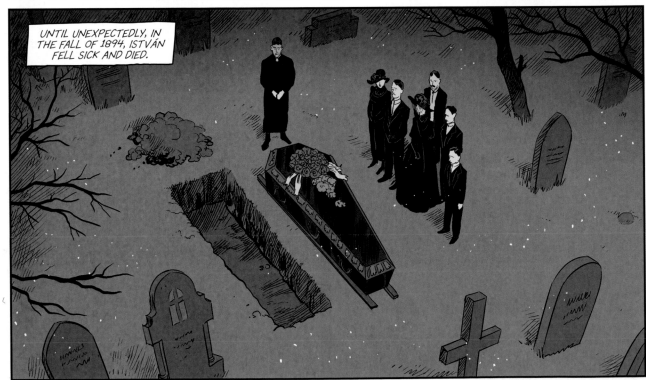

UNTIL UNEXPECTEDLY, IN THE FALL OF 1894, ISTVÁN FELL SICK AND DIED.

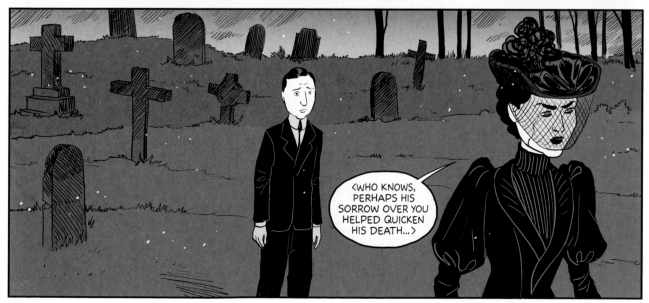

THAT NIGHT...

SMASH

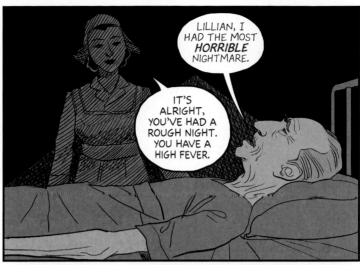

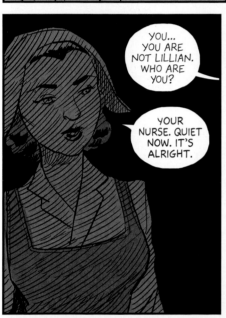

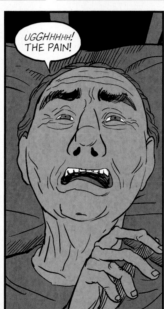

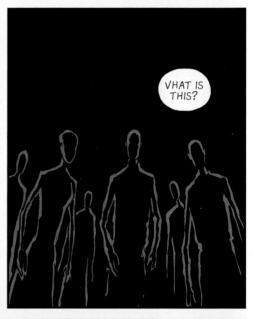

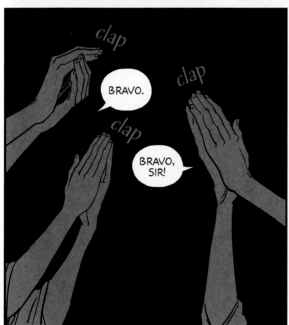

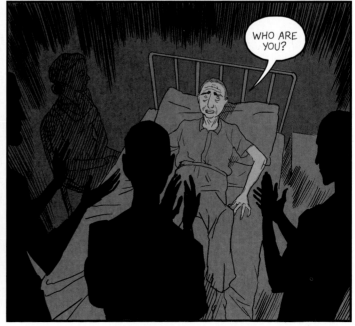

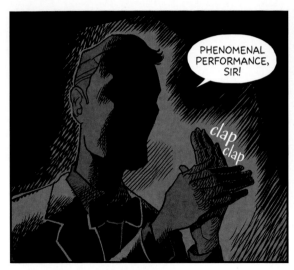

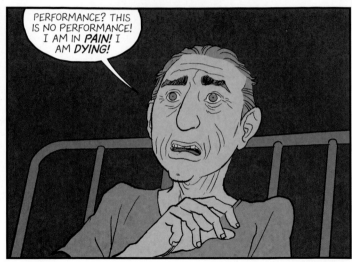

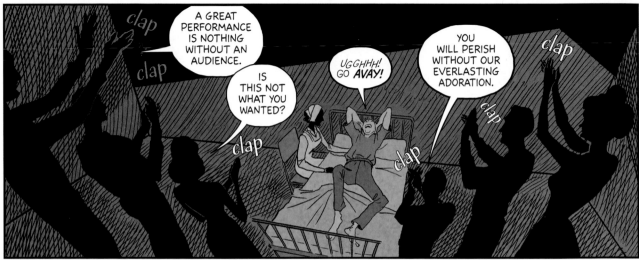

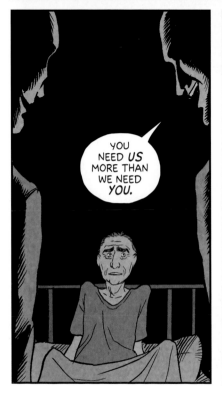

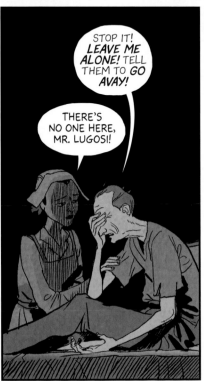

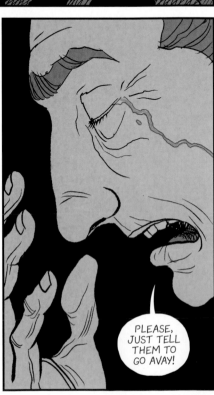

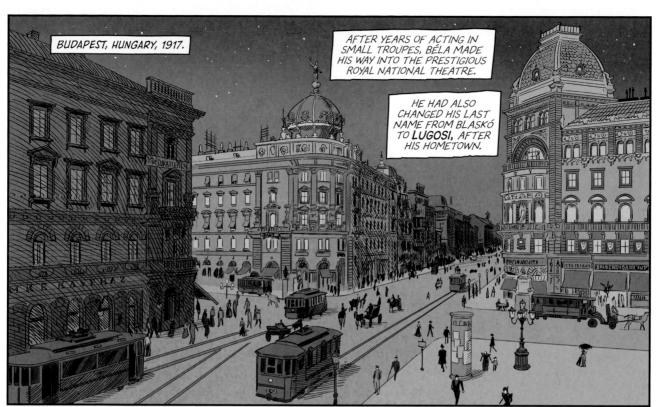

BUDAPEST, HUNGARY, 1917.

AFTER YEARS OF ACTING IN SMALL TROUPES, BÉLA MADE HIS WAY INTO THE PRESTIGIOUS ROYAL NATIONAL THEATRE.

HE HAD ALSO CHANGED HIS LAST NAME FROM BLASKÓ TO **LUGOSI**, AFTER HIS HOMETOWN.

TONIGHT, BÉLA AND HIS FRIENDS ARE ENJOYING A DRINK AFTER THEIR EVENING PERFORMANCE OF HAMLET.

Bar
Bisztró

‹CHEERS!›

‹TO ANOTHER FABULOUS PERFORMANCE!›

<WHAT YOU MUST UNDERSTAND IS THAT THE SYSTEM ITSELF IS RIGGED. IT IS RIGGED AGAINST US.>

<HERE WE GO AGAIN...>

<THE HUNGARIAN ACTOR IS A SLAVE FOR MOST OF HIS LIFE. ENSNARED BY A HIERARCHY THAT FAVORS *THE OLD* AND THE *ELITE*.>

<SEE, IN ORDER TO BE CAST IN A LEADING ROLE, YOU MUST FIRST "PAY YOUR DUES" FOR *AT LEAST* TWENTY YEARS.>

<ONLY *THEN*, WHEN YOU ARE WORN OUT, TIRED, AND PAST YOUR PRIME--*YOU LAND THE COVETED LEAD*--AND THAT IS ONLY IF YOU DON'T STARVE FIRST!>

<HE'S RIGHT! WE SHOULD ALL QUIT NOW AND BECOME ACCOUNTANTS!>

<WHAT ABOUT MARTON, *HUH?* HE'S IN HIS EARLY THIRTIES AND IS PLAYING HAMLET!>

<AH, HE IS THE EXCEPTION, *BUT WHY?* MARTON HIDES IT WELL, BUT I KNOW FOR A FACT THAT HE IS HUNGARIAN ROYALTY.>

<OF COURSE HE WILL BE ABLE TO BYPASS THE USUAL HIERARCHY.>

<SEE, WE ARE ALL MIDDLE CLASS, BUT TO THEM WE ARE AS GOOD AS PEASANTS. WE WILL SIT AND WAIT, WE WILL GROW OLD, AND *STILL* WE MAY NEVER PLAY OTHELLO.>

<A TRUE TRAGEDY!>

<THE TEARS ARE WELLING IN MY EYES.>

<OUR DEAR LITTLE ROSENCRANTZ* IS FRUSTRATED THAT HE HAS SO LITTLE TIME ON STAGE.>

*A MINOR ROLE IN HAMLET.

<MOCK ME, BUT I SPEAK THE TRUTH.>

<BÉLA, THAT'S NOT JUST HOW THE NATIONAL THEATRE WORKS.>

<THAT'S HOW *SOCIETY* WORKS!>

<DO YOU THINK AN INTERN BECOMES A GREAT SURGEON OVERNIGHT?>

<WE WILL JUST HAVE TO WAIT OUR TURN.>

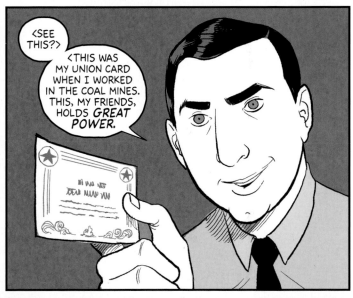

<SEE THIS?>

<THIS WAS MY UNION CARD WHEN I WORKED IN THE COAL MINES. THIS, MY FRIENDS, HOLDS *GREAT POWER.*>

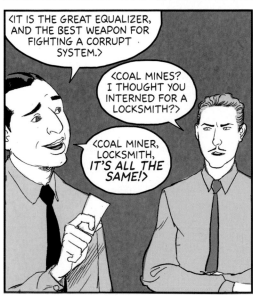

<IT IS THE GREAT EQUALIZER, AND THE BEST WEAPON FOR FIGHTING A CORRUPT SYSTEM.>

<COAL MINES? I THOUGHT YOU INTERNED FOR A LOCKSMITH?>

<COAL MINER, LOCKSMITH, *IT'S ALL THE SAME!*>

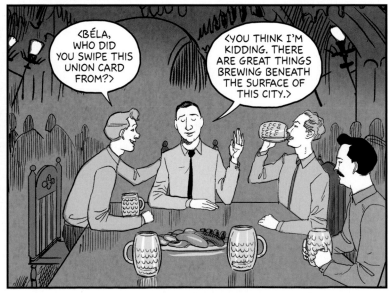

<BÉLA, WHO DID YOU SWIPE THIS UNION CARD FROM?>

<YOU THINK I'M KIDDING. THERE ARE GREAT THINGS BREWING BENEATH THE SURFACE OF THIS CITY.>

THE FOLLOWING DAY.

<OH BÉLA, YOU WERE JUST **WONDERFUL** TONIGHT! I THOUGHT YOU WERE SO HANDSOME ON STAGE.>

<I ONLY WISH I WAS UP THERE FOR MORE THAN A SPLIT SECOND.>

<IT'S NOT A BIG ROLE, BUT YOU REALLY SHINE WHEN YOU PERFORM.>

<YOU ARE SWEET, ILONA, ALWAYS LOOKING FOR THE SILVER LINING.>

<I JUST KNOW THEY WILL NOTICE YOU SOON ENOUGH.>

<BAH! THEY WOULD NOT NOTICE ME EVEN IF I HAD WINGS AND A GLOWING HALO!>

<LUGOSI!>

<YOU THOUGHT YOU COULD GET BY WITHOUT ME NOTICING? YOU OWE ME THREE MONTHS' RENT.>

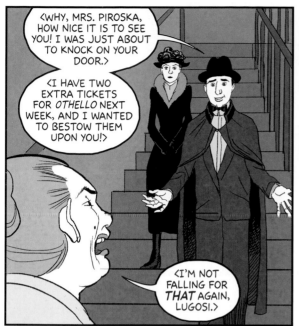

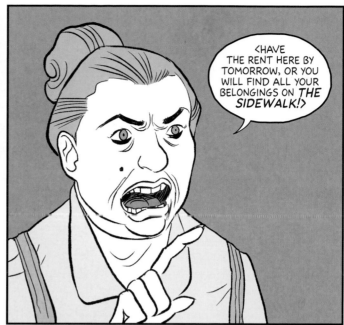

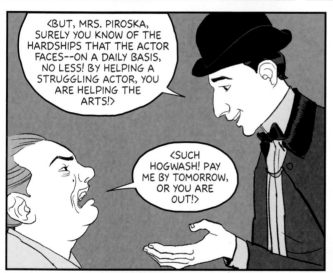

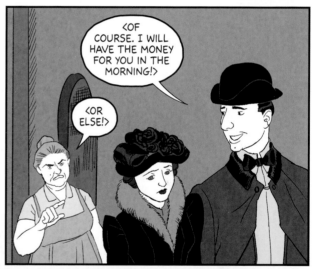

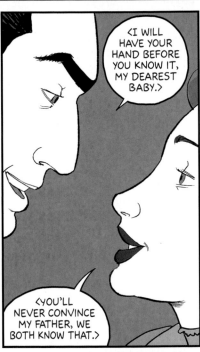

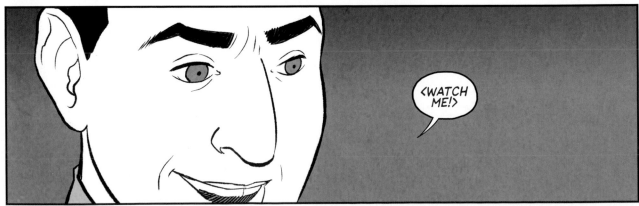

THAT SUMMER, BÉLA AND ILONA "BABY" SZMICK WERE MARRIED IN THE CHURCH OF ST. ANNE IN BUDAPEST.

ILONA'S PARENTS, WHO WERE CONCERNED FOR HER FUTURE WITH THE ALWAYS-BROKE BÉLA, STRONGLY DISAPPROVED OF THE UNION.

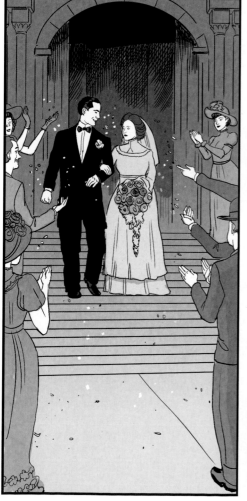

<I DO HOPE THEY ENJOY THEIR HONEYMOON. IT'S COSTING ME A PRETTY PENNY.>

<DAYLIGHT ROBBERY, THAT'S WHAT IT IS!>

<POOR ILONA, HOW COULD SHE HAVE FALLEN FOR SUCH A SWINDLER?>

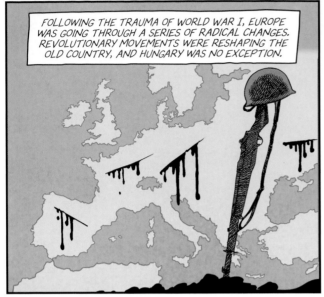

FOLLOWING THE TRAUMA OF WORLD WAR I, EUROPE WAS GOING THROUGH A SERIES OF RADICAL CHANGES. REVOLUTIONARY MOVEMENTS WERE RESHAPING THE OLD COUNTRY, AND HUNGARY WAS NO EXCEPTION.

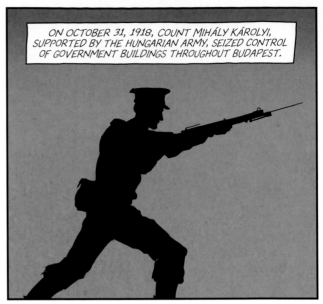

ON OCTOBER 31, 1918, COUNT MIHÁLY KÁROLYI, SUPPORTED BY THE HUNGARIAN ARMY, SEIZED CONTROL OF GOVERNMENT BUILDINGS THROUGHOUT BUDAPEST.

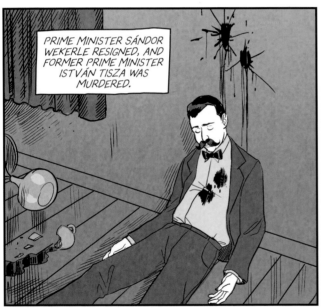

PRIME MINISTER SÁNDOR WEKERLE RESIGNED, AND FORMER PRIME MINISTER ISTVÁN TISZA WAS MURDERED.

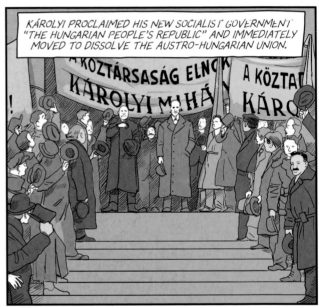

KÁROLYI PROCLAIMED HIS NEW SOCIALIST GOVERNMENT "THE HUNGARIAN PEOPLE'S REPUBLIC" AND IMMEDIATELY MOVED TO DISSOLVE THE AUSTRO-HUNGARIAN UNION.

CHARLES I--THE AUSTRO-HUNGARIAN KING--WAS FORCED TO RECOGNIZE HUNGARY'S INDEPENDENCE.

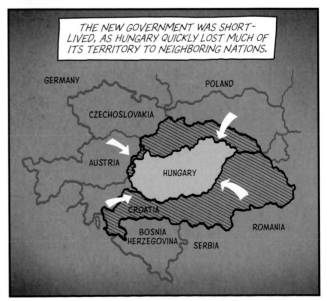

THE NEW GOVERNMENT WAS SHORT-LIVED, AS HUNGARY QUICKLY LOST MUCH OF ITS TERRITORY TO NEIGHBORING NATIONS.

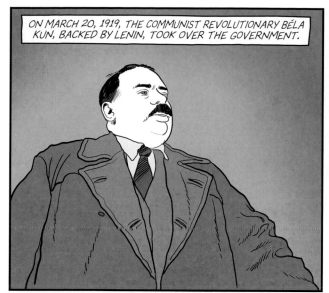

ON MARCH 20, 1919, THE COMMUNIST REVOLUTIONARY BÉLA KUN, BACKED BY LENIN, TOOK OVER THE GOVERNMENT.

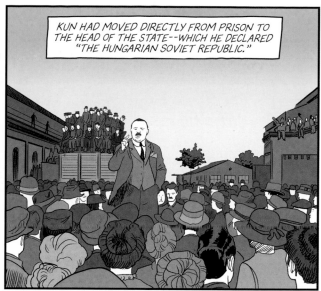

KUN HAD MOVED DIRECTLY FROM PRISON TO THE HEAD OF THE STATE--WHICH HE DECLARED "THE HUNGARIAN SOVIET REPUBLIC."

THE NEW GOVERNMENT PROCEEDED TO NATIONALIZE INDUSTRY, TRANSPORT, BANKING, AND CULTURAL INSTITUTIONS.

AROUND THE SAME TIME, PERFORMERS AROUND BUDAPEST BANDED TOGETHER TO FORM "THE NATIONAL TRADE UNION OF ACTORS"--THE FIRST ACTORS UNION IN HISTORY.

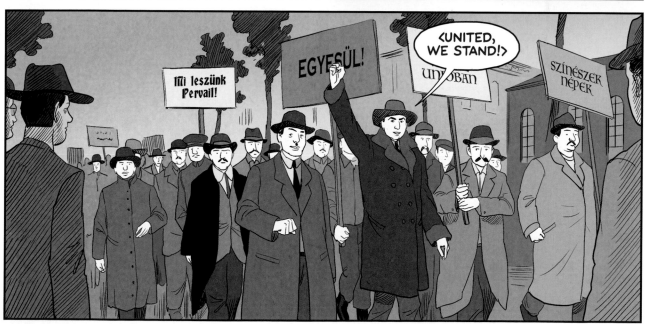

<UNITED, WE STAND!>

29

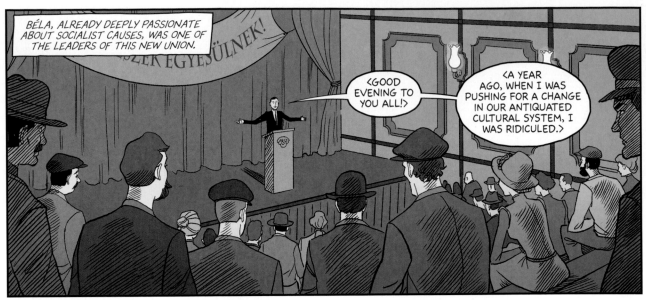

BÉLA, ALREADY DEEPLY PASSIONATE ABOUT SOCIALIST CAUSES, WAS ONE OF THE LEADERS OF THIS NEW UNION.

<GOOD EVENING TO YOU ALL!>

<A YEAR AGO, WHEN I WAS PUSHING FOR A CHANGE IN OUR ANTIQUATED CULTURAL SYSTEM, I WAS RIDICULED.>

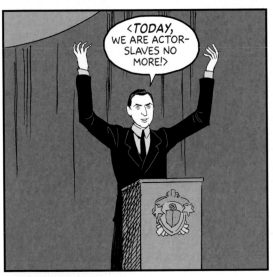

<TODAY, WE ARE ACTOR-SLAVES NO MORE!>

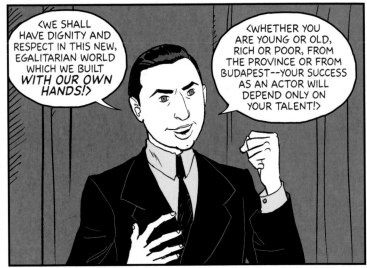

<WE SHALL HAVE DIGNITY AND RESPECT IN THIS NEW, EGALITARIAN WORLD WHICH WE BUILT *WITH OUR OWN HANDS!*>

<WHETHER YOU ARE YOUNG OR OLD, RICH OR POOR, FROM THE PROVINCE OR FROM BUDAPEST--YOUR SUCCESS AS AN ACTOR WILL DEPEND ONLY ON YOUR TALENT!>

<AND THIS IS ONLY THE BEGINNING.>

<OUR NEXT STEP WILL BE THE CREATION OF A NEW, SUPREME ARTS COUNCIL, WHICH WILL UNITE ALL FACETS OF CULTURE UNDER ONE BANNER!>

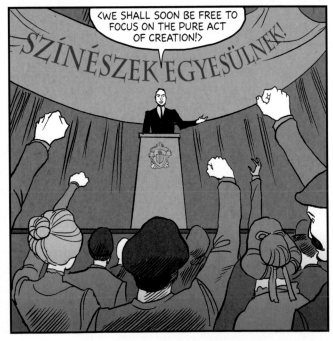

<WE SHALL SOON BE FREE TO FOCUS ON THE PURE ACT OF CREATION!>

SZÍNÉSZEK EGYESÜLNEK!

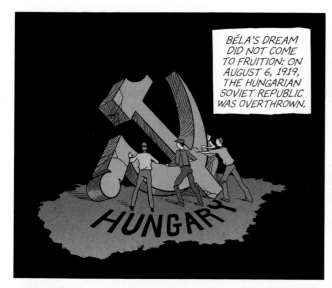

BÉLA'S DREAM DID NOT COME TO FRUITION: ON AUGUST 6, 1919, THE HUNGARIAN SOVIET REPUBLIC WAS OVERTHROWN.

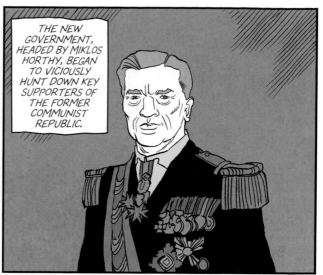

THE NEW GOVERNMENT, HEADED BY MIKLOS HORTHY, BEGAN TO VICIOUSLY HUNT DOWN KEY SUPPORTERS OF THE FORMER COMMUNIST REPUBLIC.

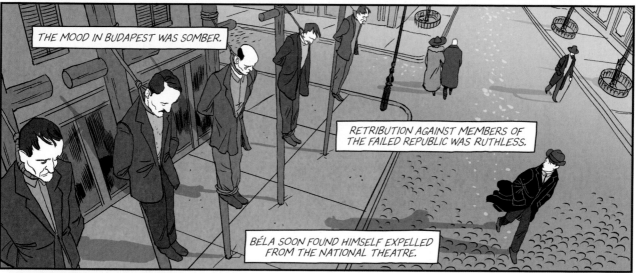

THE MOOD IN BUDAPEST WAS SOMBER.

RETRIBUTION AGAINST MEMBERS OF THE FAILED REPUBLIC WAS RUTHLESS.

BÉLA SOON FOUND HIMSELF EXPELLED FROM THE NATIONAL THEATRE.

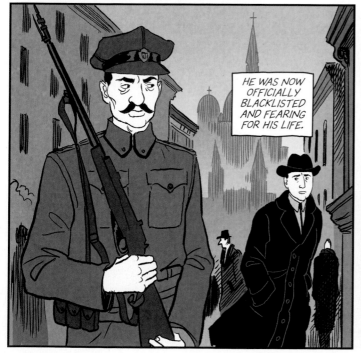

HE WAS NOW OFFICIALLY BLACKLISTED AND FEARING FOR HIS LIFE.

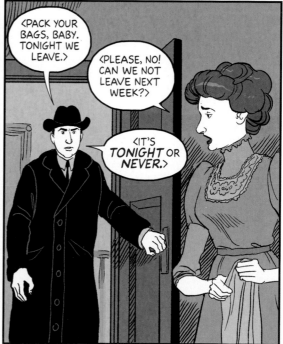

<PACK YOUR BAGS, BABY. TONIGHT WE LEAVE.>

<PLEASE, NO! CAN WE NOT LEAVE NEXT WEEK?>

<IT'S *TONIGHT* OR *NEVER.*>

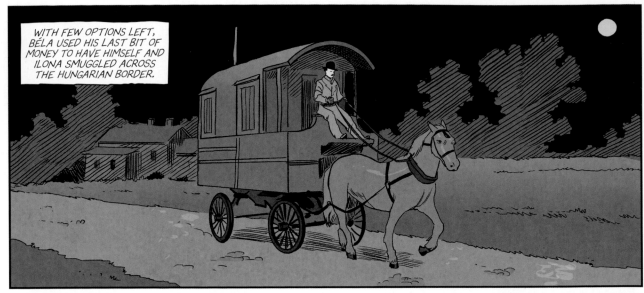

LIFE IN VIENNA WITH NO FAMILY, HELP, OR FRIENDS PROVED TOUGHER THAN EXPECTED.

THE COUPLE, WHO WERE USED TO A LIFE OF COMFORT, NOW HAD TO STRUGGLE IN POVERTY.

<I'M HOME, BABY.>

<THERE ARE A LOT OF ACTING OPPORTUNITIES HERE.>

<THE FILM INDUSTRY IS BOOMING, AND THERE ARE MANY PRODUCTIONS.>

<I MADE A FEW GOOD CONTACTS TODAY.>

<BABY?>

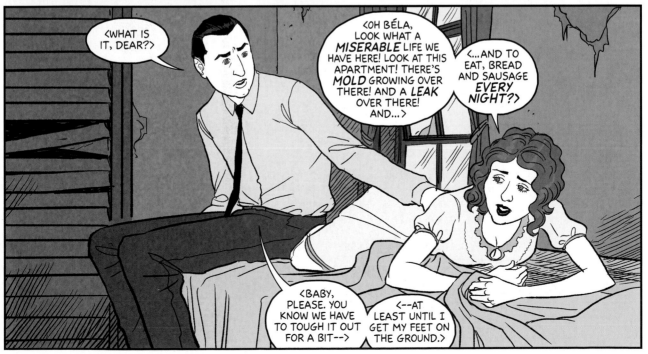

<WHAT IS IT, DEAR?>

<OH BÉLA, LOOK WHAT A *MISERABLE* LIFE WE HAVE HERE! LOOK AT THIS APARTMENT! THERE'S *MOLD* GROWING OVER THERE! AND A *LEAK* OVER THERE! AND...>

<...AND TO EAT, BREAD AND SAUSAGE *EVERY NIGHT?*>

<BABY, PLEASE. YOU KNOW WE HAVE TO TOUGH IT OUT FOR A BIT--->

<--AT LEAST UNTIL I GET MY FEET ON THE GROUND.>

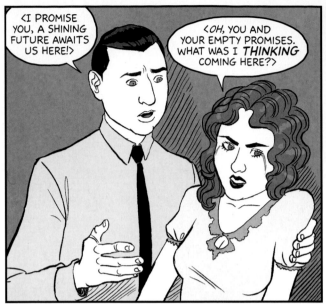

<I PROMISE YOU, A SHINING FUTURE AWAITS US HERE!>

<OH, YOU AND YOUR EMPTY PROMISES. WHAT WAS I *THINKING* COMING HERE?>

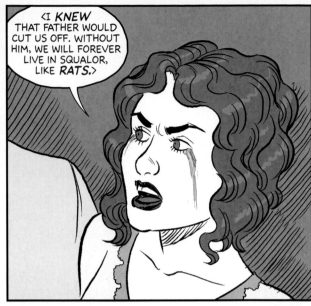

<I *KNEW* THAT FATHER WOULD CUT US OFF. WITHOUT HIM, WE WILL FOREVER LIVE IN SQUALOR, LIKE *RATS*.>

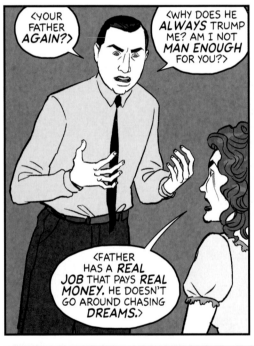

<YOUR FATHER *AGAIN*?>

<WHY DOES HE *ALWAYS* TRUMP ME? AM I NOT *MAN ENOUGH* FOR YOU?>

<FATHER HAS A *REAL JOB* THAT PAYS *REAL MONEY*. HE DOESN'T GO AROUND CHASING *DREAMS*.>

<I'VE HAD QUITE ENOUGH OF THIS.>

<YOU'VE HAD ENOUGH? *I'VE* HAD ENOUGH!>

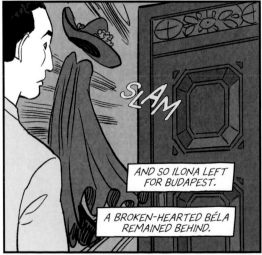

SLAM

AND SO ILONA LEFT FOR BUDAPEST.

A BROKEN-HEARTED BÉLA REMAINED BEHIND.

HE HOPED THAT SHE WOULD RETURN AND WROTE HER MANY LETTERS--BUT THEY NEVER REACHED ILONA. HER PARENTS MADE SURE TO DISPOSE OF ANY COMMUNICATIONS.

SEVERAL MONTHS AFTER LEAVING, ILONA WOULD FILE FOR DIVORCE.

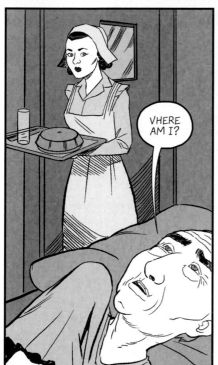

VHERE AM I?

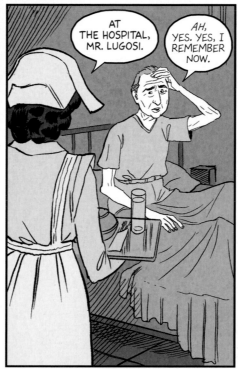

AT THE HOSPITAL, MR. LUGOSI.

AH, YES. YES, I REMEMBER NOW.

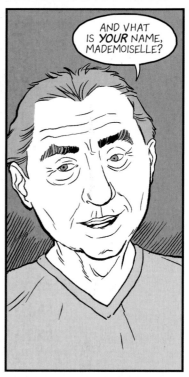

AND VHAT IS *YOUR* NAME, MADEMOISELLE?

VERONICA.

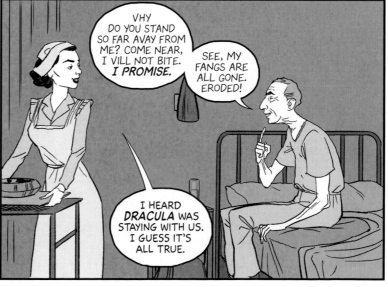

VHY DO YOU STAND SO FAR AVAY FROM ME? COME NEAR, I VILL NOT BITE. *I PROMISE.*

SEE, MY FANGS ARE ALL GONE. ERODED!

I HEARD *DRACULA* WAS STAYING WITH US. I GUESS IT'S ALL TRUE.

BELA LUGOSI, AT YOUR--

OCH!

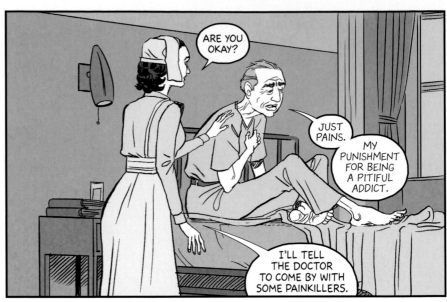

ARE YOU OKAY?

JUST PAINS. MY PUNISHMENT FOR BEING A PITIFUL ADDICT.

I'LL TELL THE DOCTOR TO COME BY WITH SOME PAINKILLERS.

I DO NOT NEED THEM! *I MUST SUFFER.* I MUST GO THROUGH PURGATORY.

I'LL CALL HIM IN JUST THE SAME.

I'M FINE NOW, NO NEED.

OKAY. LET ME KNOW IF YOU CHANGE YOUR MIND.

MR. LUGOSI, IF YOU DON'T MIND ME ASKING, WHAT KIND OF ACCENT IS THAT?

HUNGARIAN, MY DEAR! I AM A RELIC FROM THE OLD COUNTRY.

OH, I'VE *ALWAYS* WANTED TO VISIT EUROPE! BUT IT SEEMS THERE'S NEVER ENOUGH TIME.

YOU MUST VISIT! GO TO PARIS, VIENNA, BUDAPEST! YOU VILL NOT REGRET IT!

PERHAPS YOU VILL MEET A *HANDSOME EUROPEAN MAN* WHO VILL SHOW YOU AROUND.

NOT ME OF COURSE, I...AM TOO OLD!

IF EUROPE'S SO LOVELY, WHY DID YOU LEAVE?

AMERICA--IT IS THE PROMISED LAND! YOU VANTED TO MAKE IT BIG? YOU VENT TO AMERICA.

SO VON DAY, I JUST GOT UP AND LEFT. I BOARDED A STEAMBOAT AND SAILED ALL THE VAY FROM ITALY TO NEW ORLEANS.

DURING THE TRIP, I TOLD TALES OF MY ACTIVISM, MY LIFE AS AN ACTOR, AND ALL THE *VOMEN* I HAD HAD.

THE HUNGARIAN CREW VAS QUITE CONSERVATIVE. THEY DECIDED THEY VOULD EXECUTE ME!

I HAD TO HIDE BETVEEN PIPES IN THE BELLY OF THE SHIP FOR VEEKS!

MY FRIEND BROUGHT ME SKRAPS OF FOOD TO KEEP ME ALIVE!

IS THAT SO?

AH, I SEE YOU ARE A SKEPTIC, BUT IT'S ALL TRUE!

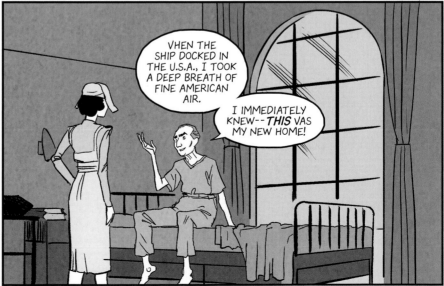

VHEN THE SHIP DOCKED IN THE U.S.A., I TOOK A DEEP BREATH OF FINE AMERICAN AIR.

I IMMEDIATELY KNEW-- *THIS* VAS MY NEW HOME!

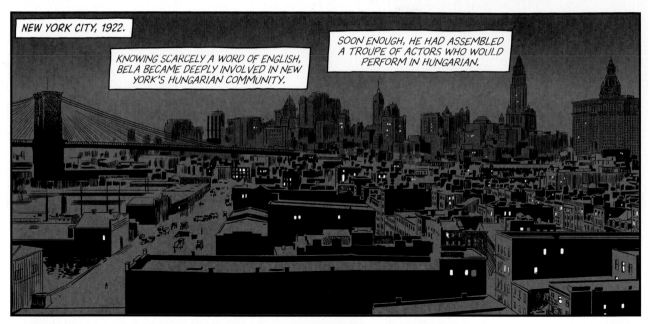

NEW YORK CITY, 1922.

KNOWING SCARCELY A WORD OF ENGLISH, BELA BECAME DEEPLY INVOLVED IN NEW YORK'S HUNGARIAN COMMUNITY.

SOON ENOUGH, HE HAD ASSEMBLED A TROUPE OF ACTORS WHO WOULD PERFORM IN HUNGARIAN.

THEATER
SZÍNHÁZ

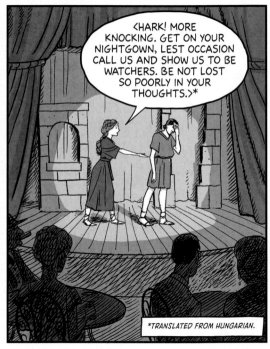

<HARK! MORE KNOCKING. GET ON YOUR NIGHTGOWN, LEST OCCASION CALL US AND SHOW US TO BE WATCHERS. BE NOT LOST SO POORLY IN YOUR THOUGHTS.>*

*TRANSLATED FROM HUNGARIAN.

<TO KNOW MY DEED, 'TWERE BEST NOT KNOW MYSELF.>

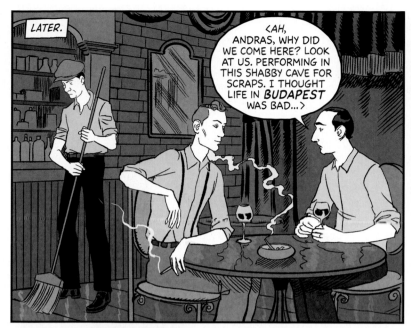

LATER.

<AH, ANDRAS, WHY DID WE COME HERE? LOOK AT US. PERFORMING IN THIS SHABBY CAVE FOR SCRAPS. I THOUGHT LIFE IN *BUDAPEST* WAS BAD...>

<YOU HAD IT GOOD, MY FRIEND, WITH A POSITION IN THE NATIONAL THEATER. IF ONLY YOU HAD KEPT YOUR MOUTH SHUT, YOU WOULD HAVE BEEN PLAYING MACBETH BY NOW.>

<MY LIFE IS A GREAT BIG FARCE.>

<COME NOW, YOU'RE TOO HARD ON YOURSELF.>

<LOOK, WITHIN A FEW MONTHS FROM ARRIVAL, YOU'VE CREATED A TROUPE, YOU'RE DIRECTING, PRODUCING, AND ACTING!>

<BAH! WHAT I NEED IS TO LAND A ROLE IN ENGLISH. THIS IS THE ONLY WAY OUT OF POVERTY ROW.>

<PERHAPS IT WOULD HELP IF YOU KNEW MORE ENGLISH. LET ME TEACH YOU A GOOD ONE:>

MIND YOUR POTATOES, JOE!

MIND YOUR POTATOES, JOE!

<ANDRAS, I WOULD LIKE YOU TO MEET MY WIFE, ILONA VON MONTAGH.>

ENCHANTÉ, <MARRIED? WHEN DID THIS HAPPEN?>

<LAST WEEK. IT WASN'T ANYTHING FANCY.>

<WELL, BELA CAN'T AFFORD FANCY.>

<DO I DETECT AN ACCENT IN YOUR HUNGARIAN?>

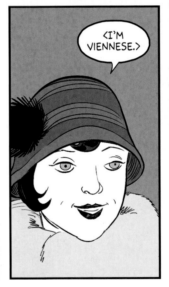

<I'M VIENNESE.>

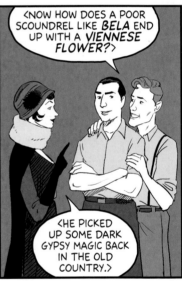

<NOW HOW DOES A POOR SCOUNDREL LIKE BELA END UP WITH A VIENNESE FLOWER?>

<HE PICKED UP SOME DARK GYPSY MAGIC BACK IN THE OLD COUNTRY.>

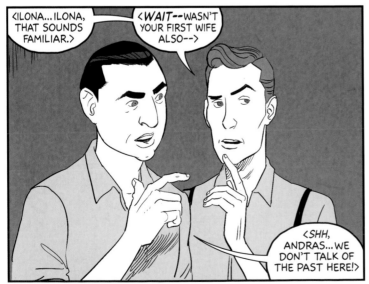

<ILONA...ILONA, THAT SOUNDS FAMILIAR.>

<WAIT--WASN'T YOUR FIRST WIFE ALSO--->

<SHH, ANDRAS...WE DON'T TALK OF THE PAST HERE!>

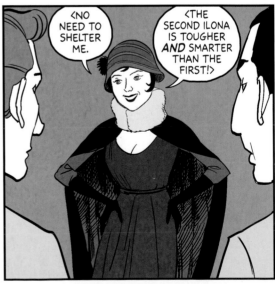

<NO NEED TO SHELTER ME.

<THE SECOND ILONA IS TOUGHER AND SMARTER THAN THE FIRST!>

LOWER EAST SIDE.

THEATER SZÍNHÁZ

clap clap clap clap

LATER.

<I'LL HAVE THE USUAL, DAVID.>

<YOU GOT IT, BELA.>

FABULOUS SHOW, OLD CHAP! I DO NOT SPEAK HUNGARIAN, BUT I UNDERSTOOD EVERY WORD!

I...I AM SORRY, NO ENGLISH.

HMM... DEUTSCHE?

WARUM, JA!*

*"WHY YES!" IN GERMAN.

‹I WAS IMPRESSED WITH YOUR PERFORMANCE. YOU ARE A SEASONED ACTOR, ARE YOU NOT?›*

*TRANSLATED FROM GERMAN.

‹I WAS A LEADING MAN IN THE HUNGARIAN NATIONAL THEATRE FOR YEARS, *A RISING STAR IN BUDAPEST*--THEN I HAD TO FLEE. THEY WERE HANGING MY KIND LEFT AND RIGHT...›

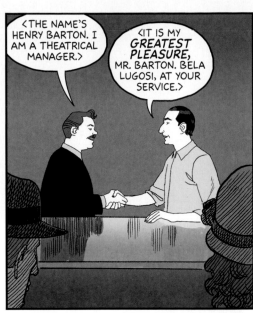

‹THE NAME'S HENRY BARTON. I AM A THEATRICAL MANAGER.›

‹IT IS MY *GREATEST PLEASURE*, MR. BARTON. BELA LUGOSI, AT YOUR SERVICE.›

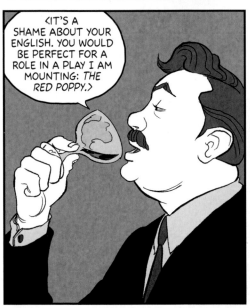

‹IT'S A SHAME ABOUT YOUR ENGLISH. YOU WOULD BE PERFECT FOR A ROLE IN A PLAY I AM MOUNTING: *THE RED POPPY*.›

‹*YOU KNOW*, I AM A QUICK LEARNER, MR. BARTON.›

‹HA! WHAT CHUTZPA.›

‹AND HOW DO YOU SUPPOSE THAT WOULD WORK?›

‹SIMPLE! HIRE A TUTOR AND DEDUCT HIS PAY FROM MY SALARY.›

‹BY THE TIME THE PLAY RUNS, I WILL BE "SINGING THE YANKEE DOODLE!"›

‹BARTENDER, CAN WE HAVE ANOTHER ROUND FOR THE ESTEEMED MR. BARTON AND MYSELF?›

‹HMMPH. PERHAPS YOU DESERVE A CHANCE...›

THE RED POPPY WAS NOT A HIT AND RAN FOR ONLY TWO WEEKS. AND YET, BELA GARNERED GREAT REVIEWS FOR HIS PERFORMANCE, AND THE PLAY ALLOWED HIM TO BREAK OUT OF THE HUNGARIAN GHETTO.

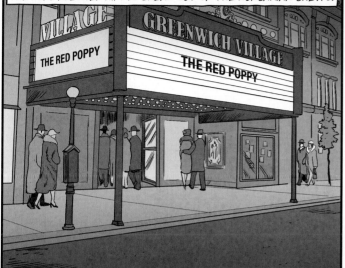

AFTER THE RED POPPY, HE WOULD START LANDING SMALL ROLES IN ENGLISH-SPEAKING THEATER AND FILM PRODUCTIONS.

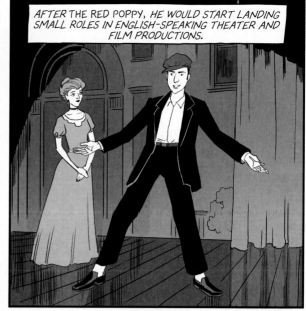

BUT THINGS WERE NOT LOOKING AS PEACHY IN BELA'S DOMESTIC LIFE.

<YOU ARE A TRUE GODDESS, MARIE!>

<BOTH ON STAGE AND UNDER THE SHEETS!>

<STOP IT!>

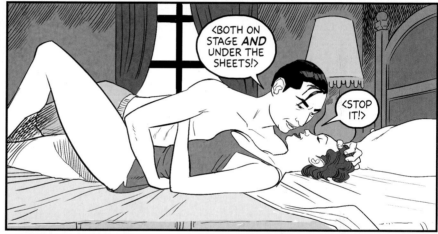

<HI, HONEY, WHY IS IT SO DARK IN HERE?>

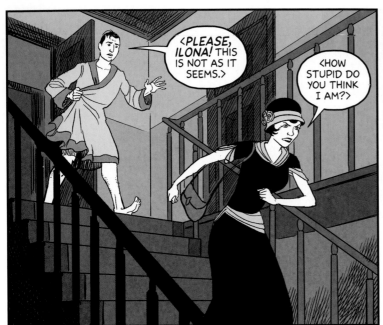

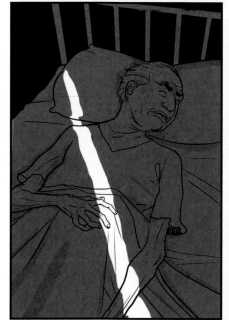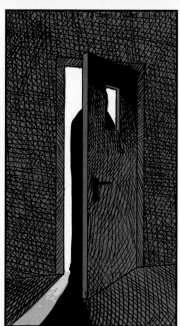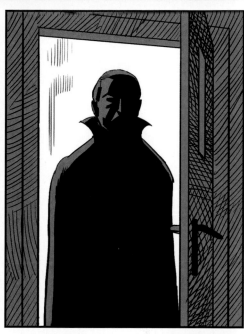

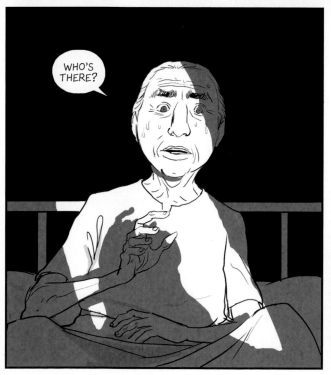

WHO'S THERE?

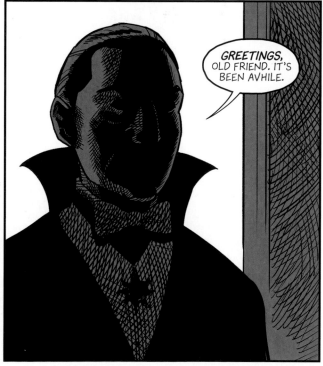

GREETINGS, OLD FRIEND. IT'S BEEN AWHILE.

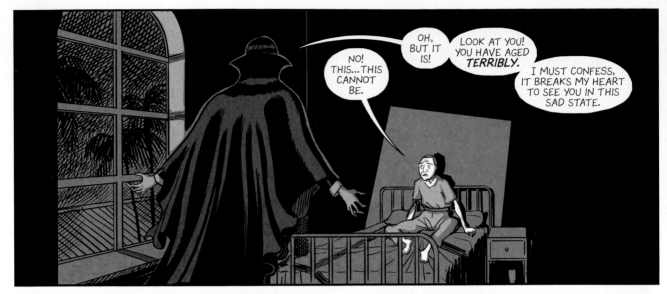

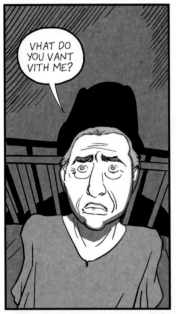

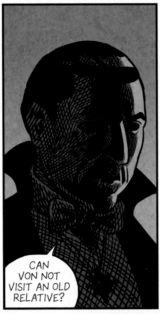

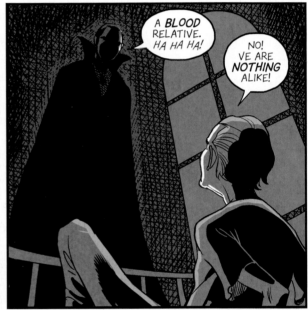

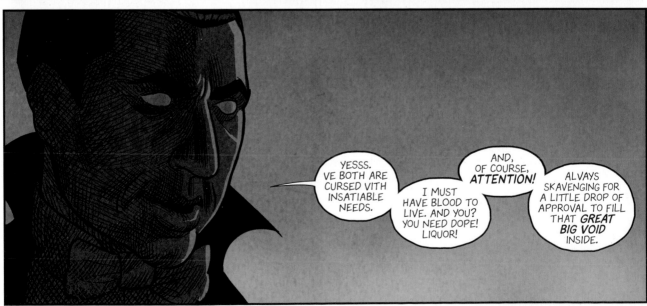

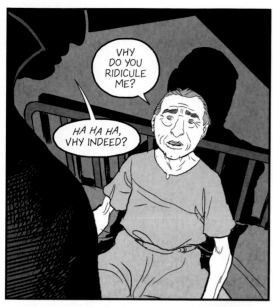

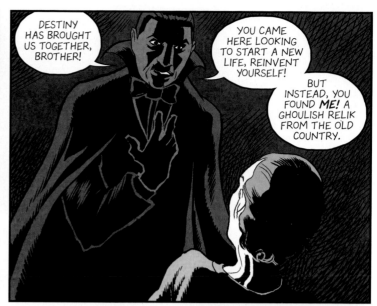

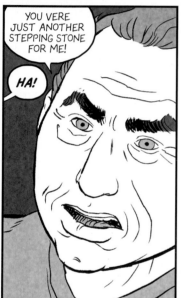

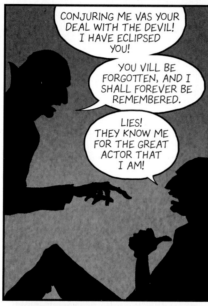

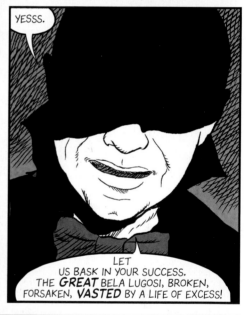

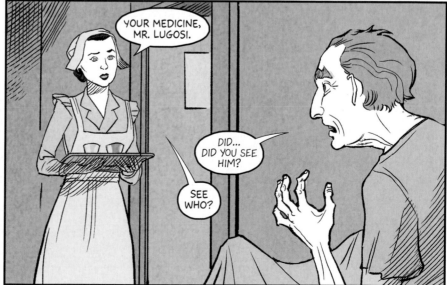

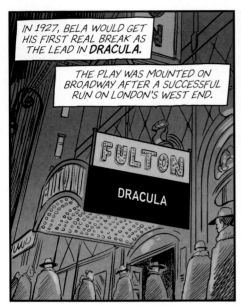

IN 1927, BELA WOULD GET HIS FIRST REAL BREAK AS THE LEAD IN **DRACULA.**

THE PLAY WAS MOUNTED ON BROADWAY AFTER A SUCCESSFUL RUN ON LONDON'S WEST END.

FULTON

DRACULA

AS A PUBLICITY STUNT, NURSES AND DOCTORS WERE HIRED TO STAND AT THE BACK OF THE THEATER TO TEND TO THOSE WHO MIGHT FAINT OR SUFFER A HEART ATTACK.

LUGOSI, FIVE MINUTES.

VORKING ON IT.

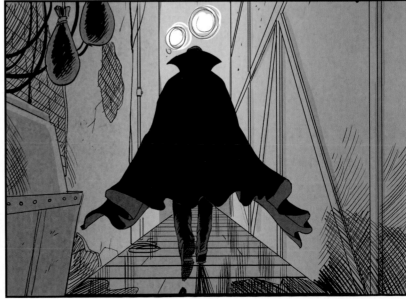

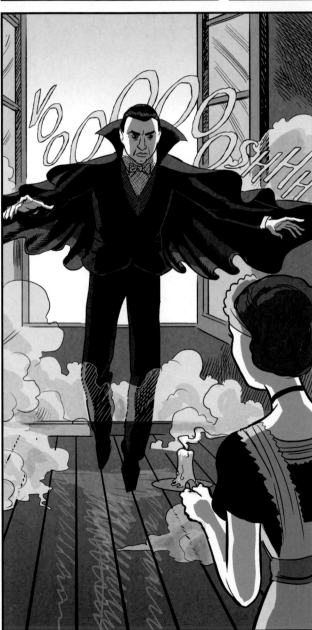

YAAAAAH!

AA AG GG GHHH!

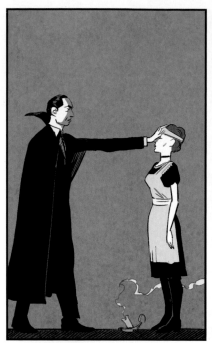

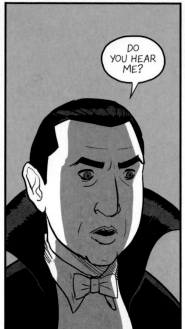

DO YOU HEAR ME?

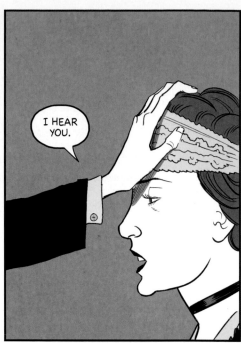

I HEAR YOU.

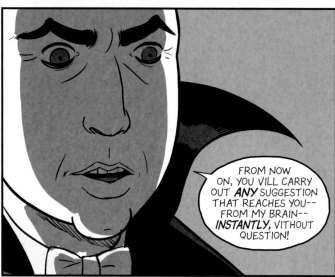

FROM NOW ON, YOU VILL CARRY OUT **ANY** SUGGESTION THAT REACHES YOU-- FROM MY BRAIN-- **INSTANTLY**, VITHOUT QUESTION!

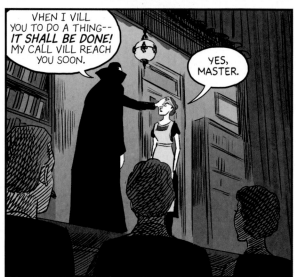

VHEN I VILL YOU TO DO A THING-- **IT SHALL BE DONE!** MY CALL VILL REACH YOU SOON.

YES, MASTER.

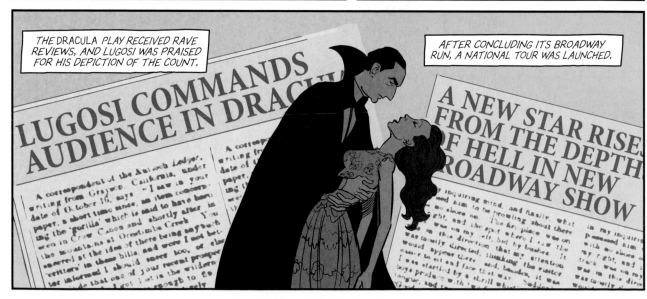

THE DRACULA PLAY RECEIVED RAVE REVIEWS, AND LUGOSI WAS PRAISED FOR HIS DEPICTION OF THE COUNT.

AFTER CONCLUDING ITS BROADWAY RUN, A NATIONAL TOUR WAS LAUNCHED.

LUGOSI COMMANDS AUDIENCE IN DRACULA

A NEW STAR RISES FROM THE DEPTHS OF HELL IN NEW BROADWAY SHOW

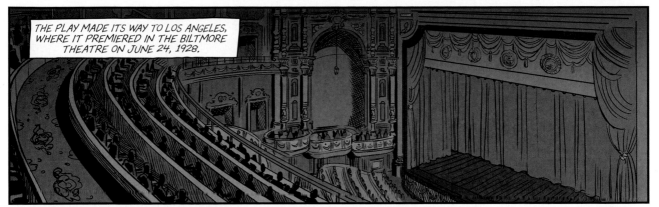

THE PLAY MADE ITS WAY TO LOS ANGELES, WHERE IT PREMIERED IN THE BILTMORE THEATRE ON JUNE 24, 1928.

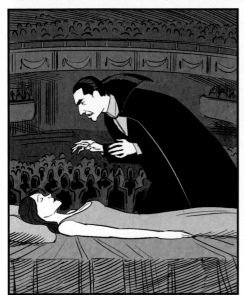

LATER.

NAWK NAWK!

YOU'VE GOT A SPECIAL GUEST!

COME IN!

CLARA, PLEASED TA MEET'CHA!

BELA LUGOSI.

ENCHANTÉ, MADEMOISELLE.

JE MCSQUEEZE MOI--BUT I DON'T SPEAK FRENCH.

ACH, MY ENGLISH, NOT SO GOOD!

AW, HON, I'M SURE IT'S NOT THAT BAD.

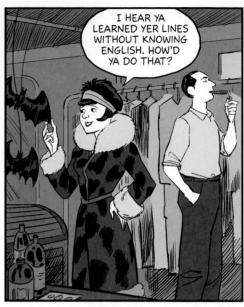

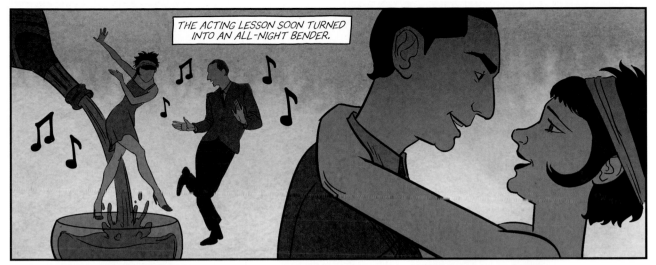

THE ACTING LESSON SOON TURNED INTO AN ALL-NIGHT BENDER.

THE NEXT DAY.

DAMN LIGHT!

HEY, BELA.

YES, DEAR?

I THINK I FORGOT OUR WHOLE LESSON FROM LAST NIGHT.

AFTER SEVERAL MONTHS OF DEBAUCHERY, BELA'S AFFAIR WITH CLARA ENDED. YET HE DID NOT REST ON HIS LAURELS.

GASSNER FURS CO

DURING DRACULA'S *SAN FRANCISCO* RUN, BELA MET A CHARMING, RICH SOCIALITE: *BEATRICE WOODRUFF WEEKS.* THE TWO BEGAN HITTING EVERY SPEAKEASY THEY COULD FIND AND SOON BECAME THE TALK OF THE TOWN.

RESTAURANT FRANCAIS

I'VE NEVER MET A VOMAN WHO COULD OUT-DRINK ME AND OUT-SMOKE ME TOO!

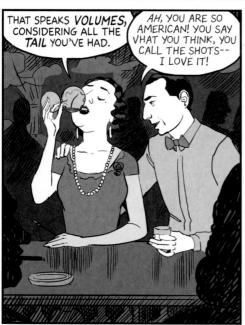

THAT SPEAKS *VOLUMES,* CONSIDERING ALL THE *TAIL* YOU'VE HAD.

AH, YOU ARE SO AMERICAN! YOU SAY VHAT YOU THINK, YOU CALL THE SHOTS-- I LOVE IT!

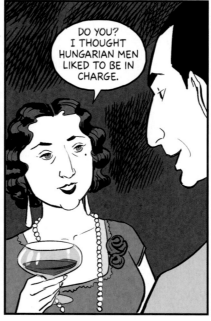

DO YOU? I THOUGHT HUNGARIAN MEN LIKED TO BE IN CHARGE.

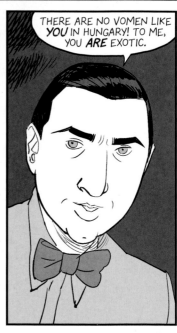

THERE ARE NO VOMEN LIKE *YOU* IN HUNGARY! TO ME, YOU *ARE* EXOTIC.

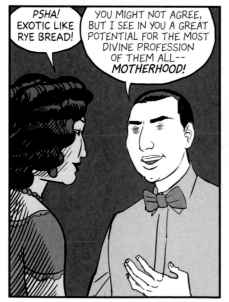

PSHA! EXOTIC LIKE RYE BREAD!

YOU MIGHT NOT AGREE, BUT I SEE IN YOU A GREAT POTENTIAL FOR THE MOST DIVINE PROFESSION OF THEM ALL-- *MOTHERHOOD!*

NOTHING DIVINE ABOUT ME, HONEY. IF ONE OF THESE DAYS I EVER DO GIVE BIRTH, THE BABE WILL POP OUT SUCKING ON A SHOT GLASS!

OKAY, FOLKS, SUN'S OUT!

LET'S WRAP IT UP...

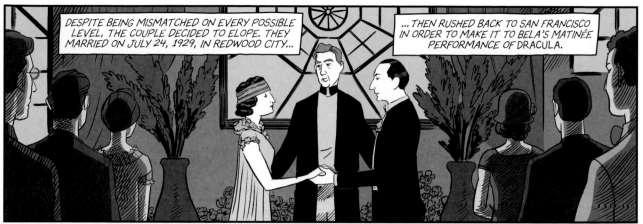

DESPITE BEING MISMATCHED ON EVERY POSSIBLE LEVEL, THE COUPLE DECIDED TO ELOPE. THEY MARRIED ON JULY 24, 1929, IN REDWOOD CITY...

...THEN RUSHED BACK TO SAN FRANCISCO IN ORDER TO MAKE IT TO BELA'S MATINÉE PERFORMANCE OF DRACULA.

THE FOLLOWING DAY, THE TWO WOKE UP TO A SOBERING REALITY.

OCH! MY HEAD!

BEATRICE? ARE YOU AVAKE?

I NEED A GLASS OF FRESHLY-SQUEEZED ORANGE JUICE AND A TABLET OF SODIUM.

MAKE IT YOURSELF-- WHAT DO YOU THINK I AM?

PERHAPS YOU SHOULD DRINK A LITTLE LESS GIN NEXT TIME, HUH?

SO YOU ARE ABLE TO TEND TO YOUR HUSBAND!

PERHAPS YOU SHOULD MIND YOUR OWN BEESWAX!

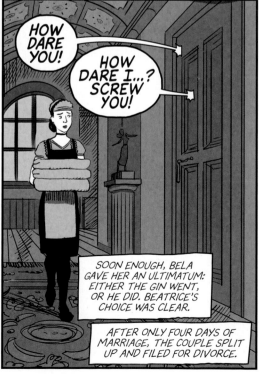

HOW DARE YOU!

HOW DARE I...? SCREW YOU!

SOON ENOUGH, BELA GAVE HER AN ULTIMATUM: EITHER THE GIN WENT, OR HE DID. BEATRICE'S CHOICE WAS CLEAR.

AFTER ONLY FOUR DAYS OF MARRIAGE, THE COUPLE SPLIT UP AND FILED FOR DIVORCE.

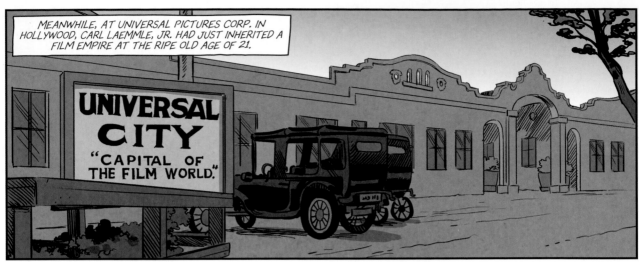

MEANWHILE, AT UNIVERSAL PICTURES CORP. IN HOLLYWOOD, CARL LAEMMLE, JR. HAD JUST INHERITED A FILM EMPIRE AT THE RIPE OLD AGE OF 21.

UNIVERSAL CITY
"CAPITAL OF THE FILM WORLD."

I HAVE A VISION, FATHER.

I WANT THE NAME "UNIVERSAL" TO BE SYNONYMOUS WITH PRESTIGE!

AND WHAT DOES THAT ENTAIL?

BIGGER PRODUCTIONS! BETTER ACTORS, GRANDER STORIES, LAVISH MUSIC. I WANT OUR FILMS TO FEEL LARGER THAN LIFE!

THAT SOUNDS EXPENSIVE, JUNIOR.

YES, I KNOW! I'VE ALREADY UPPED THE BUDGET FOR ALL QUIET ON THE WESTERN FRONT THREE TIMES!

OH DEAR.

WHY DO YOU WORRY, FATHER? BIGGER MOVIES WILL LEAD TO MASSIVE CROWDS!

WHY TAKE SUCH RISKS?

WHY NOT STICK TO THE OLD MODEL?

INEXPENSIVE FILMS, SAFE STORIES, AGGRESSIVE P.R....

YOU SAID I HAVE FREE REIN AND CREATIVE CONTROL, RIGHT?

I DID. JUST, PLEASE, PROCEED WITH CAUTION. I BUILT THIS COMPANY FROM THE GROUND UP AND WOULD HATE TO SEE ANYTHING BAD HAPPEN TO IT.

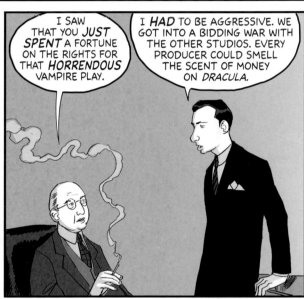

I SAW THAT YOU JUST SPENT A FORTUNE ON THE RIGHTS FOR THAT HORRENDOUS VAMPIRE PLAY.

I HAD TO BE AGGRESSIVE. WE GOT INTO A BIDDING WAR WITH THE OTHER STUDIOS. EVERY PRODUCER COULD SMELL THE SCENT OF MONEY ON DRACULA.

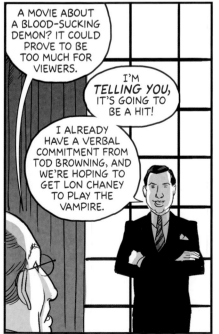

A MOVIE ABOUT A BLOOD-SUCKING DEMON? IT COULD PROVE TO BE TOO MUCH FOR VIEWERS.

I'M TELLING YOU, IT'S GOING TO BE A HIT!

I ALREADY HAVE A VERBAL COMMITMENT FROM TOD BROWNING, AND WE'RE HOPING TO GET LON CHANEY TO PLAY THE VAMPIRE.

LON IS VERY SICK. THEY THINK HE MIGHT HAVE CANCER.

HOW DO YOU KNOW?

YOUR FATHER STILL KNOWS SOME THINGS.

YOU'D BE SURPRISED...

WELL, NO MATTER. WE'LL FIND SOMEONE ELSE. DRACULA WILL BE THE FIRST OF MANY.

IT WILL BE A NEW WAVE OF HORROR UNLIKE ANYTHING SEEN BEFORE IN HOLLYWOOD!

OKAY. JUST PLEASE TRY AND KEEP THE BOOKS BALANCED!

WORD SOON GOT OUT ABOUT UNIVERSAL'S UPCOMING HORROR PRODUCTION.

FRANK!

HOW ARE YOU, MY FRIEND?

AHHH!

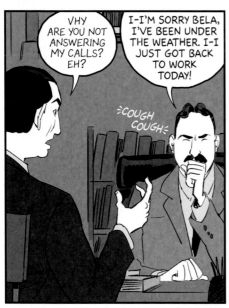

VHY ARE YOU NOT ANSWERING MY CALLS? EH?

I-I'M SORRY BELA, I'VE BEEN UNDER THE WEATHER. I-I JUST GOT BACK TO WORK TODAY!

=COUGH COUGH=

HAVE YOU ANY VORD ABOUT UNIVERSAL'S DRACULA.

WELL, I'M SURE YOU HEARD CHANEY'S DEAD, SO HE'S NOT MUCH OF A THREAT ANYMORE.

I ALSO HEARD THEY HIRED BROWNING TO DIRECT.

VELL, THAT'S QUITE A NICE TURN OF EVENTS! BROWNING AND I VORKED TOGETHER ON THE 13TH CHAIR.

FRANK, I NEED YOU TO PUSH FOR ME. I'M PERFECT FOR THIS ROLE!

NO VON KNOWS THE COUNT AS INTIMATELY AS I DO!

I'LL MAKE SOME CALLS.

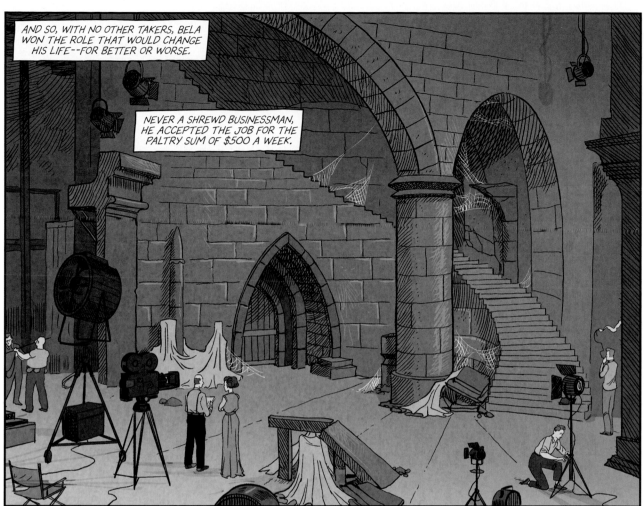

AND SO, WITH NO OTHER TAKERS, BELA WON THE ROLE THAT WOULD CHANGE HIS LIFE--FOR BETTER OR WORSE.

NEVER A SHREWD BUSINESSMAN, HE ACCEPTED THE JOB FOR THE PALTRY SUM OF $500 A WEEK.

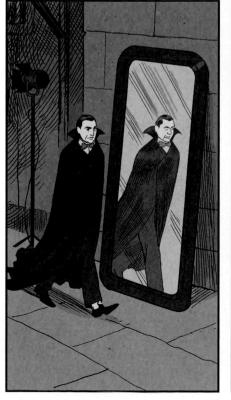

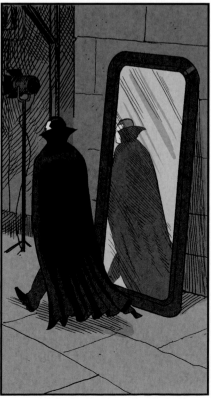

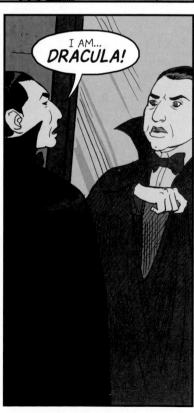

I AM... DRACULA!

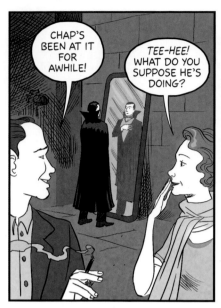

CHAP'S BEEN AT IT FOR AWHILE!

TEE-HEE! WHAT DO YOU SUPPOSE HE'S DOING?

I JUST GOT *GOOSEBUMPS* ALL OVER.

CUUUTT!

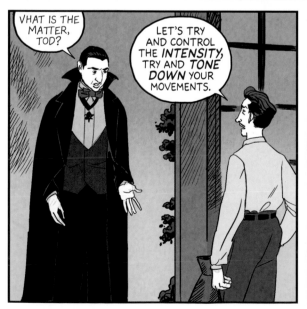

VHAT IS THE MATTER, TOD?

LET'S TRY AND CONTROL THE *INTENSITY*, TRY AND *TONE DOWN* YOUR MOVEMENTS.

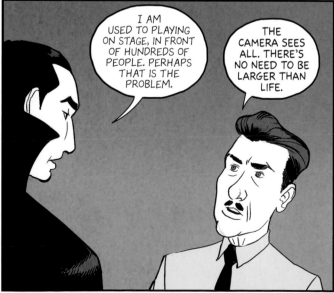

I AM USED TO PLAYING ON STAGE, IN FRONT OF HUNDREDS OF PEOPLE. PERHAPS THAT IS THE PROBLEM.

THE CAMERA SEES ALL. THERE'S NO NEED TO BE LARGER THAN LIFE.

EVERY EVENING, WHEN THE CAST AND CREW MADE THEIR WAY OUT OF THE STUDIO, THEY WOULD GREET THEIR COUNTERPARTS FROM THE SPANISH VERSION OF DRACULA WHICH SHOT OVERNIGHT USING THE SAME SETS.

HAVE A CIGAR, CARLOS. YOU'VE GOT A LONG NIGHT AHEAD OF YOU!

VHAT ELSE? US *VAMPIRES* HAVE A TASTE FOR THE *FINER THINGS* IN LIFE!

CUBAN?

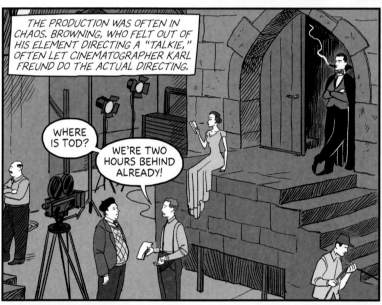

THE PRODUCTION WAS OFTEN IN CHAOS. BROWNING, WHO FELT OUT OF HIS ELEMENT DIRECTING A "TALKIE," OFTEN LET CINEMATOGRAPHER KARL FREUND DO THE ACTUAL DIRECTING.

WHERE IS TOD?

WE'RE TWO HOURS BEHIND ALREADY!

WE ARE RUNNING OUT OF TIME, KARL. WE HAVE TO SHOOT THE SCENE.

JUST *SHOOT SOMETHING,* OR WE'LL ALL BE OUT OF A JOB!

BUT...

ALRIGHT, EVERYONE, TAKE YOUR PLACES!

ELSEWHERE...

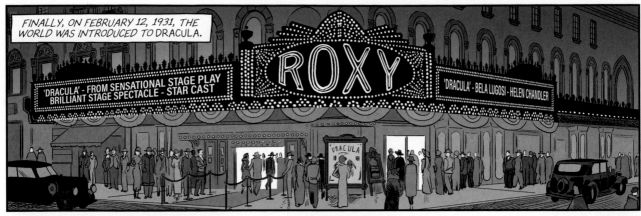

FINALLY, ON FEBRUARY 12, 1931, THE WORLD WAS INTRODUCED TO DRACULA.

ROXY

'DRACULA' - FROM SENSATIONAL STAGE PLAY
BRILLIANT STAGE SPECTACLE - STAR CAST

'DRACULA' - BELA LUGOSI - HELEN CHANDLER

DRACULA

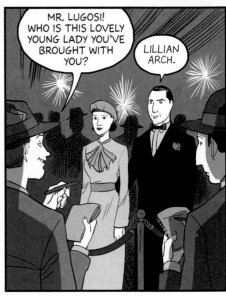

MR. LUGOSI! WHO IS THIS LOVELY YOUNG LADY YOU'VE BROUGHT WITH YOU?

LILLIAN ARCH.

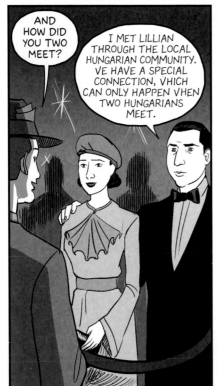

AND HOW DID YOU TWO MEET?

I MET LILLIAN THROUGH THE LOCAL HUNGARIAN COMMUNITY. VE HAVE A SPECIAL CONNECTION, VHICH CAN ONLY HAPPEN VHEN TWO HUNGARIANS MEET.

WHEN DID YOU KNOW YOU WANTED TO SEE HER?

SHE HAS BEEN MY ASSISTANT FOR AVHILE. IT VAS ONLY *RECENTLY* THAT I THOUGHT, PERHAPS IT VAS TIME FOR US TO BECOME *MORE* THAN JUST WORK FRIENDS.

MS. ARCH, ARE YOU AFRAID OF MR. LUGOSI TURNING INTO A BAT IN THE MIDDLE OF THE NIGHT?

OH, NOT AT ALL. QUITE THE OPPOSITE.

MR. LUGOSI IS A TRUE GENTLEMAN.

HE IS KIND, FUNNY, AND THERE'S NOTHING DEMONIC ABOUT HIM.

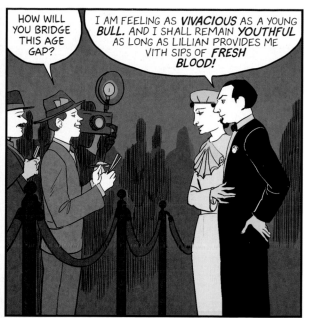

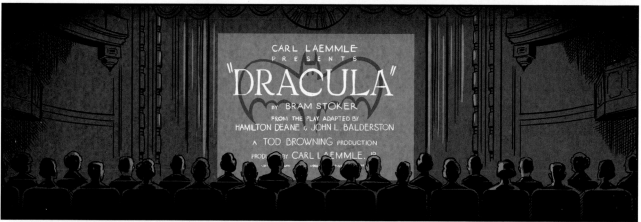

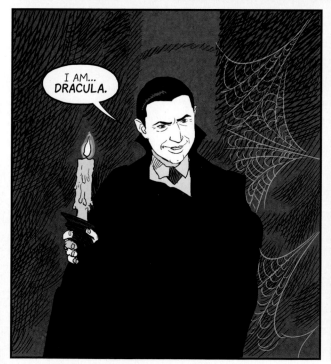

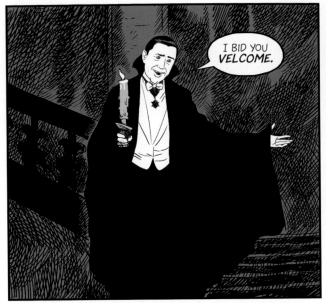

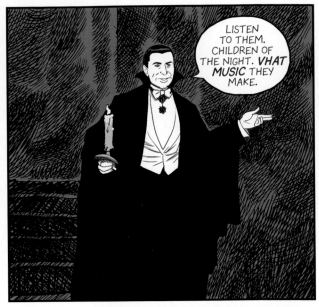

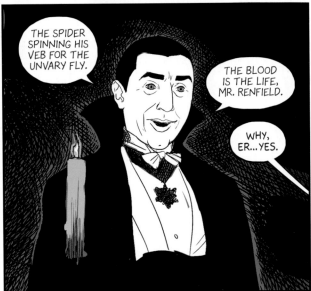

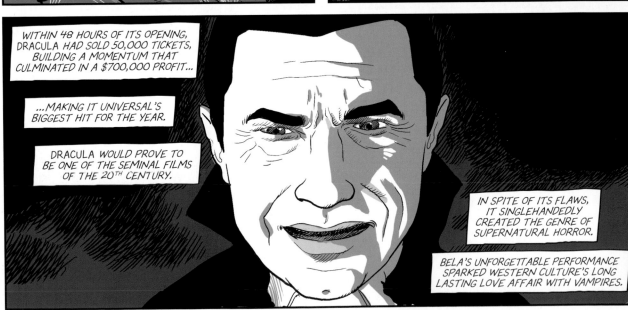

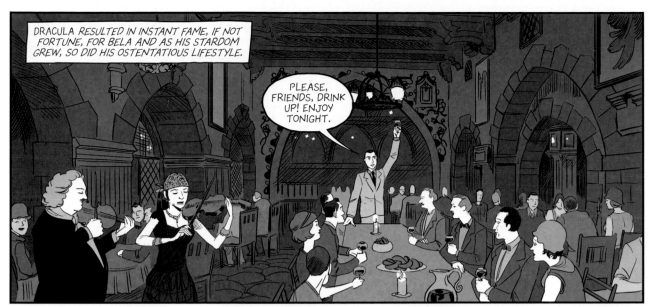

DRACULA *RESULTED IN INSTANT FAME, IF NOT FORTUNE, FOR BELA AND AS HIS STARDOM GREW, SO DID HIS OSTENTATIOUS LIFESTYLE.*

PLEASE, FRIENDS, DRINK UP! ENJOY TONIGHT.

I HAVE IMPORTED THE FINEST BAVARIAN WINE FOR THIS OCCASION.

TO BELA! HIS SUCCESS IS OUR SUCCESS!

TO BELA!

BELA, MAY WE SPEAK FOR A MOMENT?

OF COURSE!

<I'M EMBARRASSED TO BE DOING THIS, BUT COULD I KINDLY ASK YOU FOR A LITTLE LOAN? I'VE BEEN OUT OF WORK FOR WEEKS, AND WE NEED TO PAY THE RENT!>*

<HOW MUCH DO YOU NEED?>

*HUNGARIAN

<CAN YOU SPARE A THOUSAND DOLLARS?>

<OF COURSE, MILOSCH.>

<FOR YOU, I WILL GIVE THE WORLD!>

<OH, THANK YOU, THANK YOU, BELA!>

<YOU ARE WELCOME!>

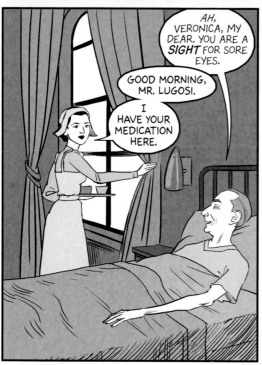

AH, VERONICA, MY DEAR. YOU ARE A **SIGHT** FOR SORE EYES.

GOOD MORNING, MR. LUGOSI.

I HAVE YOUR MEDICATION HERE.

ACH, POISON ON TOP OF POISON. IT NEVER ENDS.

YOU MUST TAKE THESE JUST THE SAME.

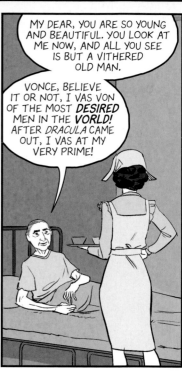

MY DEAR, YOU ARE SO YOUNG AND BEAUTIFUL. YOU LOOK AT ME NOW, AND ALL YOU SEE IS BUT A VITHERED OLD MAN.

VONCE, BELIEVE IT OR NOT, I VAS VON OF THE MOST **DESIRED** MEN IN THE **VORLD!** AFTER *DRACULA* CAME OUT, I VAS AT MY VERY PRIME!

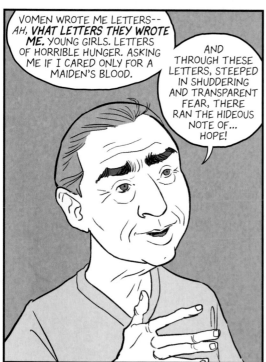

VOMEN WROTE ME LETTERS-- AH, **VHAT LETTERS THEY WROTE ME.** YOUNG GIRLS. LETTERS OF HORRIBLE HUNGER. ASKING ME IF I CARED ONLY FOR A MAIDEN'S BLOOD.

AND THROUGH THESE LETTERS, STEEPED IN SHUDDERING AND TRANSPARENT FEAR, THERE RAN THE HIDEOUS NOTE OF... HOPE!

HOPE?

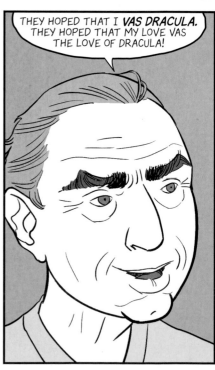

THEY HOPED THAT I **VAS DRACULA.** THEY HOPED THAT MY LOVE VAS THE LOVE OF DRACULA!

GOOD AFTERNOON, MR. LUGOSI.

I'M AFRAID I HAVE SOME BAD NEWS.

MY EX-VIFE IS IN THE BUILDING? VHY DID YOU LET HER IN?

NOTHING OF THAT SORT. WE'VE CHECKED WITH THE SCREEN ACTORS GUILD, AND IT TURNS OUT YOU HAVE NOT APPEARED IN ANY UNION FILMS IN OVER FIVE YEARS. THEY WON'T COVER YOUR BILL.

VHAT?

AND SPEAKING OF BILLS, YOU NOW OWE US FOR THE DURATION OF YOUR STAY. I'VE GOT ALL THE PAPERS HERE--

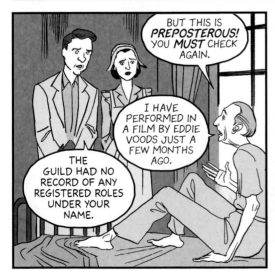

BUT THIS IS PREPOSTEROUS! YOU MUST CHECK AGAIN.

I HAVE PERFORMED IN A FILM BY EDDIE VOODS JUST A FEW MONTHS AGO.

THE GUILD HAD NO RECORD OF ANY REGISTERED ROLES UNDER YOUR NAME.

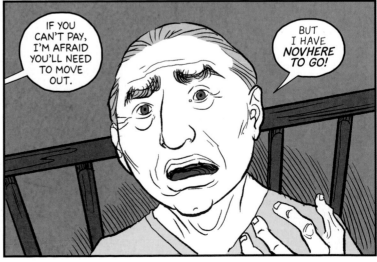

IF YOU CAN'T PAY, I'M AFRAID YOU'LL NEED TO MOVE OUT.

BUT I HAVE NOVHERE TO GO!

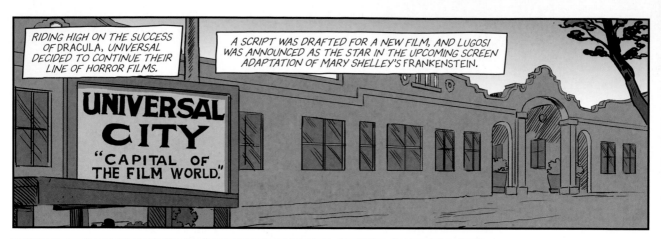

RIDING HIGH ON THE SUCCESS OF DRACULA, UNIVERSAL DECIDED TO CONTINUE THEIR LINE OF HORROR FILMS.

A SCRIPT WAS DRAFTED FOR A NEW FILM, AND LUGOSI WAS ANNOUNCED AS THE STAR IN THE UPCOMING SCREEN ADAPTATION OF MARY SHELLEY'S FRANKENSTEIN.

UNIVERSAL CITY
"CAPITAL OF THE FILM WORLD."

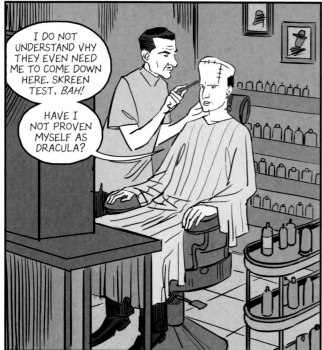

I DO NOT UNDERSTAND VHY THEY EVEN NEED ME TO COME DOWN HERE. SKREEN TEST, *BAH!*

HAVE I NOT PROVEN MYSELF AS DRACULA?

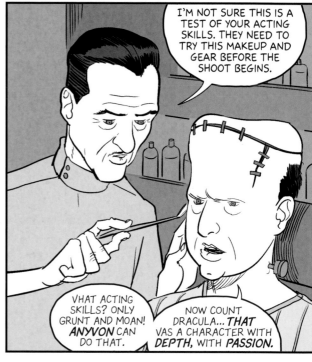

I'M NOT SURE THIS IS A TEST OF YOUR ACTING SKILLS. THEY NEED TO TRY THIS MAKEUP AND GEAR BEFORE THE SHOOT BEGINS.

VHAT ACTING SKILLS? ONLY GRUNT AND MOAN! *ANYVON* CAN DO THAT.

NOW COUNT DRACULA... *THAT* VAS A CHARACTER WITH *DEPTH,* WITH *PASSION.*

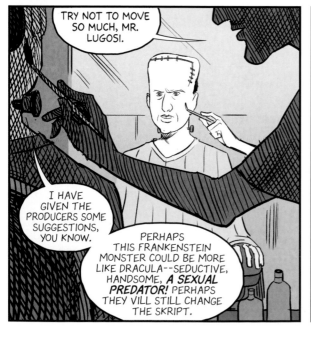

TRY NOT TO MOVE SO MUCH, MR. LUGOSI.

I HAVE GIVEN THE PRODUCERS SOME SUGGESTIONS, YOU KNOW.

PERHAPS THIS FRANKENSTEIN MONSTER COULD BE MORE LIKE DRACULA--SEDUCTIVE, HANDSOME, *A SEXUAL PREDATOR!* PERHAPS THEY VILL STILL CHANGE THE SKRIPT.

HOW MUCH LONGER VILL THIS TAKE?

AT LEAST ANOTHER TWO HOURS...

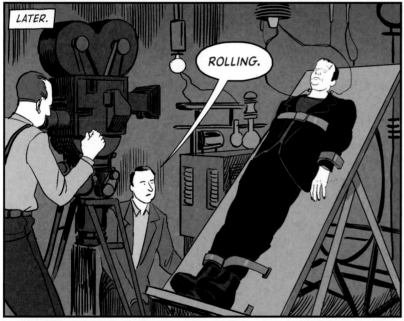

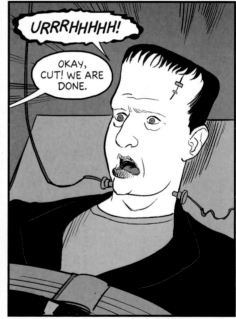

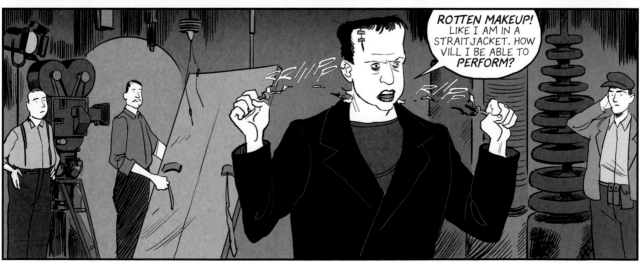

BY THIS TIME, SEVERAL PRESS RELEASES HAD ANNOUNCED BELA WAS SET TO PLAY THE PART OF FRANKENSTEIN'S MONSTER.

SCREENING ROOM

BUT AT UNIVERSAL, THE PRODUCTION WAS BEING SHAKEN UP AS ROBERT FLOREY WAS KICKED OFF THE PROJECT AND REPLACED BY BRITISH DIRECTOR **JAMES WHALE.**

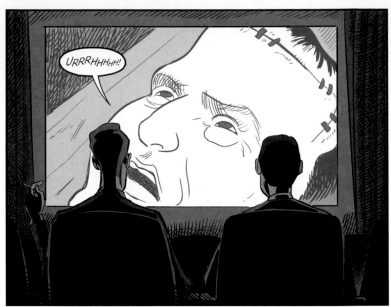

URRRHHHHH!

WELL, JIMMY, WHAT DO YOU THINK?

DO YOU WANT ME TO BE HONEST?

OF COURSE!

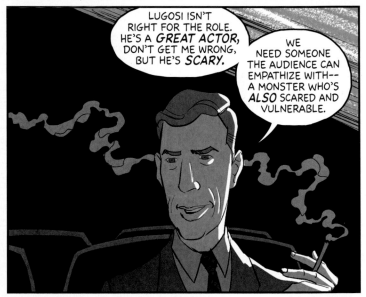

LUGOSI ISN'T RIGHT FOR THE ROLE. HE'S A *GREAT ACTOR,* DON'T GET ME WRONG, BUT HE'S *SCARY.*

WE NEED SOMEONE THE AUDIENCE CAN EMPATHIZE WITH-- A MONSTER WHO'S *ALSO* SCARED AND VULNERABLE.

WELL, DON'T KEEP ME HANGING. WHO DO YOU HAVE IN MIND?

THERE'S THIS CHAP, HE'S VIRTUALLY UNKNOWN, BUT I THINK HE WOULD BE *PERFECT.*

RIGHT BEFORE THE SHOOT WAS TO BEGIN, DIRECTOR JAMES WHALE CONVINCED UNIVERSAL TO DROP LUGOSI.

THE ROLE OF THE MONSTER WOULD BE PLAYED BY A SCARCELY KNOWN BRITISH ACTOR BY THE NAME OF BORIS KARLOFF.

YES. YES, I UNDERSTAND. THANK YOU.

SLAM

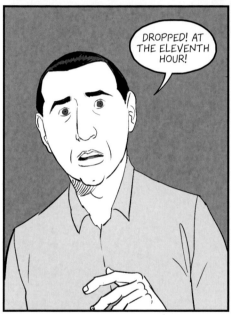

DROPPED! AT THE ELEVENTH HOUR!

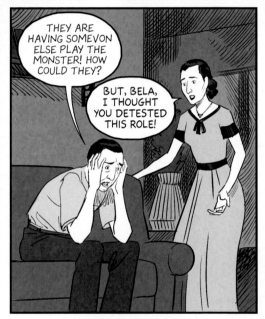

THEY ARE HAVING SOMEVON ELSE PLAY THE MONSTER! HOW COULD THEY?

BUT, BELA, I THOUGHT YOU DETESTED THIS ROLE!

YOU'VE BEEN COMPLAINING ABOUT IT FOR MONTHS NOW-- HOW IT'S BENEATH YOU!

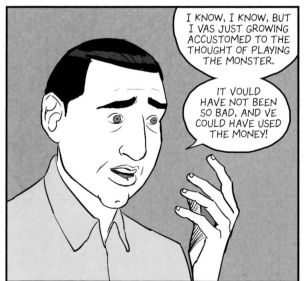

I KNOW, I KNOW, BUT I VAS JUST GROWING ACCUSTOMED TO THE THOUGHT OF PLAYING THE MONSTER.

IT VOULD HAVE NOT BEEN SO BAD, AND VE COULD HAVE USED THE MONEY!

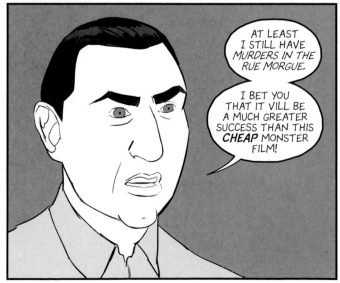

AT LEAST I STILL HAVE MURDERS IN THE RUE MORGUE.

I BET YOU THAT IT VILL BE A MUCH GREATER SUCCESS THAN THIS CHEAP MONSTER FILM!

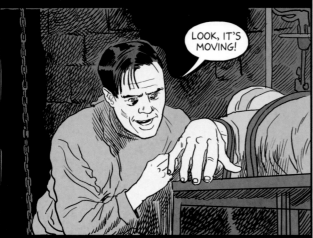

BELA WAS WRONG. FRANKENSTEIN WOULD COMPLETELY UPHEND HIS CAREER.

LOOK, IT'S MOVING!

THE FILM CREATED A POWERFUL, LIFELONG NEMESIS WHICH WOULD FORVER HAUNT HIM.

IT'S ALIVE.

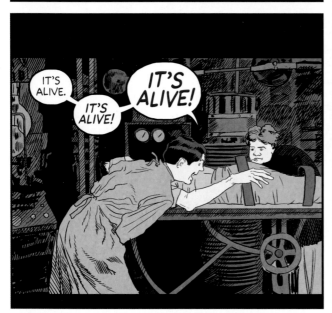

IT'S ALIVE.

IT'S ALIVE!

IT'S ALIVE!

IN THE NAME OF GOD, NOW I KNOW WHAT IT FEELS LIKE TO BE GOD!

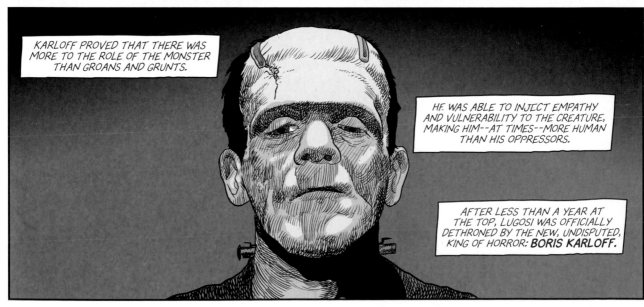

KARLOFF PROVED THAT THERE WAS MORE TO THE ROLE OF THE MONSTER THAN GROANS AND GRUNTS.

HE WAS ABLE TO INJECT EMPATHY AND VULNERABILITY TO THE CREATURE, MAKING HIM--AT TIMES--MORE HUMAN THAN HIS OPPRESSORS.

AFTER LESS THAN A YEAR AT THE TOP, LUGOSI WAS OFFICIALLY DETHRONED BY THE NEW, UNDISPUTED, KING OF HORROR: BORIS KARLOFF.

LOS ANGELES COUNTY COURT.

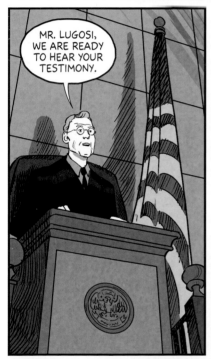

MR. LUGOSI, WE ARE READY TO HEAR YOUR TESTIMONY.

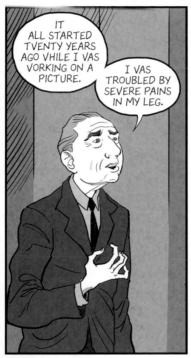

IT ALL STARTED TVENTY YEARS AGO VHILE I VAS VORKING ON A PICTURE.

I VAS TROUBLED BY SEVERE PAINS IN MY LEG.

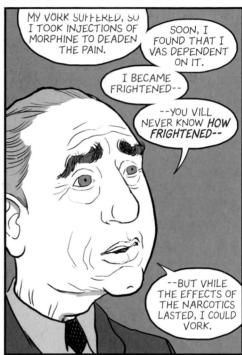

MY VORK SUFFERED, SO I TOOK INJECTIONS OF MORPHINE TO DEADEN THE PAIN.

SOON, I FOUND THAT I VAS DEPENDENT ON IT.

I BECAME FRIGHTENED--

--YOU VILL NEVER KNOW HOW FRIGHTENED--

--BUT VHILE THE EFFECTS OF THE NARCOTICS LASTED, I COULD VORK.

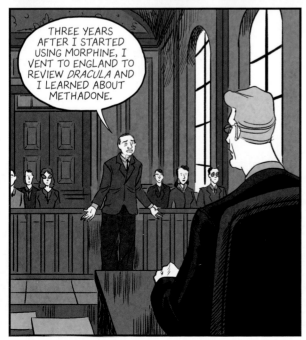

THREE YEARS AFTER I STARTED USING MORPHINE, I VENT TO ENGLAND TO REVIEW DRACULA AND I LEARNED ABOUT METHADONE.

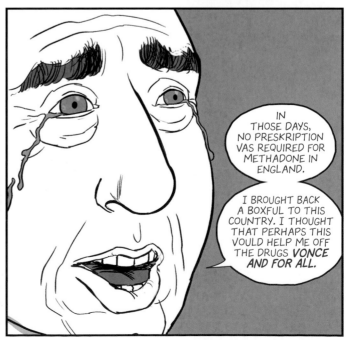

IN THOSE DAYS, NO PRESKRIPTION VAS REQUIRED FOR METHADONE IN ENGLAND.

I BROUGHT BACK A BOXFUL TO THIS COUNTRY. I THOUGHT THAT PERHAPS THIS VOULD HELP ME OFF THE DRUGS VONCE AND FOR ALL.

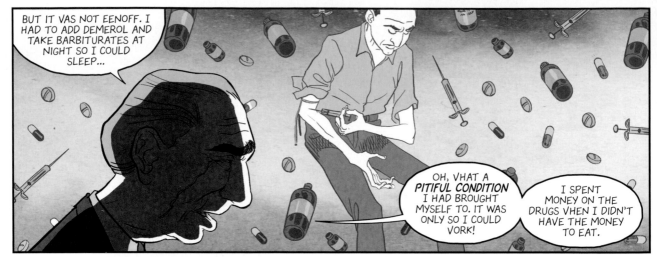

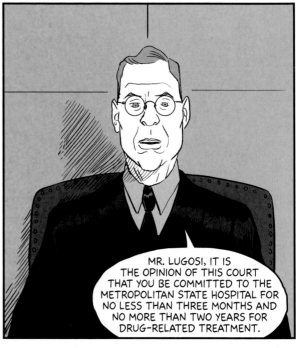

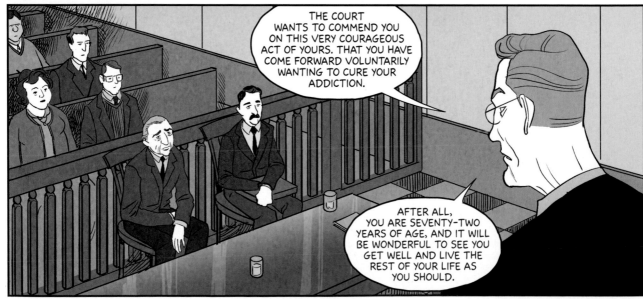

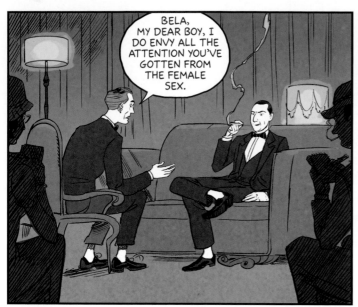

BELA, MY DEAR BOY, I DO ENVY ALL THE ATTENTION YOU'VE GOTTEN FROM THE FEMALE SEX.

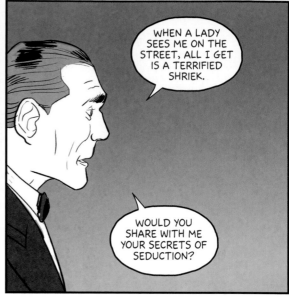

WHEN A LADY SEES ME ON THE STREET, ALL I GET IS A TERRIFIED SHRIEK.

WOULD YOU SHARE WITH ME YOUR SECRETS OF SEDUCTION?

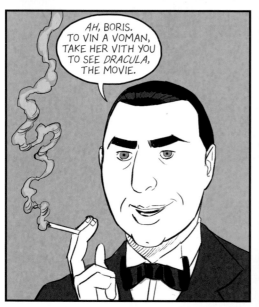

AH, BORIS. TO VIN A VOMAN, TAKE HER VITH YOU TO SEE *DRACULA*, THE MOVIE.

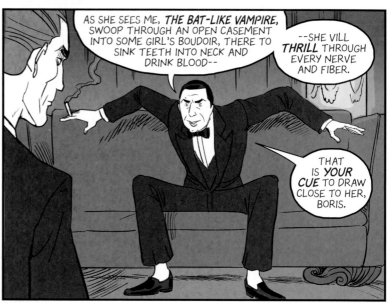

AS SHE SEES ME, *THE BAT-LIKE VAMPIRE*, SWOOP THROUGH AN OPEN CASEMENT INTO SOME GIRL'S BOUDOIR, THERE TO SINK TEETH INTO NECK AND DRINK BLOOD--

--SHE VILL *THRILL* THROUGH EVERY NERVE AND FIBER.

THAT IS *YOUR CUE* TO DRAW CLOSE TO HER, BORIS.

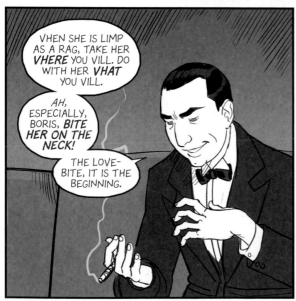

VHEN SHE IS LIMP AS A RAG, TAKE HER *VHERE* YOU VILL. DO WITH HER *VHAT* YOU VILL.

AH, ESPECIALLY, BORIS, *BITE HER ON THE NECK!*

THE LOVE-BITE, IT IS THE BEGINNING.

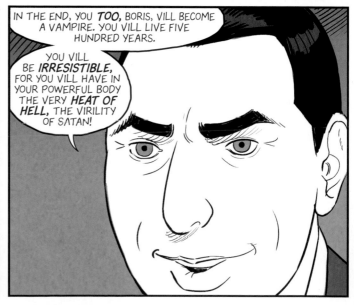

IN THE END, YOU *TOO*, BORIS, VILL BECOME A VAMPIRE. YOU VILL LIVE FIVE HUNDRED YEARS.

YOU VILL BE *IRRESISTIBLE*, FOR YOU VILL HAVE IN YOUR POWERFUL BODY THE VERY *HEAT OF HELL*, THE VIRILITY OF SATAN!

BELA'S NEXT FILM WAS MURDERS IN THE RUE MORGUE. IT WAS VERY LOOSELY BASED ON AN EDGAR ALLAN POE STORY BY THE SAME NAME.

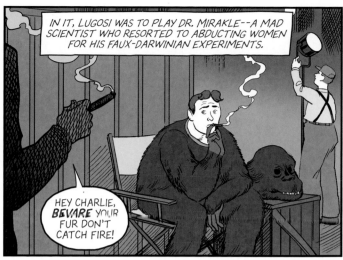

IN IT, LUGOSI WAS TO PLAY DR. MIRAKLE--A MAD SCIENTIST WHO RESORTED TO ABDUCTING WOMEN FOR HIS FAUX-DARWINIAN EXPERIMENTS.

HEY CHARLIE, *BEVARE* YOUR FUR DON'T CATCH FIRE!

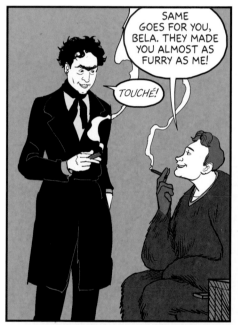

SAME GOES FOR YOU, BELA. THEY MADE YOU ALMOST AS FURRY AS ME!

TOUCHÉ!

BREAK'S OVER, MEN. LET'S GET IN POSITIONS.

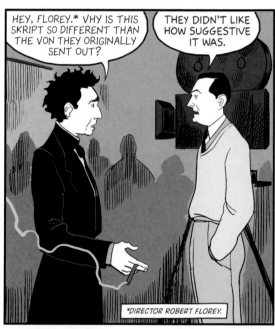

HEY, FLOREY.* VHY IS THIS SKRIPT SO DIFFERENT THAN THE VON THEY ORIGINALLY SENT OUT?

THEY DIDN'T LIKE HOW SUGGESTIVE IT WAS.

*DIRECTOR ROBERT FLOREY.

SUGGESTIVE OF *VHAT?*

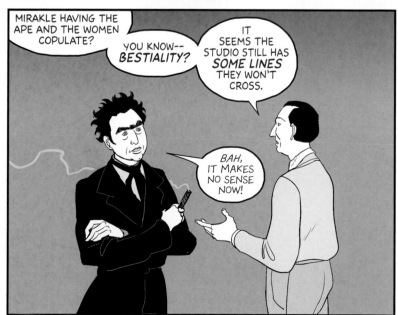

MIRAKLE HAVING THE APE AND THE WOMEN COPULATE?

YOU KNOW-- *BESTIALITY?*

IT SEEMS THE STUDIO STILL HAS *SOME LINES* THEY WON'T CROSS.

BAH, IT MAKES NO SENSE NOW!

DR. MIRAKLE WAS A FAR CRY FROM COUNT DRACULA. THIS SIMPLE VILLAIN LACKED ANY COMPLEXITY AND CHARM.

WHAT A FUNNY-LOOKING MAN.

HE'S A SHOW IN HIMSELF!

DID YOU NOTICE HIS ACCENT?

I WONDER WHERE HE COMES FROM.

I'VE NEVER HEARD AN ACCENT LIKE IT.

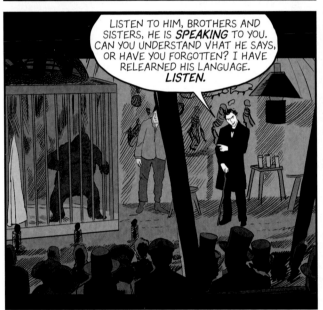

LISTEN TO HIM, BROTHERS AND SISTERS, HE IS **SPEAKING** TO YOU. CAN YOU UNDERSTAND VHAT HE SAYS, OR HAVE YOU FORGOTTEN? I HAVE RELEARNED HIS LANGUAGE. **LISTEN.**

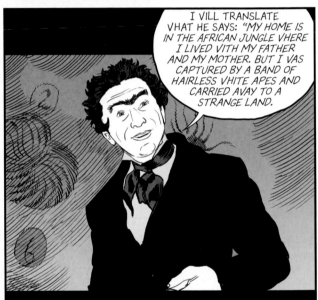

I VILL TRANSLATE VHAT HE SAYS: "MY HOME IS IN THE AFRICAN JUNGLE VHERE I LIVED VITH MY FATHER AND MY MOTHER. BUT I VAS CAPTURED BY A BAND OF HAIRLESS VHITE APES AND CARRIED AVAY TO A STRANGE LAND."

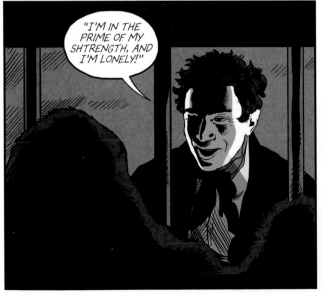

"I'M IN THE PRIME OF MY SHTRENGTH, AND I'M LONELY!"

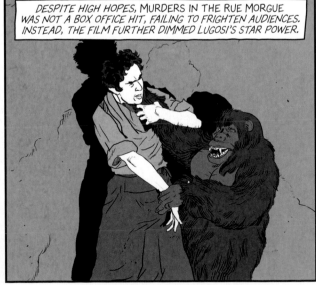

DESPITE HIGH HOPES, MURDERS IN THE RUE MORGUE WAS NOT A BOX OFFICE HIT, FAILING TO FRIGHTEN AUDIENCES. INSTEAD, THE FILM FURTHER DIMMED LUGOSI'S STAR POWER.

METROPOLITAN STATE HOSPITAL

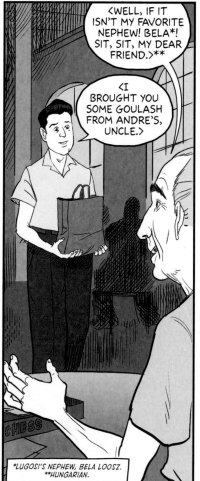

<WELL, IF IT ISN'T MY FAVORITE NEPHEW! BELA*! SIT, SIT, MY DEAR FRIEND.>**

<I BROUGHT YOU SOME GOULASH FROM ANDRE'S, UNCLE.>

*LUGOSI'S NEPHEW, BELA LOOSZ.
**HUNGARIAN.

<THANK YOU! I WILL SAVOR EVERY BIT OF IT.>

<HOW ARE YOU HOLDING UP?>

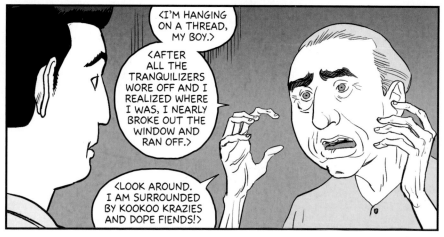

<I'M HANGING ON A THREAD, MY BOY.>

<AFTER ALL THE TRANQUILIZERS WORE OFF AND I REALIZED WHERE I WAS, I NEARLY BROKE OUT THE WINDOW AND RAN OFF.>

<LOOK AROUND. I AM SURROUNDED BY KOOKOO KRAZIES AND DOPE FIENDS!>

<I KNOW IT'S NOT AS FANCY AS YOUR ACTOR HOSPITAL, BUT THIS IS FOR THE BEST. THEY'LL HELP CURE YOU.>

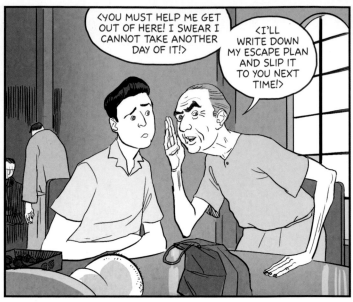

<YOU MUST HELP ME GET OUT OF HERE! I SWEAR I CANNOT TAKE ANOTHER DAY OF IT!>

<I'LL WRITE DOWN MY ESCAPE PLAN AND SLIP IT TO YOU NEXT TIME!>

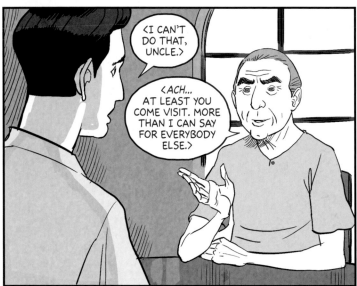

<I CAN'T DO THAT, UNCLE.>

<ACH... AT LEAST YOU COME VISIT. MORE THAN I CAN SAY FOR EVERYBODY ELSE.>

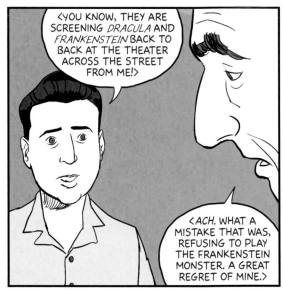

<YOU KNOW, THEY ARE SCREENING *DRACULA* AND *FRANKENSTEIN* BACK TO BACK AT THE THEATER ACROSS THE STREET FROM ME!>

<ACH. WHAT A MISTAKE THAT WAS, REFUSING TO PLAY THE FRANKENSTEIN MONSTER. A GREAT REGRET OF MINE.>

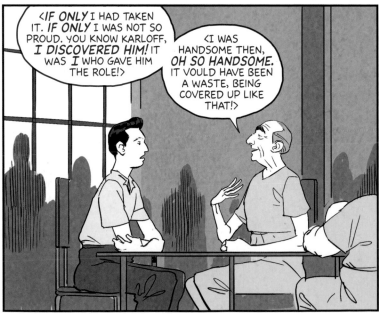

<*IF ONLY* I HAD TAKEN IT. *IF ONLY* I WAS NOT SO PROUD. YOU KNOW KARLOFF, *I DISCOVERED HIM!* IT WAS *I* WHO GAVE HIM THE ROLE!>

<I WAS HANDSOME THEN, *OH SO HANDSOME.* IT VOULD HAVE BEEN A WASTE, BEING COVERED UP LIKE THAT!>

<NOW KARLOFF, WITH OR WITHOUT THE MAKE-UP-- *TERRIBLE FACE.*>

NEVER CAREFUL WITH MONEY, BELA'S NEWFOUND FAME HAD UNLEASHED A LIFE OF EXCESS THAT COULD NOT KEEP UP WITH HIS INCOME. IN 1932, THE DEBTORS BEGAN TO KNOCK AT HIS DOOR, BRINGING THE PARTY TO AN END.

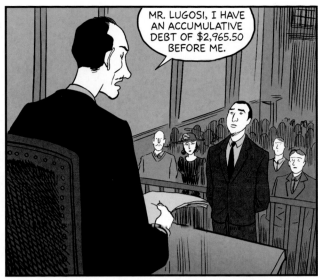

MR. LUGOSI, I HAVE AN ACCUMULATIVE DEBT OF $2,965.50 BEFORE ME.

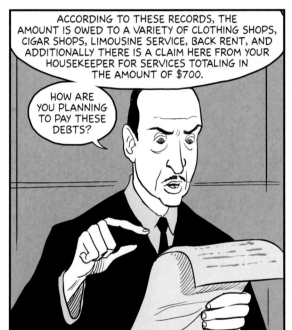

ACCORDING TO THESE RECORDS, THE AMOUNT IS OWED TO A VARIETY OF CLOTHING SHOPS, CIGAR SHOPS, LIMOUSINE SERVICE, BACK RENT, AND ADDITIONALLY THERE IS A CLAIM HERE FROM YOUR HOUSEKEEPER FOR SERVICES TOTALING IN THE AMOUNT OF $700.

HOW ARE YOU PLANNING TO PAY THESE DEBTS?

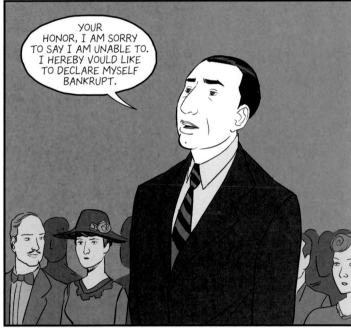

YOUR HONOR, I AM SORRY TO SAY I AM UNABLE TO. I HEREBY VOULD LIKE TO DECLARE MYSELF BANKRUPT.

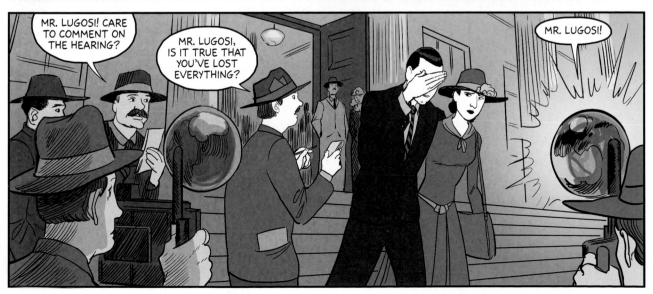

MR. LUGOSI! CARE TO COMMENT ON THE HEARING?

MR. LUGOSI, IS IT TRUE THAT YOU'VE LOST EVERYTHING?

MR. LUGOSI!

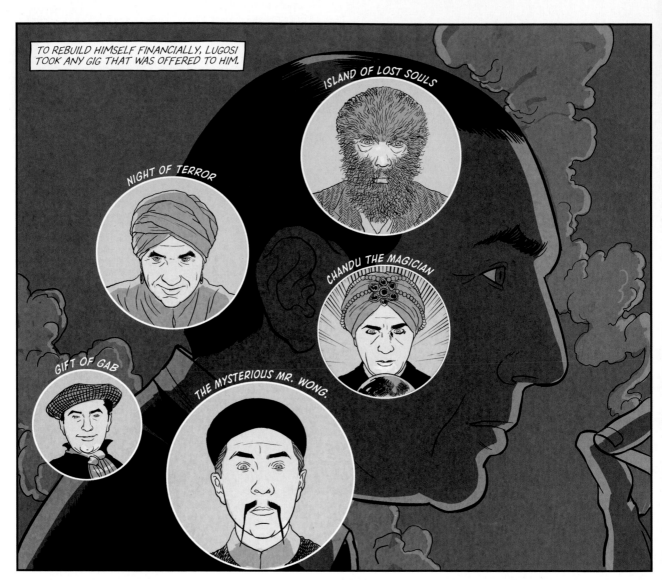

TO REBUILD HIMSELF FINANCIALLY, LUGOSI TOOK ANY GIG THAT WAS OFFERED TO HIM.

ISLAND OF LOST SOULS

NIGHT OF TERROR

CHANDU THE MAGICIAN

GIFT OF GAB

THE MYSTERIOUS MR. WONG.

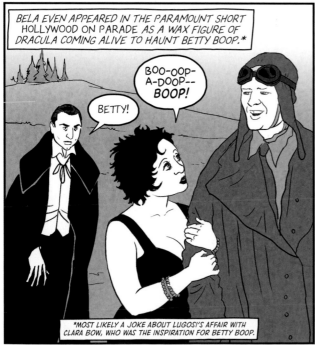

BELA EVEN APPEARED IN THE PARAMOUNT SHORT HOLLYWOOD ON PARADE AS A WAX FIGURE OF DRACULA COMING ALIVE TO HAUNT BETTY BOOP.*

BOO-OOP-A-DOOP--BOOP!

BETTY!

*MOST LIKELY A JOKE ABOUT LUGOSI'S AFFAIR WITH CLARA BOW, WHO WAS THE INSPIRATION FOR BETTY BOOP.

YOU HAVE BOOPED YOUR LAST BOOP!

AAAHHH!!!!!

MOST OF BELA'S ROLES IN B-FILMS WOULD BE FORGOTTEN, WITH THE EXCEPTION OF THE 1932 FILM WHITE ZOMBIE, WHICH, DESPITE ITS LOW BUDGET, PROVED INFLUENTIAL AND LASTING.

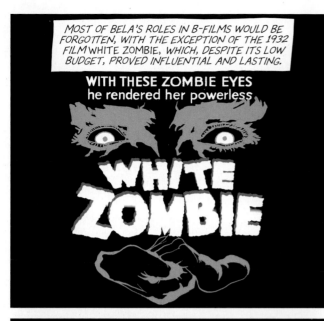

THE FILM, WHICH TAKES PLACE IN A HAITIAN PLANTATION, IS ONE OF THE EARLIEST DEPICTIONS OF ZOMBIES IN THE MEDIUM. IN IT, LUGOSI PLAYS A PLANTATION OWNER WHO ALSO COMMANDS AN ARMY OF ZOMBIES.

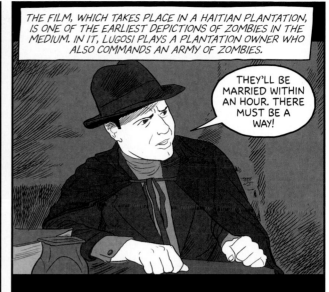

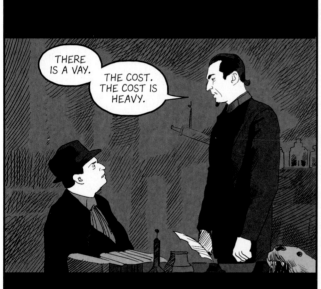

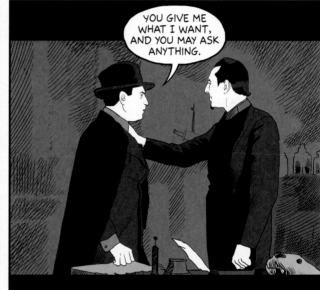

83

83

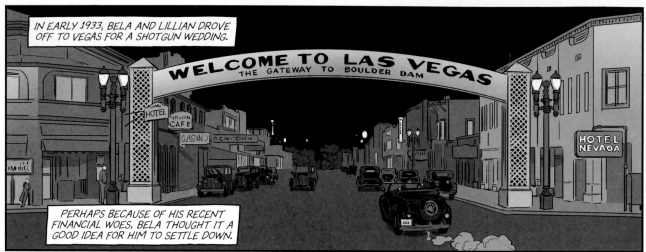

IN EARLY 1933, BELA AND LILLIAN DROVE OFF TO VEGAS FOR A SHOTGUN WEDDING.

WELCOME TO LAS VEGAS
THE GATEWAY TO BOULDER DAM

PERHAPS BECAUSE OF HIS RECENT FINANCIAL WOES, BELA THOUGHT IT A GOOD IDEA FOR HIM TO SETTLE DOWN.

AND DO YOU, LILLIAN, TAKE THIS MAN TO BE YOUR HUSBAND?

I DO.

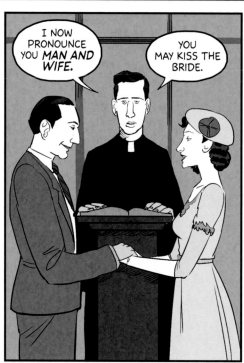

I NOW PRONOUNCE YOU *MAN AND WIFE.*

YOU MAY KISS THE BRIDE.

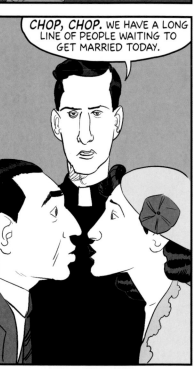

CHOP, CHOP. WE HAVE A LONG LINE OF PEOPLE WAITING TO GET MARRIED TODAY.

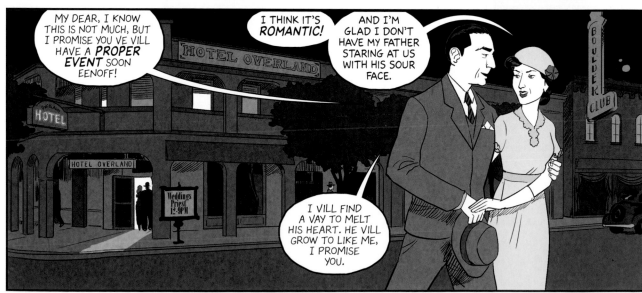

MY DEAR, I KNOW THIS IS NOT MUCH, BUT I PROMISE YOU VE VILL HAVE A *PROPER EVENT* SOON EENOFF!

I THINK IT'S *ROMANTIC!*

AND I'M GLAD I DON'T HAVE MY FATHER STARING AT US WITH HIS SOUR FACE.

I VILL FIND A VAY TO MELT HIS HEART. HE VILL GROW TO LIKE ME, I PROMISE YOU.

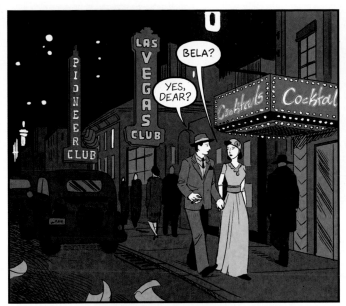

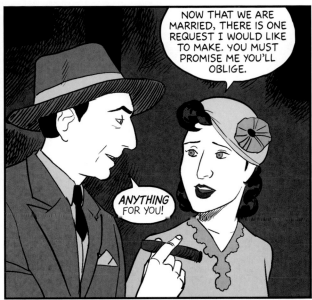

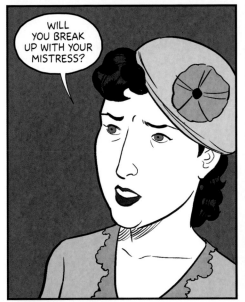

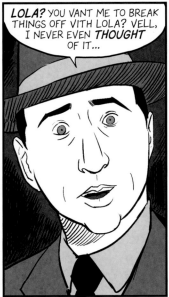

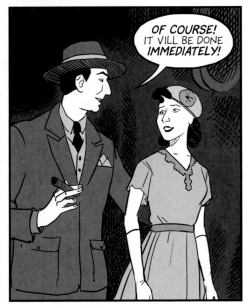

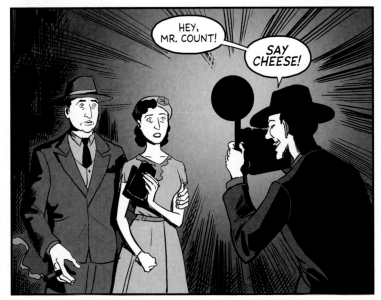

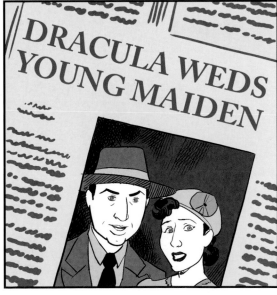

LILLIAN ARCH WOKE UP THE NEXT DAY BESIDE HER NEW HUSBAND.

IF SHE EXPECTED TO BE LIVING WITH THE DASHING HUNGARIAN GENTLEMAN SHE FELL FOR, SHE WAS IN FOR A RUDE SURPRISE.

LILLIAN...

LILLIAN! VAKE UP, PLEASE.

HUH?

I AM IN *TERRIBLE* PAIN!

WHAT'S WRONG?

THERE IS A *HORRIBLE* NUMBNESS IN MY FEET EACH DAY VHEN I VAKE!

IT IS THE RESULT OF AN OLD *VAR INJURY!*

I *MUST* HAVE MY FEET RUBBED EACH MORNING...

...OTHERVISE I CANNOT FUNCTION!

AHH, YES, RIGHT THERE!

86

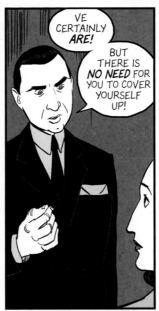

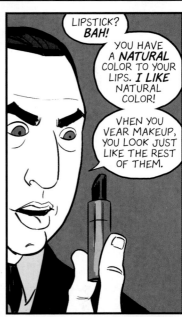

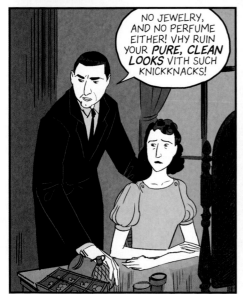

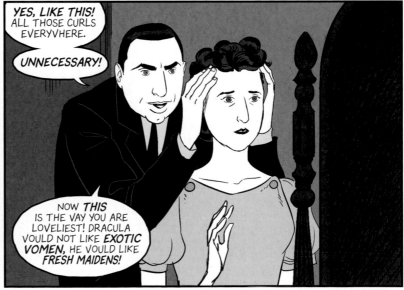

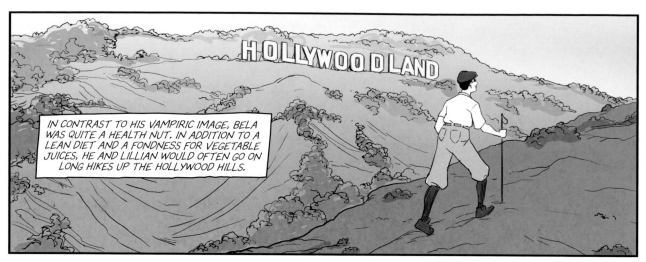

IN CONTRAST TO HIS VAMPIRIC IMAGE, BELA WAS QUITE A HEALTH NUT. IN ADDITION TO A LEAN DIET AND A FONDNESS FOR VEGETABLE JUICES, HE AND LILLIAN WOULD OFTEN GO ON LONG HIKES UP THE HOLLYWOOD HILLS.

PERFECTO!

HEEYYY! LET THEM OUT.

YES, MY LOYAL HELLHOUNDS, VE VILL HAVE A *NICE HIKE* TODAY.

SO ARE WE GOING TO THE GALA LATER?

CLARK GABLE IS SUPPOSED TO BE THERE TONIGHT.

I DO NOT THINK SO.

BUT WE'VE BEEN INVITED.

YOU KNOW HOW I HATE ALL THAT *HOLLYVOOD* MASQUERADING.

I WAS HOPING WE COULD STILL--

I HAVE AN IDEA OF VHAT VE COULD DO TONIGHT!

LATER.

BUDAPEST CAFE

HAHA, YES! NOW PLAY "HELGA THE MILKMAID!"

<ZOLTAN? WHAT ARE YOU DOING *HERE?* I THOUGHT YOU LIVED IN NEW YORK?>*

<OH, WHAT A NICE SURPRISE TO SEE YOU!>

<YES, I ONLY RECENTLY MOVED TO LOS ANGELES.>

*HUNGARIAN.

<ANY PARTICULAR REASON?>

<I TRUST YOU NOT TO TELL...>

<...I FOLLOWED *THAT* GENTLEMAN.>

<WITHOUT HIS BIG TIPS, IT WAS HARD TO MAKE A LIVING BACK IN NEW YORK!>

MEANWHILE, AT UNIVERSAL PICTURES, JUNIOR HAD BEEN LOOKING FOR A FILM KARLOFF AND LUGOSI COULD STAR IN TOGETHER.

JUNIOR RECOGNIZED THE POTENTIAL PUBLICITY POWER OF PITTING THE TWO *TITANS OF TERROR* AGAINST EACH OTHER IN A SINGLE FILM.

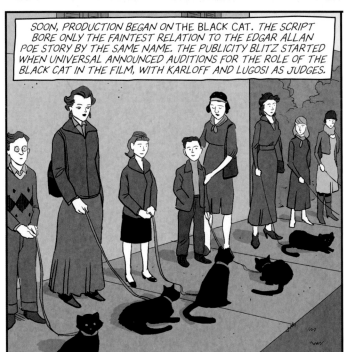

SOON, PRODUCTION BEGAN ON THE BLACK CAT. THE SCRIPT BORE ONLY THE FAINTEST RELATION TO THE EDGAR ALLAN POE STORY BY THE SAME NAME. THE PUBLICITY BLITZ STARTED WHEN UNIVERSAL ANNOUNCED AUDITIONS FOR THE ROLE OF THE BLACK CAT IN THE FILM, WITH KARLOFF AND LUGOSI AS JUDGES.

HELLO, SON, WHAT'S YOUR NAME?

BILLY.

AND WHO'S THIS LITTLE FELLOW?

THIS IS ROCCO.

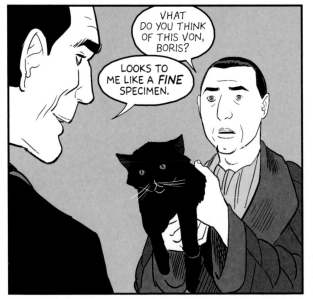

VHAT DO YOU THINK OF THIS VON, BORIS?

LOOKS TO ME LIKE A *FINE* SPECIMEN.

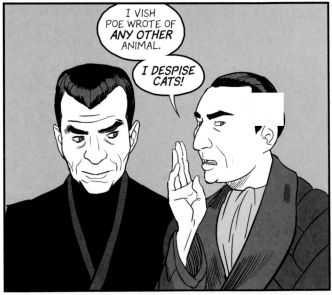

I VISH POE WROTE OF *ANY OTHER* ANIMAL.

I DESPISE CATS!

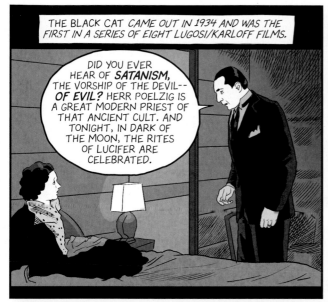

THE BLACK CAT *CAME OUT IN 1934 AND WAS THE FIRST IN A SERIES OF EIGHT LUGOSI/KARLOFF FILMS.*

DID YOU EVER HEAR OF *SATANISM,* THE VORSHIP OF THE DEVIL-- *OF EVIL?* HERR POELZIG IS A GREAT MODERN PRIEST OF THAT ANCIENT CULT. AND TONIGHT, IN DARK OF THE MOON, THE RITES OF LUCIFER ARE CELEBRATED.

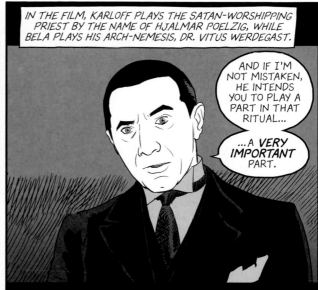

IN THE FILM, KARLOFF PLAYS THE SATAN-WORSHIPPING PRIEST BY THE NAME OF HJALMAR POELZIG, WHILE BELA PLAYS HIS ARCH-NEMESIS, DR. VITUS WERDEGAST.

AND IF I'M NOT MISTAKEN, HE INTENDS YOU TO PLAY A PART IN THAT RITUAL...

...A *VERY IMPORTANT* PART.

OH!

THERE, CHILD. BE BRAVE. NO MATTER *HOW* HOPELESS IT ALL SEEMS.

YOU KNOW VHAT I AM GOING TO DO TO YOU NOW? *NO?* DID YOU EVER SEE AN ANIMAL SKINNED, HJALMAR? HA, HA, HA.

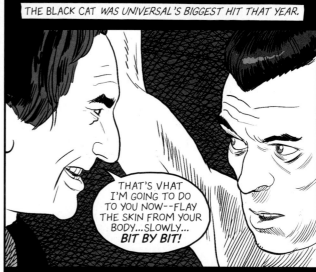

THE BLACK CAT *WAS UNIVERSAL'S BIGGEST HIT THAT YEAR.*

THAT'S VHAT I'M GOING TO DO TO YOU NOW--FLAY THE SKIN FROM YOUR BODY...SLOWLY... *BIT BY BIT!*

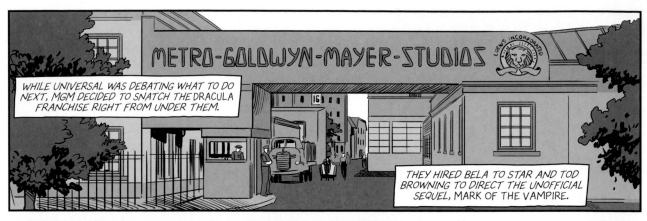

METRO-GOLDWYN-MAYER-STUDIOS

WHILE UNIVERSAL WAS DEBATING WHAT TO DO NEXT, MGM DECIDED TO SNATCH THE DRACULA FRANCHISE RIGHT FROM UNDER THEM.

THEY HIRED BELA TO STAR AND TOD BROWNING TO DIRECT THE UNOFFICIAL SEQUEL, MARK OF THE VAMPIRE.

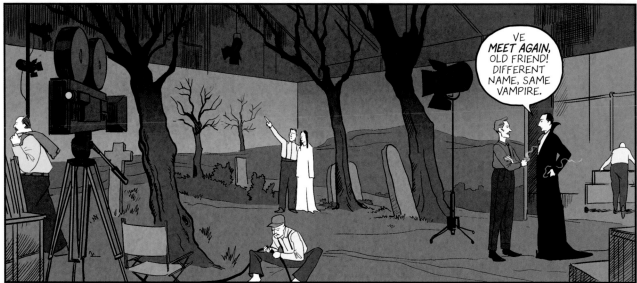

VE *MEET AGAIN*, OLD FRIEND! DIFFERENT NAME, SAME VAMPIRE.

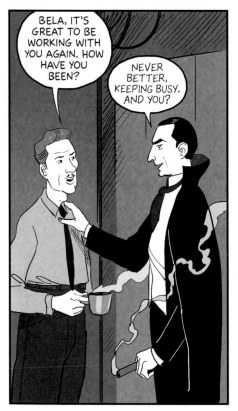

BELA, IT'S GREAT TO BE WORKING WITH YOU AGAIN. HOW HAVE YOU BEEN?

NEVER BETTER, KEEPING BUSY. AND YOU?

BEEN LICKING MY WOUNDS. I'M SURPRISED *ANYONE* IS STILL HIRING ME IN THIS TOWN AFTER FREAKS.*

*BROWNING'S 1932 MASTERPIECE ABOUT SIDESHOW FREAKS WAS A FLOP AT THE TIME.

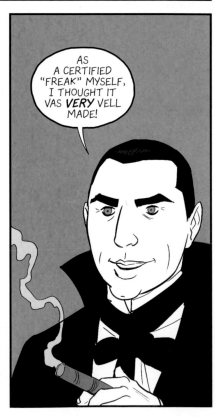

AS A CERTIFIED "FREAK" MYSELF, I THOUGHT IT VAS *VERY* VELL MADE!

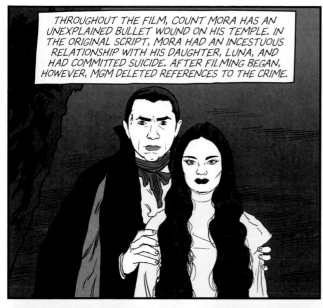

THROUGHOUT THE FILM, COUNT MORA HAS AN UNEXPLAINED BULLET WOUND ON HIS TEMPLE. IN THE ORIGINAL SCRIPT, MORA HAD AN INCESTUOUS RELATIONSHIP WITH HIS DAUGHTER, LUNA, AND HAD COMMITTED SUICIDE. AFTER FILMING BEGAN, HOWEVER, MGM DELETED REFERENCES TO THE CRIME.

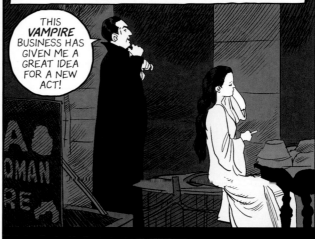

THE FILM HAD A SOMEWHAT OFF-KEY ENDING: MORA AND LUNA TURN OUT TO BE HIRED ACTORS RATHER THAN REAL VAMPIRES. BROWNING DID NOT LIKE THIS ENDING BUT HAD LITTLE SWAY WITH THE STUDIO AT THIS POINT.

THIS *VAMPIRE* BUSINESS HAS GIVEN ME A GREAT IDEA FOR A NEW ACT!

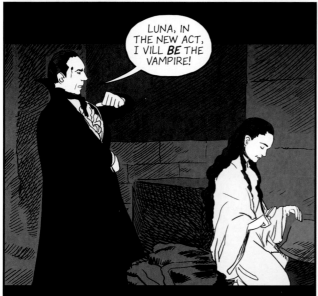

LUNA, IN THE NEW ACT, I VILL *BE* THE VAMPIRE!

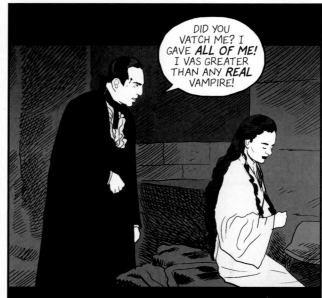

DID YOU VATCH ME? I GAVE *ALL OF ME!* I VAS GREATER THAN ANY *REAL* VAMPIRE!

SURE, SURE, BUT GET OFF YOUR MAKEUP.

AND HELP ME WITH SOME OF THIS PACKING!

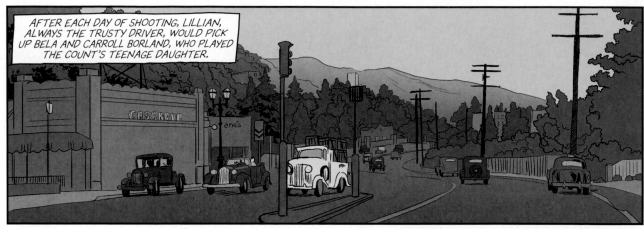

AFTER EACH DAY OF SHOOTING, LILLIAN, ALWAYS THE TRUSTY DRIVER, WOULD PICK UP BELA AND CARROLL BORLAND, WHO PLAYED THE COUNT'S TEENAGE DAUGHTER.

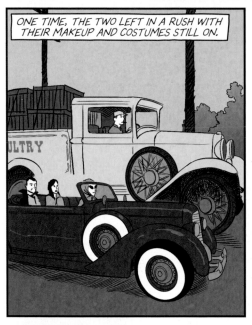

ONE TIME, THE TWO LEFT IN A RUSH WITH THEIR MAKEUP AND COSTUMES STILL ON.

HUH?

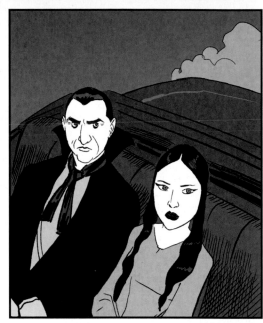

VROOOM

BEEP
HONK

94

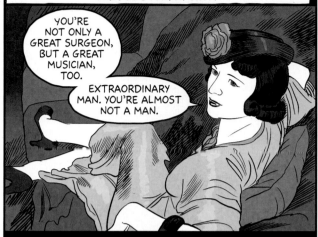

IN 1935, UNIVERSAL RELEASED *THE RAVEN*, BELA AND BORIS' SECOND COLLABORATION. INFERIOR TO ITS PREDECESSOR, THE FILM STILL MANAGED TO BE A HIT, CEMENTING THE DUO'S PROFITABILITY.

YOU'RE NOT ONLY A GREAT SURGEON, BUT A GREAT MUSICIAN, TOO.

EXTRAORDINARY MAN. YOU'RE ALMOST NOT A MAN.

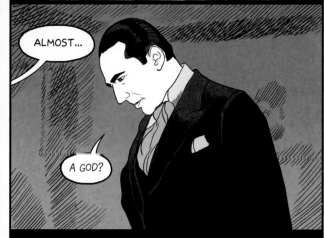

THIS TIME BELA PLAYED DR. RICHARD VOLLIN, AN EVIL MASTER SURGEON SCHEMING TO CAPTURE A YOUNG WOMAN HE HAD REVIVED.

ALMOST...

A GOD?

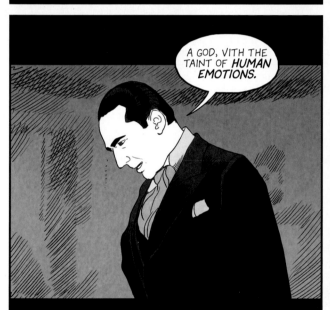

A GOD, VITH THE TAINT OF *HUMAN* EMOTIONS.

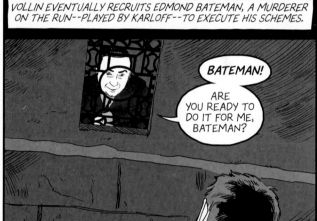

VOLLIN EVENTUALLY RECRUITS EDMOND BATEMAN, A MURDERER ON THE RUN--PLAYED BY KARLOFF--TO EXECUTE HIS SCHEMES.

BATEMAN!

ARE YOU READY TO DO IT FOR ME, BATEMAN?

FIX MY MOUTH!

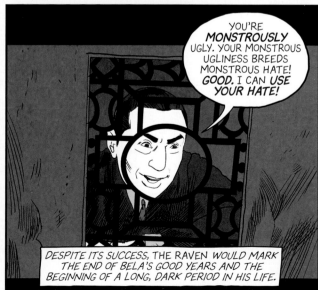

YOU'RE *MONSTROUSLY* UGLY. YOUR MONSTROUS UGLINESS BREEDS MONSTROUS HATE! *GOOD.* I CAN *USE YOUR HATE!*

DESPITE ITS SUCCESS, *THE RAVEN* WOULD MARK THE END OF BELA'S GOOD YEARS AND THE BEGINNING OF A LONG, DARK PERIOD IN HIS LIFE.

METROPOLITAN STATE HOSPITAL

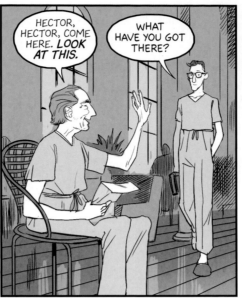

HECTOR, HECTOR, COME HERE. *LOOK AT THIS.*

WHAT HAVE YOU GOT THERE?

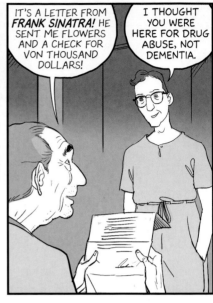

IT'S A LETTER FROM *FRANK SINATRA!* HE SENT ME FLOWERS AND A CHECK FOR VON THOUSAND DOLLARS!

I THOUGHT YOU WERE HERE FOR DRUG ABUSE, NOT DEMENTIA.

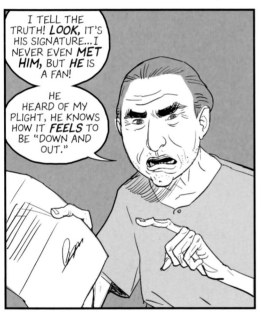

I TELL THE TRUTH! *LOOK,* IT'S HIS SIGNATURE...I NEVER EVEN *MET HIM,* BUT *HE* IS A FAN!

HE HEARD OF MY *PLIGHT,* HE KNOWS HOW IT *FEELS* TO BE "DOWN AND OUT."

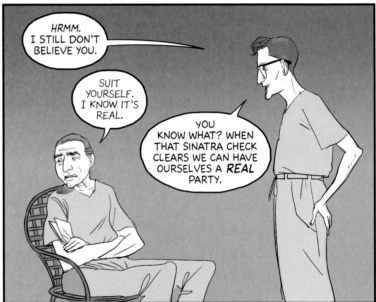

HRMM. I STILL DON'T BELIEVE YOU.

SUIT YOURSELF. I KNOW IT'S REAL.

YOU KNOW WHAT? WHEN THAT SINATRA CHECK CLEARS WE CAN HAVE OURSELVES A *REAL* PARTY.

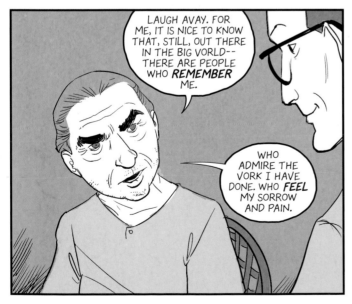

LAUGH AVAY. FOR ME, IT IS NICE TO KNOW THAT, STILL, OUT THERE IN THE BIG VORLD-- THERE ARE PEOPLE WHO *REMEMBER* ME.

WHO ADMIRE THE VORK I HAVE DONE. WHO *FEEL* MY SORROW AND PAIN.

BELIEVE ME, I KNOW *ALL TOO VELL* HOW IT FEELS TO BE COMPLETELY FORGOTTEN.

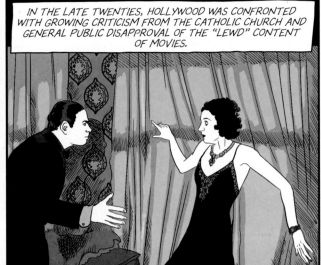

1935 PROVED TO BE A HIGH POINT IN BELA'S CAREER, BUT A PERFECT STORM WAS FORMING ON THE HORIZON, THREATENING HIS VERY LIVELIHOOD.

IN THE LATE TWENTIES, HOLLYWOOD WAS CONFRONTED WITH GROWING CRITICISM FROM THE CATHOLIC CHURCH AND GENERAL PUBLIC DISAPPROVAL OF THE "LEWD" CONTENT OF MOVIES.

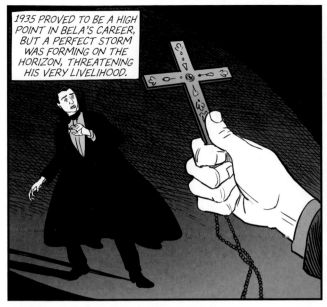

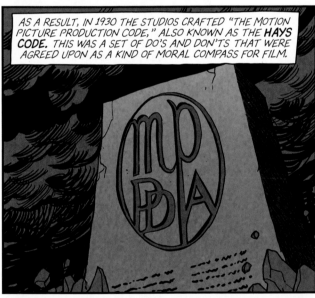

AS A RESULT, IN 1930 THE STUDIOS CRAFTED "THE MOTION PICTURE PRODUCTION CODE," ALSO KNOWN AS THE **HAYS CODE.** THIS WAS A SET OF DO'S AND DON'TS THAT WERE AGREED UPON AS A KIND OF MORAL COMPASS FOR FILM.

IN REALITY, THE CODE WAS NOT TRULY ENFORCED UNTIL 1934, WHEN RELIGIOUS GROUPS AND "MORALISTS" PETITIONED FOR FEDERAL OVERSIGHT OF FILM.

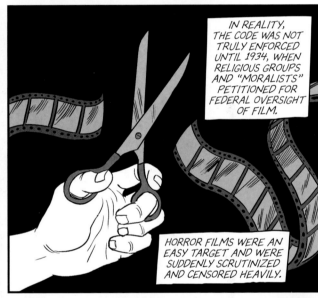

HORROR FILMS WERE AN EASY TARGET AND WERE SUDDENLY SCRUTINIZED AND CENSORED HEAVILY.

HOLLYWOOD'S APPETITE FOR HORROR WAS FURTHER DIMINISHED WITH THE "BRITISH HORROR BAN."

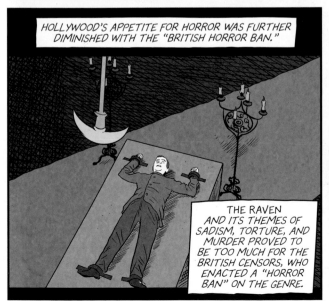

THE RAVEN AND ITS THEMES OF SADISM, TORTURE, AND MURDER PROVED TO BE TOO MUCH FOR THE BRITISH CENSORS, WHO ENACTED A "HORROR BAN" ON THE GENRE.

THE FOLLOWING YEAR, AFTER FAILING TO REPAY THEIR DEBTORS, THE LAEMMLES LOST THEIR STAKE IN UNIVERSAL PICTURES.

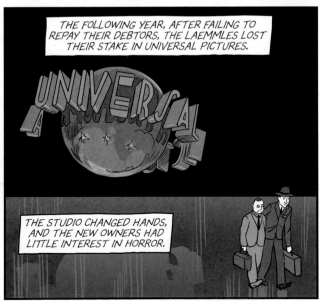

THE STUDIO CHANGED HANDS, AND THE NEW OWNERS HAD LITTLE INTEREST IN HORROR.

THESE EVENTS PROVED DEVASTATING TO BELA'S CAREER, AND BY 1937 HE FOUND HIMSELF WITHOUT ANY OFFERS AND, ONCE AGAIN, IN DIRE FINANCIAL PERIL.

BOOM
THUD

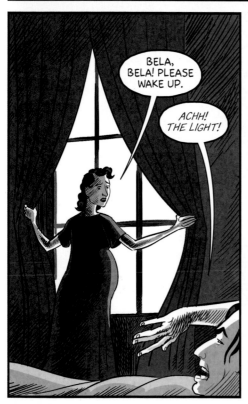

BELA, BELA! PLEASE WAKE UP.

ACHH! THE LIGHT!

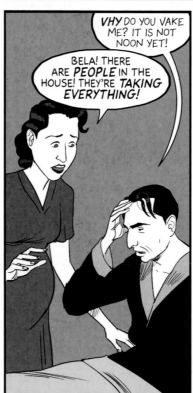

VHY DO YOU VAKE ME? IT IS NOT NOON YET!

BELA! THERE ARE PEOPLE IN THE HOUSE! THEY'RE TAKING EVERYTHING!

VHAT?

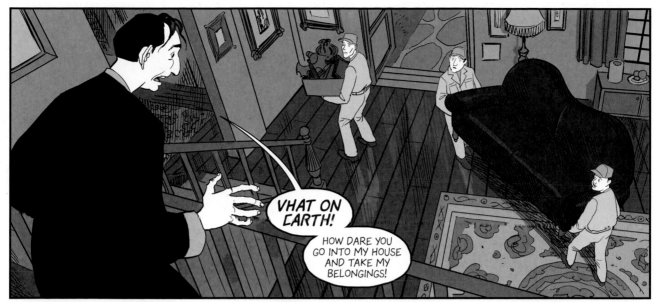

VHAT ON EARTH!

HOW DARE YOU GO INTO MY HOUSE AND TAKE MY BELONGINGS!

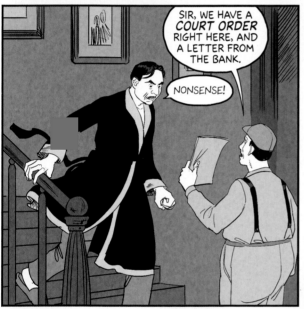

SIR, WE HAVE A **COURT ORDER** RIGHT HERE, AND A LETTER FROM THE BANK.

NONSENSE!

LEAVE THAT ALONE! THAT VAS **A GIFT** FROM THE MAYOR OF **BUDAPEST!**

WOULD YOU JUST **LOOK AT THIS PLACE!** YOU'D THINK A **REAL VAMPIRE** LIVED HERE!

SUPPOSE HE WRITES HIS LETTERS WITH BLOOD?

IF YOU **TOUCH** MY CIGAR HUMIDOR, I VILL BLOW **A HOLE** RIGHT THROUGH YOUR THICK SKULL!

I HAVE A GUN HIDDEN IN **EVERY ROOM!**

BELA, *WHAT'S GOING ON?*

PLEASE BE FRANK WITH ME!

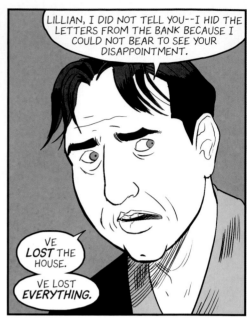

LILLIAN, I DID NOT TELL YOU--I HID THE LETTERS FROM THE BANK BECAUSE I COULD NOT BEAR TO SEE YOUR DISAPPOINTMENT.

VE *LOST* THE HOUSE.

VE LOST *EVERYTHING.*

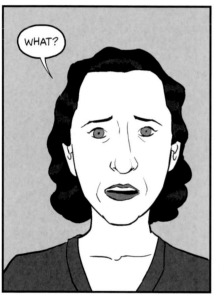

WHAT?

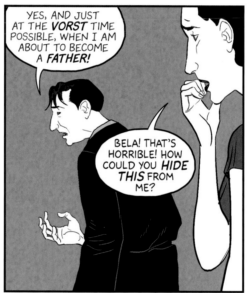

YES, AND JUST AT THE *VORST* TIME POSSIBLE, WHEN I AM ABOUT TO BECOME A *FATHER!*

BELA! THAT'S HORRIBLE! HOW COULD YOU *HIDE THIS* FROM ME?

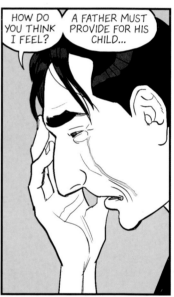

HOW DO YOU THINK I FEEL?

A FATHER MUST PROVIDE FOR HIS CHILD...

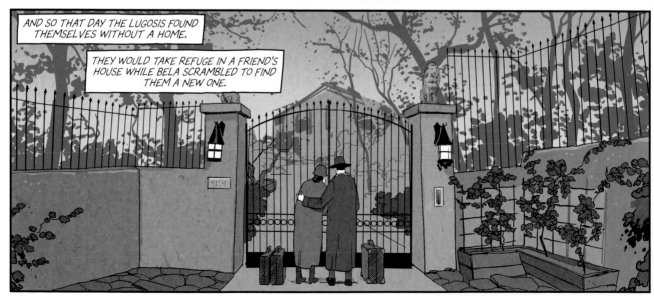

AND SO THAT DAY THE LUGOSIS FOUND THEMSELVES WITHOUT A HOME.

THEY WOULD TAKE REFUGE IN A FRIEND'S HOUSE WHILE BELA SCRAMBLED TO FIND THEM A NEW ONE.

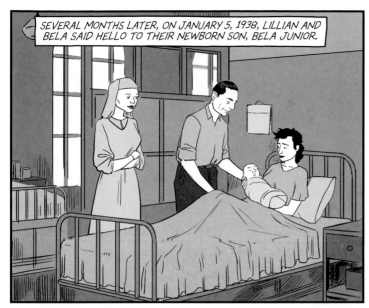

SEVERAL MONTHS LATER, ON JANUARY 5, 1938, LILLIAN AND BELA SAID HELLO TO THEIR NEWBORN SON, BELA JUNIOR.

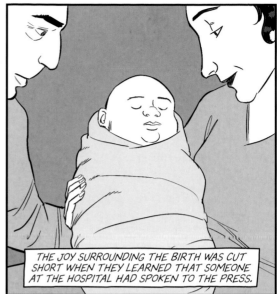

THE JOY SURROUNDING THE BIRTH WAS CUT SHORT WHEN THEY LEARNED THAT SOMEONE AT THE HOSPITAL HAD SPOKEN TO THE PRESS.

BELA LUGOSI JOBLESS

What's the matter with Hollywood producers when a fine actor like Bela Lugosi can't find a job? I happen to know that Bela has been so down on his luck that he has been well nigh desperate. His wife just had a baby, and there was no money forthcoming to pay the doctor until the Motion Picture Relief Fund came to the rescue.

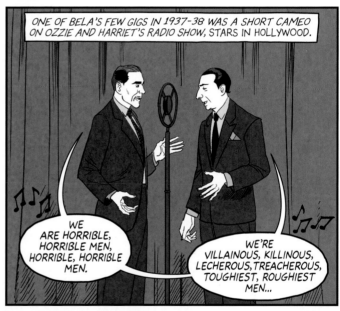

ONE OF BELA'S FEW GIGS IN 1937-38 WAS A SHORT CAMEO ON OZZIE AND HARRIET'S RADIO SHOW, STARS IN HOLLYWOOD.

WE ARE HORRIBLE, HORRIBLE MEN, HORRIBLE, HORRIBLE MEN.

WE'RE VILLAINOUS, KILLINOUS, LECHEROUS, TREACHEROUS, TOUGHIEST, ROUGHIEST MEN...

TO THE GRAVE WE COME IN, 'T WOULD MAKE STRONG MEN AFRAID, YOU CAN'T BLAME US FOR IT, FOR THE RENT-MUST-BE-*PAID*...

THOUGH THE MOVIES WOULD MAKE ME A TERRIBLE BRUTE, WHEN MY MAKE UP IS OFF I AM REALLY... QUITE... CUTE!

HOW HAVE YOU BEEN, OLD CHAP?

AH, BORIS! I HAVE BEEN QUITE VELL, QUITE VELL. AND YOU?

I'M DOING *SWELL*. I'VE HEARD YOU'VE HAD A SON, CONGRATULATIONS FOR THAT!

YES, BELA, JR. A HEALTHY, *BEAUTIFUL* BABY.

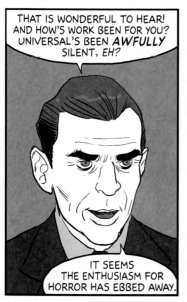

THAT IS WONDERFUL TO HEAR! AND HOW'S WORK BEEN FOR YOU? UNIVERSAL'S BEEN *AWFULLY* SILENT, *EH?*

IT SEEMS THE ENTHUSIASM FOR HORROR HAS EBBED AWAY.

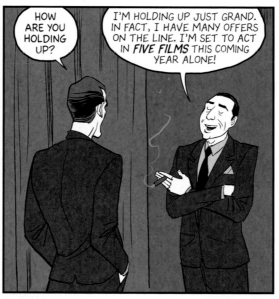

HOW ARE YOU HOLDING UP?

I'M HOLDING UP JUST GRAND. IN FACT, I HAVE MANY OFFERS ON THE LINE. I'M SET TO ACT IN *FIVE FILMS* THIS COMING YEAR ALONE!

ANYTHING I'VE HEARD OF?

I HIGHLY DOUBT IT. MOST OF THESE PROJECTS ARE TOP SEKRET.

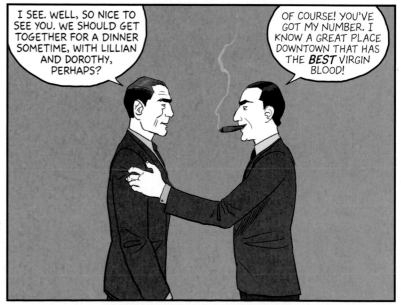

I SEE. WELL, SO NICE TO SEE YOU. WE SHOULD GET TOGETHER FOR A DINNER SOMETIME, WITH LILLIAN AND DOROTHY, PERHAPS?

OF COURSE! YOU'VE GOT MY NUMBER. I KNOW A GREAT PLACE DOWNTOWN THAT HAS THE *BEST* VIRGIN BLOOD!

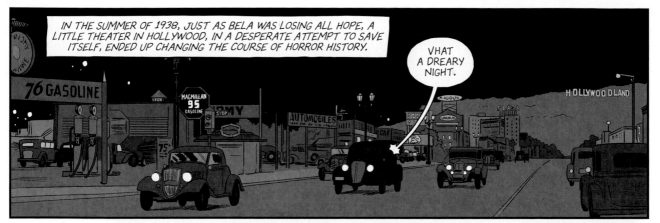

IN THE SUMMER OF 1938, JUST AS BELA WAS LOSING ALL HOPE, A LITTLE THEATER IN HOLLYWOOD, IN A DESPERATE ATTEMPT TO SAVE ITSELF, ENDED UP CHANGING THE COURSE OF HORROR HISTORY.

VHAT A DREARY NIGHT.

I'VE HAD *EENOFF* OF THIS MISERABLE TOWN. TAKE ME HOME, LILLIAN.

VHAT ON EARTH...?

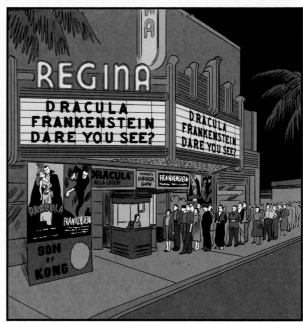

LILLIAN, STOP THE CAR!

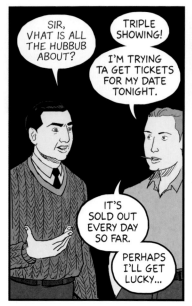

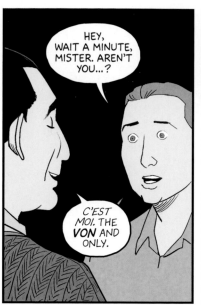

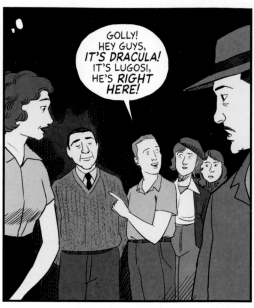

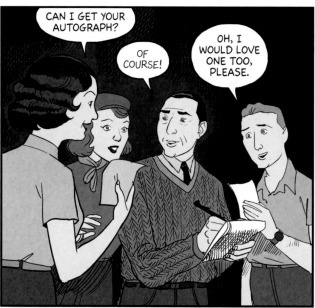

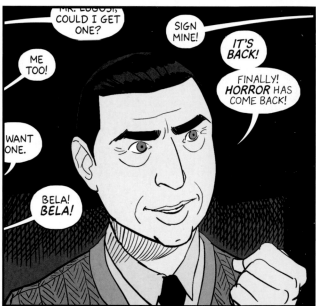

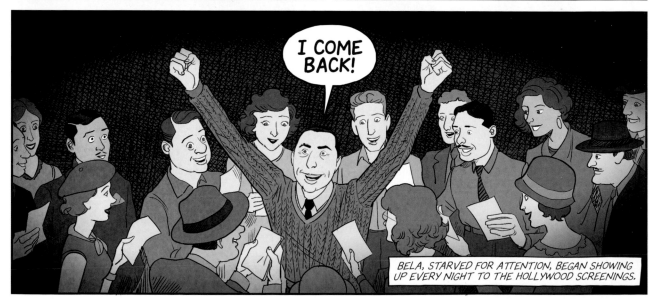

BELA, STARVED FOR ATTENTION, BEGAN SHOWING UP EVERY NIGHT TO THE HOLLYWOOD SCREENINGS.

MEANWHILE, THE UNIVERSAL EXECUTIVES WHO HAD REJECTED THE STUDIO'S TRADITION OF HORROR FILMS COULD NOT IGNORE AUDIENCES AND THEIR GROWING DESIRE FOR THE GENRE.

UNIVERSAL PICTURES COMPANY INC

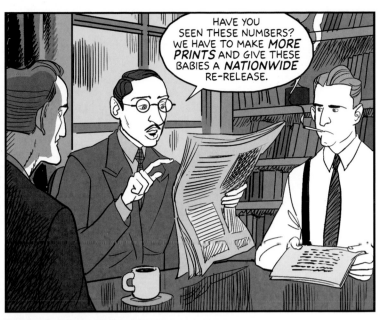

HAVE YOU SEEN THESE NUMBERS? WE HAVE TO MAKE **MORE PRINTS** AND GIVE THESE BABIES A **NATIONWIDE** RE-RELEASE.

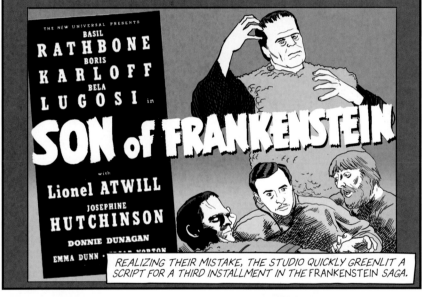

THE NEW UNIVERSAL PRESENTS

BASIL **RATHBONE**
BORIS **KARLOFF**
BELA **LUGOSI** in

SON of FRANKENSTEIN

with Lionel **ATWILL**

JOSEPHINE **HUTCHINSON**

DONNIE DUNAGAN

EMMA DUNN

REALIZING THEIR MISTAKE, THE STUDIO QUICKLY GREENLIT A SCRIPT FOR A THIRD INSTALLMENT IN THE FRANKENSTEIN SAGA.

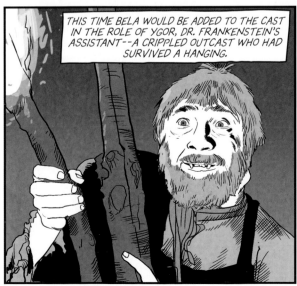

THIS TIME BELA WOULD BE ADDED TO THE CAST IN THE ROLE OF YGOR, DR. FRANKENSTEIN'S ASSISTANT--A CRIPPLED OUTCAST WHO HAD SURVIVED A HANGING.

AWARE OF BELA'S DIRE FINANCIAL SITUATION, THE STUDIO OFFERED HIM ONLY $500 A WEEK--THE SAME RATE HE GOT FOR DRACULA ALMOST EIGHT YEARS EARLIER. ADDING INSULT TO INJURY, THE STUDIO PAID KARLOFF AN ESTIMATED $4,000 A WEEK.

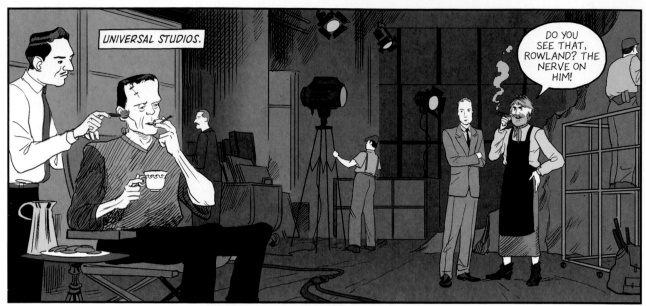

UNIVERSAL STUDIOS.

DO YOU SEE THAT, ROWLAND? THE NERVE ON HIM!

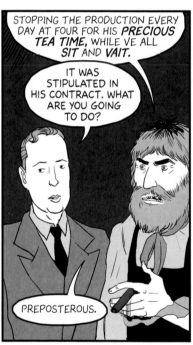

STOPPING THE PRODUCTION EVERY DAY AT FOUR FOR HIS *PRECIOUS TEA TIME,* WHILE VE ALL *SIT* AND *VAIT.*

IT WAS STIPULATED IN HIS CONTRACT. WHAT ARE YOU GOING TO DO?

PREPOSTEROUS.

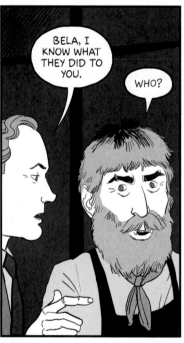

BELA, I KNOW WHAT THEY DID TO YOU.

WHO?

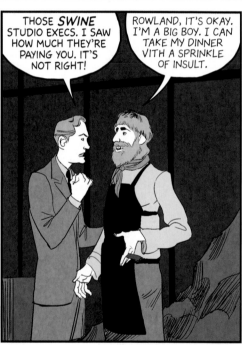

THOSE *SWINE* STUDIO EXECS. I SAW HOW MUCH THEY'RE PAYING YOU. IT'S NOT RIGHT!

ROWLAND, IT'S OKAY. I'M A BIG BOY. I CAN TAKE MY DINNER VITH A SPRINKLE OF INSULT.

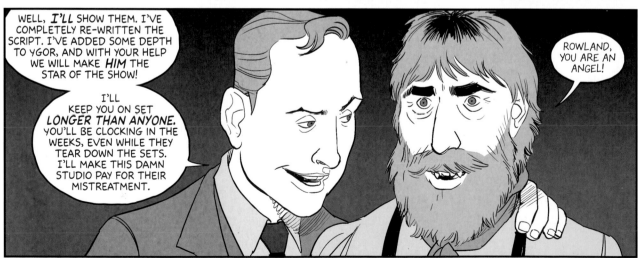

WELL, *I'LL* SHOW THEM. I'VE COMPLETELY RE-WRITTEN THE SCRIPT. I'VE ADDED SOME DEPTH TO YGOR, AND WITH YOUR HELP WE WILL MAKE *HIM* THE STAR OF THE SHOW!

I'LL KEEP YOU ON SET *LONGER THAN ANYONE.* YOU'LL BE CLOCKING IN THE WEEKS, EVEN WHILE THEY TEAR DOWN THE SETS. I'LL MAKE THIS DAMN STUDIO PAY FOR THEIR MISTREATMENT.

ROWLAND, YOU ARE AN ANGEL!

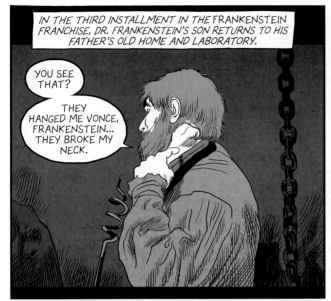

IN THE THIRD INSTALLMENT IN THE FRANKENSTEIN FRANCHISE, DR. FRANKENSTEIN'S SON RETURNS TO HIS FATHER'S OLD HOME AND LABORATORY.

YOU SEE THAT?

THEY HANGED ME VONCE, FRANKENSTEIN... THEY BROKE MY NECK.

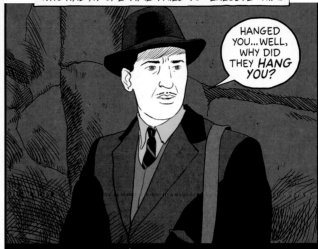

YGOR'S CHARACTER SHARED A KINSHIP WITH BELA: HERE HE WAS AGAIN, WORKING FOR THE BIG STUDIO WHO HAD AT ONE TIME TRIED TO "EXECUTE" HIM.

HANGED YOU... WELL, WHY DID THEY *HANG* YOU?

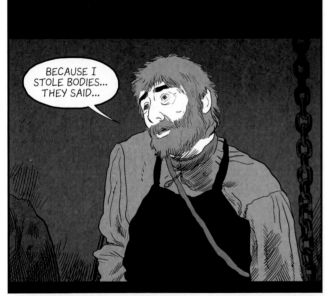

BECAUSE I STOLE BODIES... THEY SAID...

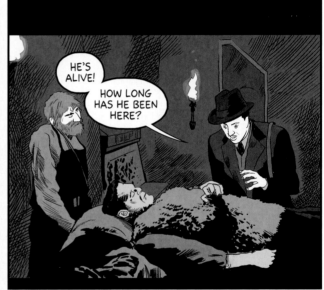

HE'S ALIVE!

HOW LONG HAS HE BEEN HERE?

LONG TIME. HE'S MY FRIEND.

HE DOES THINGS FOR ME.

HAS HE ALWAYS BEEN HERE?

NEARLY ALVAYS. THIS IS PLACE OF THE DEAD. VE ARE *ALL* DEAD HERE.

WHEN THE FILM WAS FINALLY RELEASED, KARLOFF WAS LIVID.

STRAND

SON OF
FRANKENSTEIN
KARLOFF

SON OF
FRANKENSTEIN

Exclusive MILLINERY

YOU'VE BEEN SO QUIET, BORIS. IS ANYTHING THE MATTER?

DID YOU NOT LIKE THE FILM?

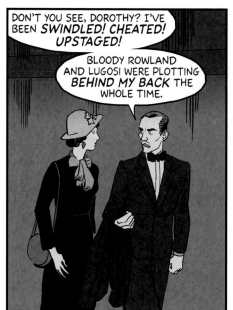

DON'T YOU SEE, DOROTHY? I'VE BEEN *SWINDLED! CHEATED! UPSTAGED!*

BLOODY ROWLAND AND LUGOSI WERE PLOTTING *BEHIND MY BACK* THE WHOLE TIME.

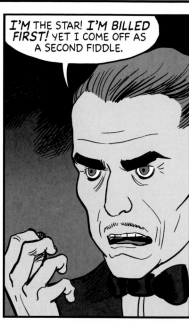

I'M THE STAR! I'M BILLED *FIRST!* YET I COME OFF AS A SECOND FIDDLE.

YOU SHOULD LET THE STUDIO KNOW.

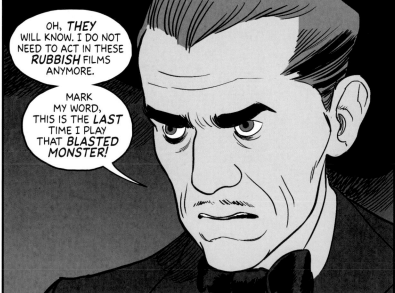

OH, *THEY* WILL KNOW. I DO NOT NEED TO ACT IN THESE *RUBBISH* FILMS ANYMORE.

MARK MY WORD, THIS IS THE *LAST* TIME I PLAY THAT *BLASTED MONSTER!*

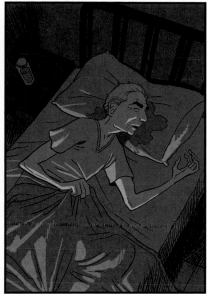

WHO'S THERE?

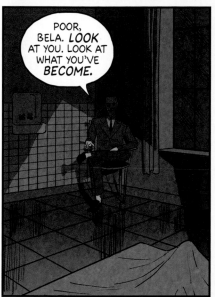
POOR, BELA. *LOOK* AT YOU. LOOK AT WHAT YOU'VE *BECOME.*

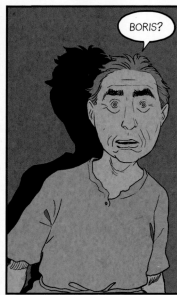
BORIS?

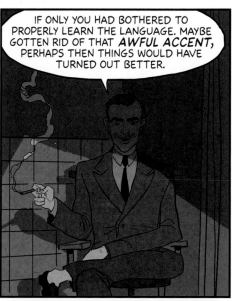
IF ONLY YOU HAD BOTHERED TO PROPERLY LEARN THE LANGUAGE. MAYBE GOTTEN RID OF THAT *AWFUL ACCENT,* PERHAPS THEN THINGS WOULD HAVE TURNED OUT BETTER.

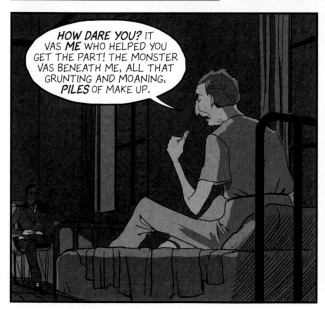
HOW DARE YOU? IT VAS *ME* WHO HELPED YOU GET THE PART! THE MONSTER VAS BENEATH ME, ALL THAT GRUNTING AND MOANING, *PILES* OF MAKE UP.

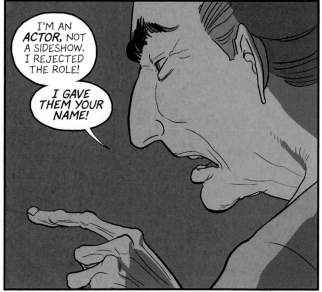
I'M AN *ACTOR,* NOT A SIDESHOW. I REJECTED THE ROLE!

I GAVE THEM YOUR NAME!

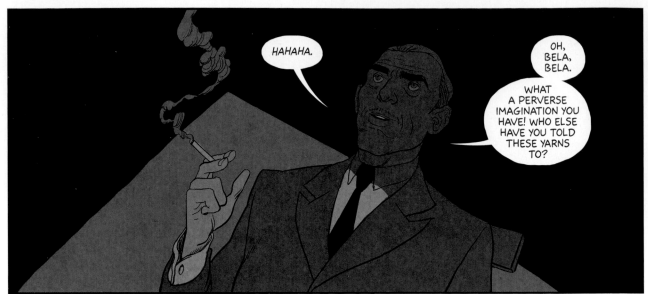

HAHAHA.

OH, BELA, BELA.

WHAT A PERVERSE IMAGINATION YOU HAVE! WHO ELSE HAVE YOU TOLD THESE YARNS TO?

PERHAPS IF YOU HAD TRIED A LITTLE HARDER, BEEN A LITTLE MORE CAREFUL, YOU WOULD STILL BE WORKING TODAY!

YOU VERE ALVAYS A COLD FISH, BORIS. AS SOON AS YOU CAME ON, THE STAGE VOULD TURN TO *ICE.* MEANVHILE, THEY ALL FLOCKED TO MY FLAME! MY VARMTH!

FLOCKED? I REMEMBERER YOU MOSTLY KEEPING TO YOURSELF, OLD CHAP. SMOKING THOSE CIGARS IN THE SHADOWS.

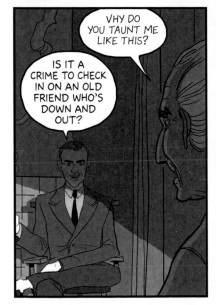

VHY DO YOU TAUNT ME LIKE THIS?

IS IT A CRIME TO CHECK IN ON AN OLD FRIEND WHO'S DOWN AND OUT?

HUH?

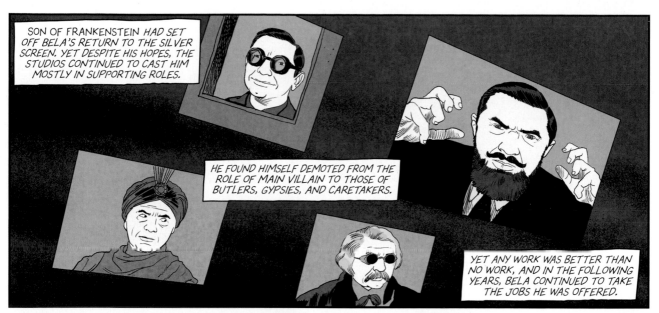

SON OF FRANKENSTEIN *HAD SET OFF BELA'S RETURN TO THE SILVER SCREEN. YET DESPITE HIS HOPES, THE STUDIOS CONTINUED TO CAST HIM MOSTLY IN SUPPORTING ROLES.*

HE FOUND HIMSELF DEMOTED FROM THE ROLE OF MAIN VILLAIN TO THOSE OF BUTLERS, GYPSIES, AND CARETAKERS.

YET ANY WORK WAS BETTER THAN NO WORK, AND IN THE FOLLOWING YEARS, BELA CONTINUED TO TAKE THE JOBS HE WAS OFFERED.

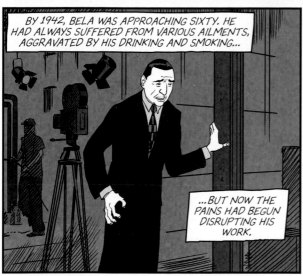

BY 1942, BELA WAS APPROACHING SIXTY. HE HAD ALWAYS SUFFERED FROM VARIOUS AILMENTS, AGGRAVATED BY HIS DRINKING AND SMOKING...

...BUT NOW THE PAINS HAD BEGUN DISRUPTING HIS WORK.

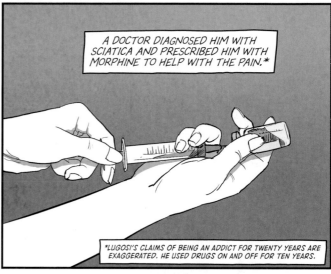

A DOCTOR DIAGNOSED HIM WITH SCIATICA AND PRESCRIBED HIM WITH MORPHINE TO HELP WITH THE PAIN.*

*LUGOSI'S CLAIMS OF BEING AN ADDICT FOR TWENTY YEARS ARE EXAGGERATED. HE USED DRUGS ON AND OFF FOR TEN YEARS.

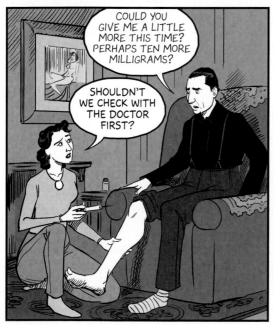

COULD YOU GIVE ME A LITTLE MORE THIS TIME? PERHAPS TEN MORE MILLIGRAMS?

SHOULDN'T WE CHECK WITH THE DOCTOR FIRST?

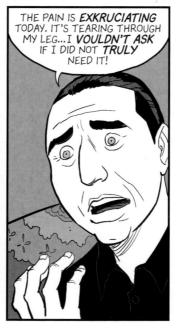

THE PAIN IS *EXKRUCIATING* TODAY. IT'S TEARING THROUGH MY LEG...I *VOULDN'T ASK* IF I DID NOT *TRULY* NEED IT!

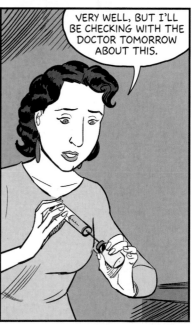

VERY WELL, BUT I'LL BE CHECKING WITH THE DOCTOR TOMORROW ABOUT THIS.

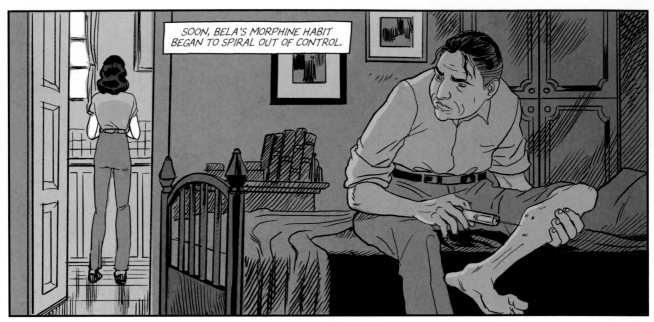

SOON, BELA'S MORPHINE HABIT BEGAN TO SPIRAL OUT OF CONTROL.

AND ONLY GREW WORSE WHEN THE BAD NEWS ROLLED IN.

UNIVERSAL SAYS LON CHANEY JR. WILL BE THEIR NEW DRACULA

AZ ÖRDÖG VIGYEN EL!*

CRASH

*"TAKE THE DEVIL AWAY!" IN HUNGARIAN.

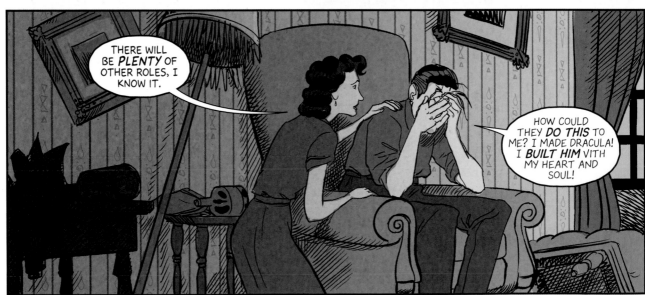

THERE WILL BE *PLENTY* OF OTHER ROLES, I KNOW IT.

HOW COULD THEY *DO THIS* TO ME? I MADE DRACULA! I *BUILT HIM* VITH MY HEART AND SOUL!

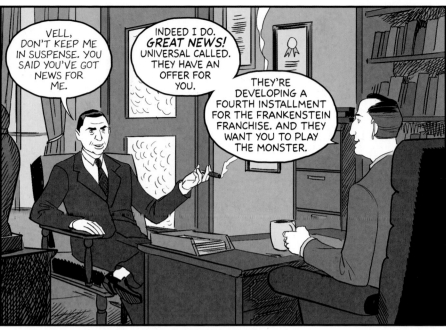

VELL, DON'T KEEP ME IN SUSPENSE. YOU SAID YOU'VE GOT NEWS FOR ME.

INDEED I DO. *GREAT NEWS!* UNIVERSAL CALLED. THEY HAVE AN OFFER FOR YOU.

THEY'RE DEVELOPING A FOURTH INSTALLMENT FOR THE FRANKENSTEIN FRANCHISE. AND THEY WANT YOU TO PLAY THE MONSTER.

ME? BUT VHAT ABOUT KARLOFF?

WELL...KARLOFF PASSED, HE HAS OTHER COMMITMENTS.

SO I AM TO TAKE KARLOFF'S UNVANTED TRASH?

THIS IS THE ROLE I HAD *REFUSED* TO TAKE!

THE ROLE WHICH WAS BENEATH ME!

IT'S A MAJOR JOB, IN A BIG-BUDGET FILM. AND WE'RE NOT EXACTLY *SWIMMING* IN OFFERS RIGHT NOW.

I...I DON'T KNOW. I MUST THINK ABOUT THIS.

DESPERATE FOR WORK AND MONEY, BELA AGREED TO TAKE THE ROLE OF THE MONSTER IN *FRANKENSTEIN MEETS THE WOLF MAN.*

RRR RRINGG

THUMP

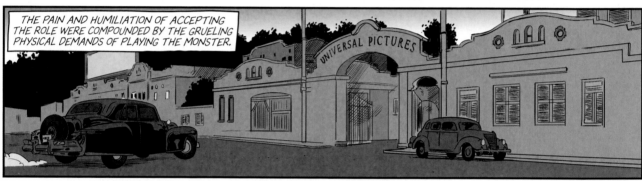

THE PAIN AND HUMILIATION OF ACCEPTING THE ROLE WERE COMPOUNDED BY THE GRUELING PHYSICAL DEMANDS OF PLAYING THE MONSTER.

UNIVERSAL PICTURES

GRRRRAAAAA!

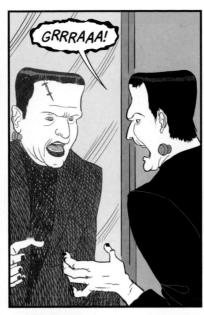

GRRRAAA!

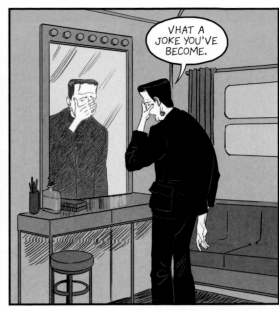

VHAT A JOKE YOU'VE BECOME.

BELA, IT'S TIME TO HEAD TO THE SET.

LILLIAN!

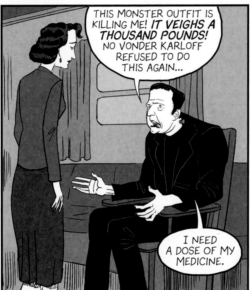

THIS MONSTER OUTFIT IS KILLING ME! *IT VEIGHS A THOUSAND POUNDS!* NO VONDER KARLOFF REFUSED TO DO THIS AGAIN...

I NEED A DOSE OF MY MEDICINE.

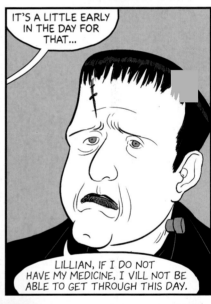

IT'S A LITTLE EARLY IN THE DAY FOR THAT...

LILLIAN, IF I DO NOT HAVE MY MEDICINE, I VILL NOT BE ABLE TO GET THROUGH THIS DAY.

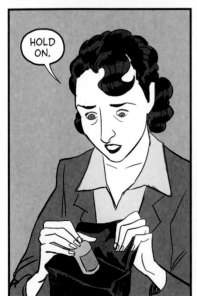

HOLD ON.

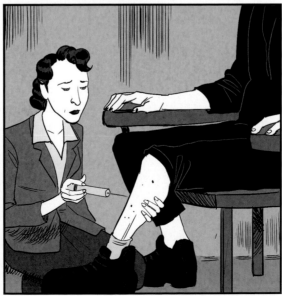

AHHHHH...

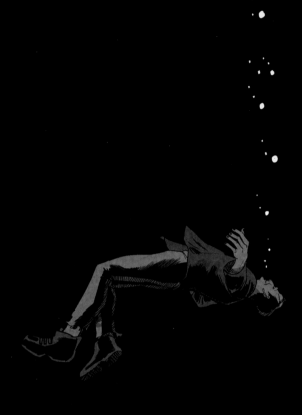

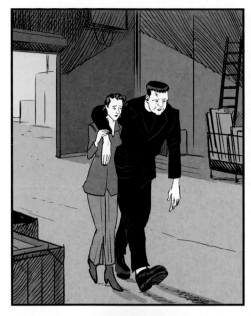

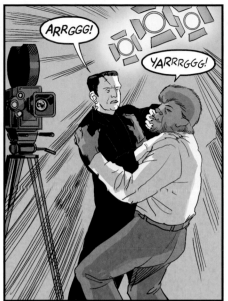

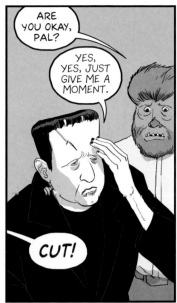

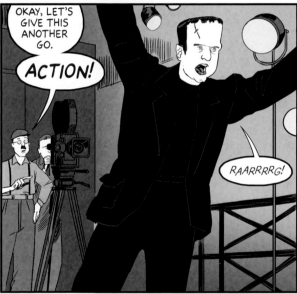

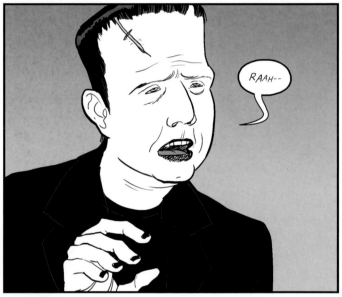

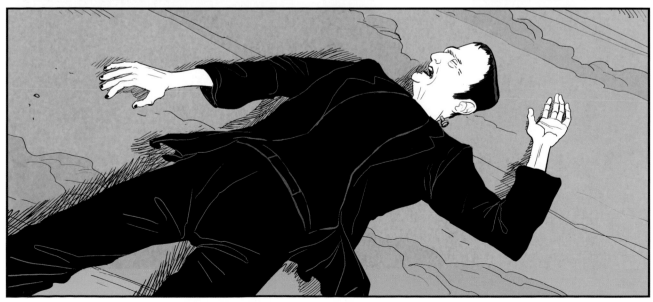

BELA, DEAR, HOW ARE YOU FEELING?

MUCH, MUCH BETTER. I DO NOT KNOW VHAT VENT OVER ME.

HAVE YOU BROUGHT MY MEDICINE? I'M STARTING TO FEEL THE PAINS COMING.

YES.

GOOD. VHAT IS THAT YOU GOT THERE?

≶SIGH≶...THERE'S A LITTLE WRITE-UP IN THE GOSSIP SECTION... SOMEONE TOLD *THE HOLLYWOOD REPORTER* THAT YOU COLLAPSED ON SET.

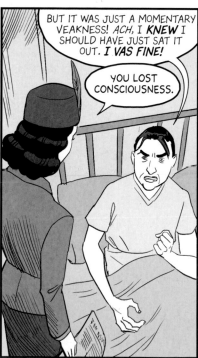

BUT IT WAS JUST A MOMENTARY VEAKNESS! ACH, I *KNEW* I SHOULD HAVE JUST SAT IT OUT. *I VAS FINE!*

YOU LOST CONSCIOUSNESS.

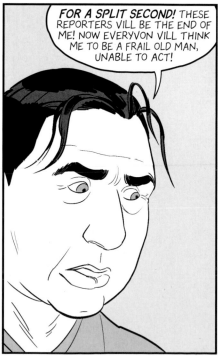

FOR A SPLIT SECOND! THESE REPORTERS VILL BE THE END OF ME! NOW EVERYVON VILL THINK ME TO BE A FRAIL OLD MAN, UNABLE TO ACT!

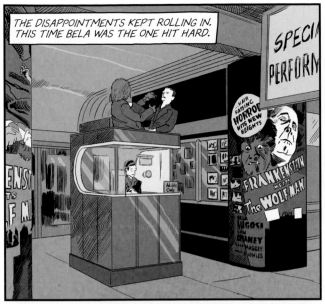

THE DISAPPOINTMENTS KEPT ROLLING IN. THIS TIME BELA WAS THE ONE HIT HARD.

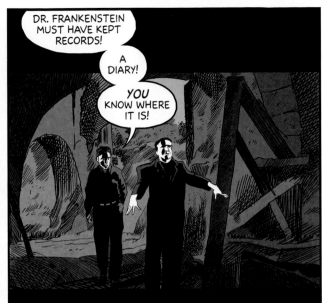

DR. FRANKENSTEIN MUST HAVE KEPT RECORDS!

A DIARY!

YOU KNOW WHERE IT IS!

IT ISN'T HERE.

LATER.

YARRRGGGGG!

GRRRAAAA!

RRRAARRGGGGG!

BELA, WAIT FOR ME!

WHAT'S WRONG, DEAR?

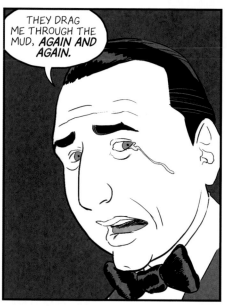

THEY DRAG ME THROUGH THE MUD, *AGAIN AND AGAIN.*

WHAT ARE YOU TALKING ABOUT?

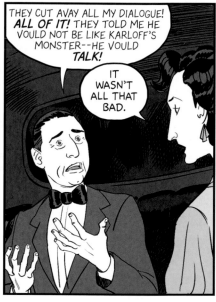

THEY CUT AVAY ALL MY DIALOGUE! *ALL OF IT!* THEY TOLD ME HE VOULD NOT BE LIKE KARLOFF'S MONSTER--HE VOULD *TALK!*

IT WASN'T ALL THAT BAD.

ARE YOU JOKING? THEY EVEN CUT OUT THE BIT ABOUT *THE MONSTER'S BLINDNESS!* I AM VALKING AROUND LIKE A LOBOTOMIZED NINNY, BUMPING INTO VALLS!

YOU HEARD THE KROWED, THEY VERE *LAUGHING!*

THEY VERE LAUGHING *AT ME.*

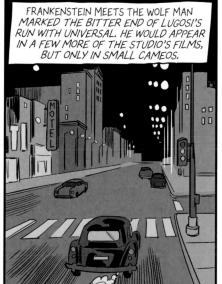

FRANKENSTEIN MEETS THE WOLF MAN MARKED THE BITTER END OF LUGOSI'S RUN WITH UNIVERSAL. HE WOULD APPEAR IN A FEW MORE OF THE STUDIO'S FILMS, BUT ONLY IN SMALL CAMEOS.

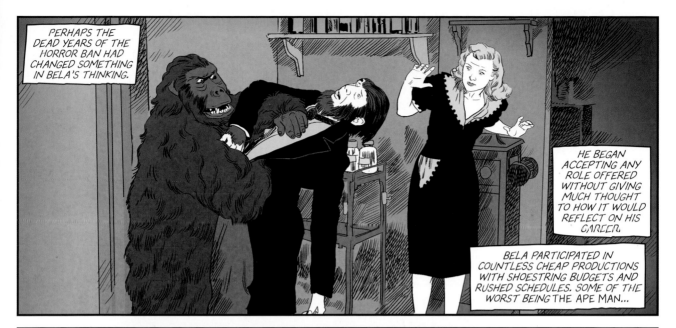

PERHAPS THE DEAD YEARS OF THE HORROR BAN HAD CHANGED SOMETHING IN BELA'S THINKING.

HE BEGAN ACCEPTING ANY ROLE OFFERED WITHOUT GIVING MUCH THOUGHT TO HOW IT WOULD REFLECT ON HIS CAREER.

BELA PARTICIPATED IN COUNTLESS CHEAP PRODUCTIONS WITH SHOESTRING BUDGETS AND RUSHED SCHEDULES. SOME OF THE WORST BEING THE APE MAN...

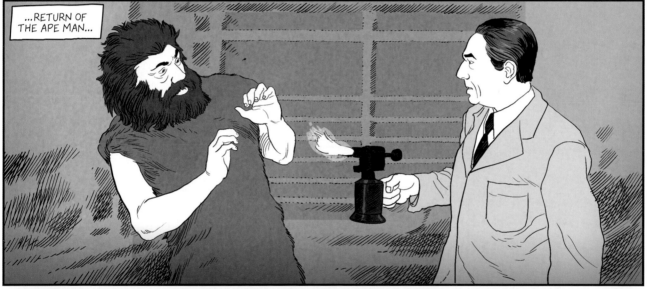

...RETURN OF THE APE MAN...

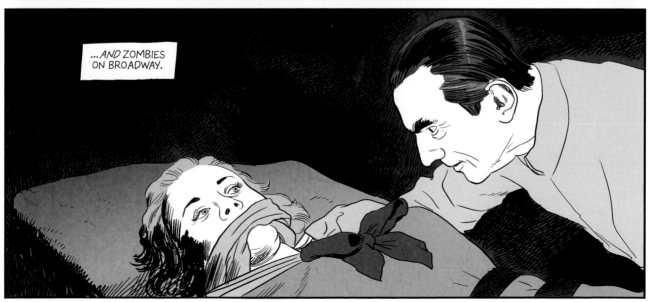

...AND ZOMBIES ON BROADWAY.

WELCOME FAMILIES and FRIENDS

HAHA!

I GOT IT!

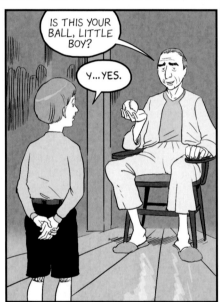

IS THIS YOUR BALL, LITTLE BOY?

Y...YES.

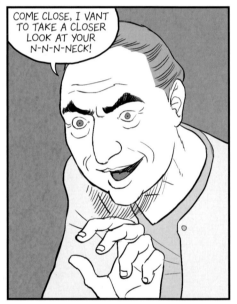

COME CLOSE, I VANT TO TAKE A CLOSER LOOK AT YOUR N-N-N-NECK!

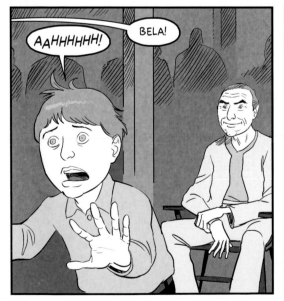

AAHHHHHH!

BELA!

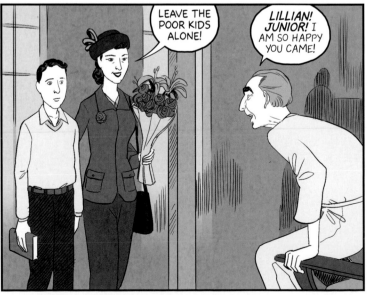

LEAVE THE POOR KIDS ALONE!

LILLIAN! JUNIOR! I AM SO HAPPY YOU CAME!

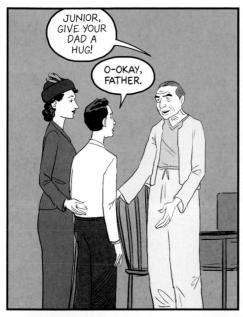

JUNIOR, GIVE YOUR DAD A HUG!

O-OKAY, FATHER.

YOU LOOK WELL. THIS PLACE MUST NOT BE AS BAD AS YOU MADE IT SOUND OVER THE PHONE.

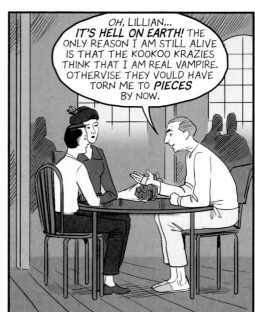

OH, LILLIAN... *IT'S HELL ON EARTH!* THE ONLY REASON I AM STILL ALIVE IS THAT THE KOOKOO KRAZIES THINK THAT I AM REAL VAMPIRE. OTHERVISE THEY WOULD HAVE TORN ME TO *PIECES* BY NOW.

ALWAYS SO DRAMATIC.

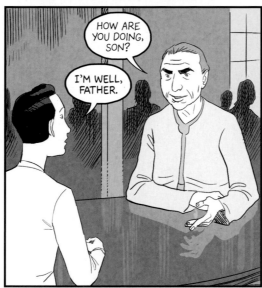

HOW ARE YOU DOING, SON?

I'M WELL, FATHER.

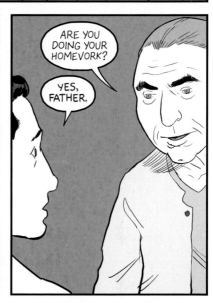

ARE YOU DOING YOUR HOMEVORK?

YES, FATHER.

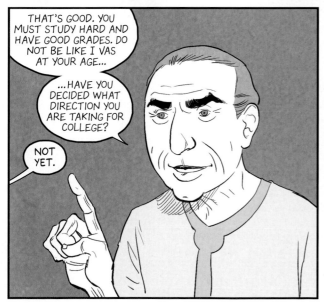

THAT'S GOOD. YOU MUST STUDY HARD AND HAVE GOOD GRADES. DO NOT BE LIKE I VAS AT YOUR AGE...

...HAVE YOU DECIDED WHAT DIRECTION YOU ARE TAKING FOR COLLEGE?

NOT YET.

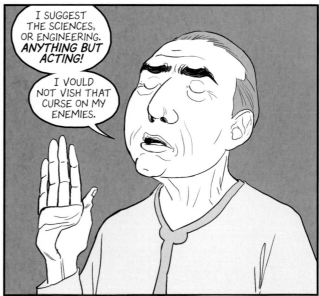

I SUGGEST THE SCIENCES, OR ENGINEERING. *ANYTHING BUT ACTING!*

I VOULD NOT VISH THAT CURSE ON MY ENEMIES.

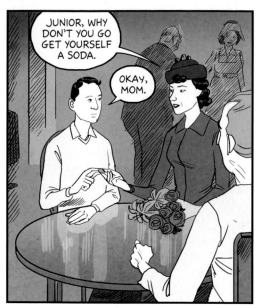

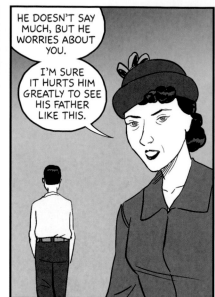

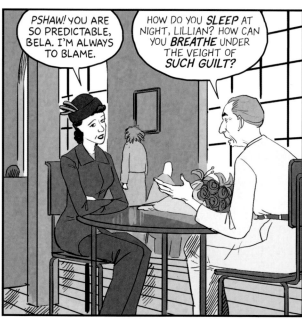

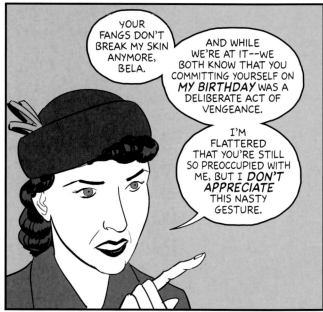

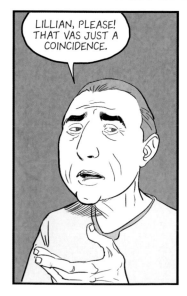

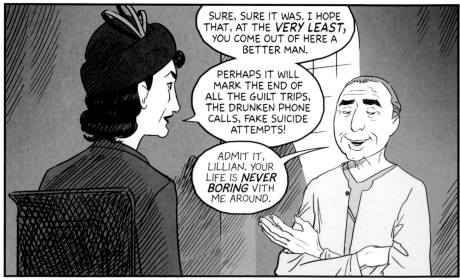

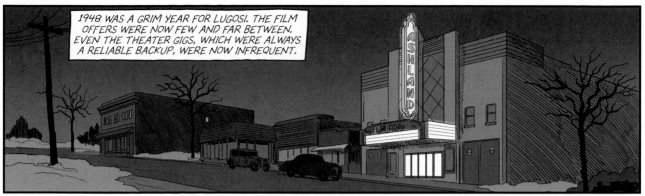

1948 WAS A GRIM YEAR FOR LUGOSI. THE FILM OFFERS WERE NOW FEW AND FAR BETWEEN. EVEN THE THEATER GIGS, WHICH WERE ALWAYS A RELIABLE BACKUP, WERE NOW INFREQUENT.

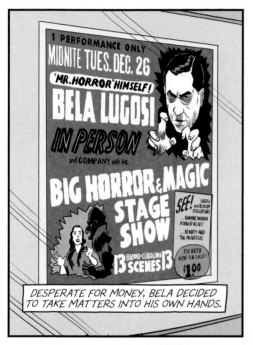

1 PERFORMANCE ONLY

MIDNITE TUES. DEC. 26

"MR. HORROR" HIMSELF!

BELA LUGOSI

IN PERSON

and COMPANY with his

BIG HORROR & MAGIC STAGE SHOW

SEE! LUGOSI and BLOODY CURDLING!
...VAMPIRE MAIDEN BURNED ALIVE!
...BEAUTY AND THE MONSTER!

13 BLOOD-CURDLING SCENES 13

TICKETS NOW ON SALE! $1.00

DESPERATE FOR MONEY, BELA DECIDED TO TAKE MATTERS INTO HIS OWN HANDS.

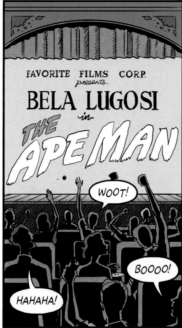

FAVORITE FILMS CORP. presents...

BELA LUGOSI in

THE APE MAN

WOOT!

BOOOO!

HAHAHA!

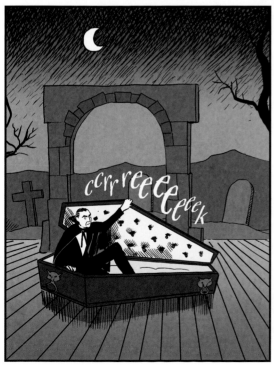

ccrrreeeeeeeek

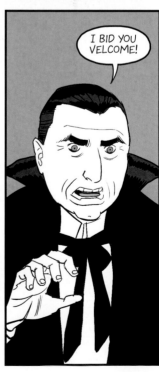

I BID YOU VELCOME!

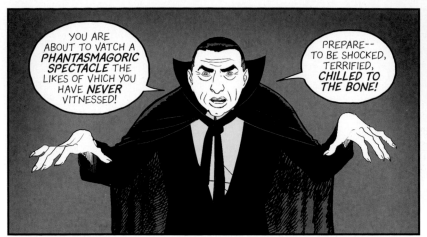

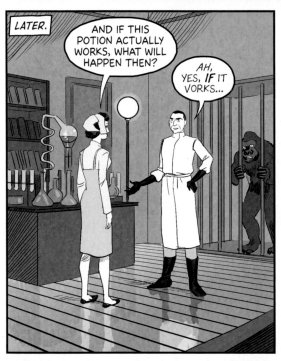

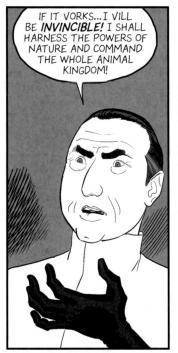

LATER.

GODDAMN IT TO HELL!

HAD TO VALK A MILE TO FIND A LIQUOR STORE IN THIS SHITHOLE TOWN!

:SOB:

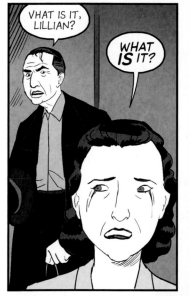

VHAT IS IT, LILLIAN?

WHAT *IS* IT?

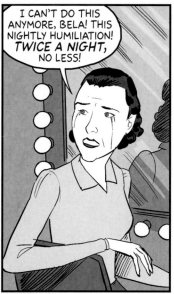

I CAN'T DO THIS ANYMORE, BELA! THIS NIGHTLY HUMILIATION! *TWICE A NIGHT*, NO LESS!

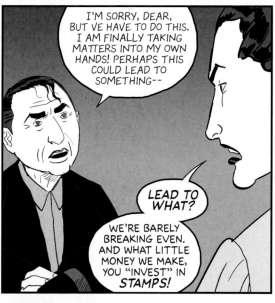

I'M SORRY, DEAR, BUT VE HAVE TO DO THIS. I AM FINALLY TAKING MATTERS INTO MY OWN HANDS! PERHAPS THIS COULD LEAD TO SOMETHING--

LEAD TO WHAT?

WE'RE BARELY BREAKING EVEN. AND WHAT LITTLE MONEY WE MAKE, YOU "INVEST" IN *STAMPS!*

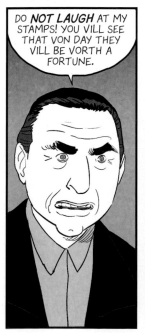

DO *NOT LAUGH* AT MY STAMPS! YOU VILL SEE THAT VON DAY THEY VILL BE VORTH A FORTUNE.

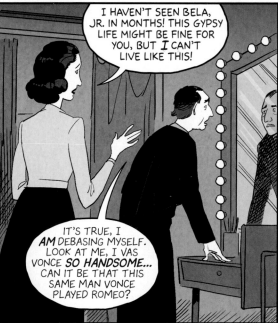

I HAVEN'T SEEN BELA, JR. IN MONTHS! THIS GYPSY LIFE MIGHT BE FINE FOR YOU, BUT *I* CAN'T LIVE LIKE THIS!

IT'S TRUE, I *AM* DEBASING MYSELF. LOOK AT ME, I VAS VONCE *SO HANDSOME...* CAN IT BE THAT THIS SAME MAN VONCE PLAYED ROMEO?

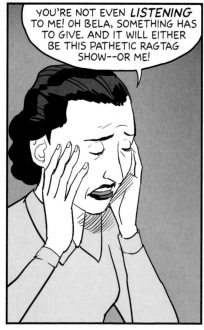

YOU'RE NOT EVEN *LISTENING* TO ME! OH BELA, SOMETHING HAS TO GIVE. AND IT WILL EITHER BE THIS PATHETIC RAGTAG SHOW--OR ME!

THE SITUATION IMPROVED SLIGHTLY WHEN AN OFFER CAME TO ACT IN A BRITISH STAGE REVIVAL OF DRACULA.

THE LUGOSIS PACKED THEIR BAGS AND SAILED ACROSS THE ATLANTIC TO ENGLAND, BEGINNING AN ARDUOUS TOUR OF THE COUNTRYSIDE.

THE PLAY PROVIDED THE TWO WITH A MUCH-NEEDED CASH INFUSION BUT ALSO FURTHER STRAINED THEIR ALREADY FRAYED MARRIAGE.

BZZZZ

FUCKING BAT-- *VHEN* WILL THEY GET IT RIGHT!

BZZZZZZ

LATER.

I HAVE *SEEN* HOW YOU LOOK AT ME, BETTY. *DO NOT RESIST* YOUR *VOMANLY INSTINCT!*

AAH!

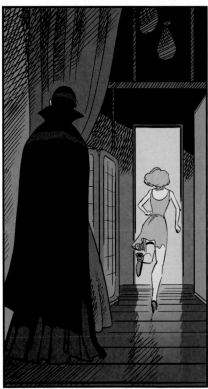

LATER.

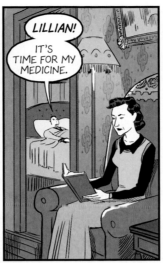

LILLIAN! IT'S TIME FOR MY MEDICINE.

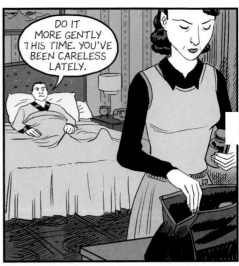

DO IT MORE GENTLY THIS TIME. YOU'VE BEEN CARELESS LATELY.

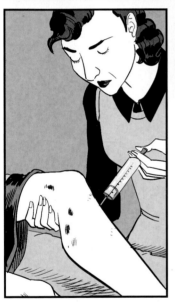

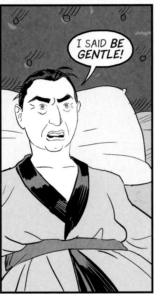

I SAID *BE GENTLE!*

SKRAK

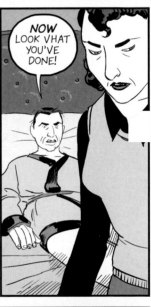

NOW LOOK VHAT YOU'VE DONE!

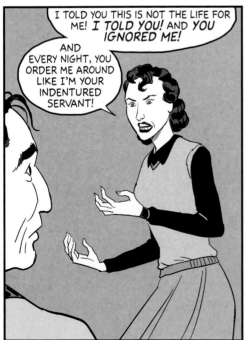

I TOLD YOU THIS IS NOT THE LIFE FOR ME! *I TOLD YOU!* AND *YOU IGNORED ME!*

AND EVERY NIGHT, YOU ORDER ME AROUND LIKE I'M YOUR INDENTURED SERVANT!

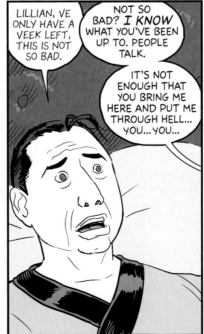

LILLIAN, VE ONLY HAVE A VEEK LEFT, THIS IS NOT SO BAD.

NOT SO BAD? *I KNOW* WHAT YOU'VE BEEN UP TO. PEOPLE TALK.

IT'S NOT ENOUGH THAT YOU BRING ME HERE AND PUT ME THROUGH HELL... YOU... YOU...

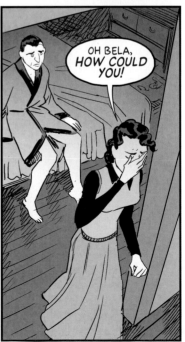

OH BELA, *HOW COULD YOU!*

129

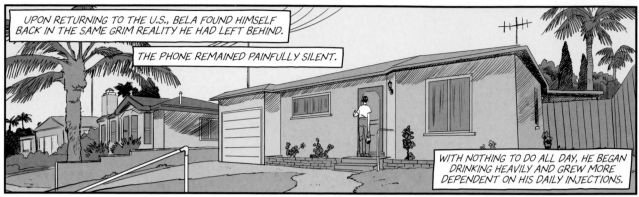

UPON RETURNING TO THE U.S., BELA FOUND HIMSELF BACK IN THE SAME GRIM REALITY HE HAD LEFT BEHIND.

THE PHONE REMAINED PAINFULLY SILENT.

WITH NOTHING TO DO ALL DAY, HE BEGAN DRINKING HEAVILY AND GREW MORE DEPENDENT ON HIS DAILY INJECTIONS.

AH! VILLIE, I'M SO HAPPY YOU HAVE COME. DID YOU BRING THE PÁLINKA?

YES, OF COURSE.

COME IN, COME IN.

VE VOULD DRINK THIS AFTER A SUCCESSFUL PERFORMANCE AT THE NATIONAL THEATER. LATE AT NIGHT, THEY VOULD POUR IT INTO BEAUTIFUL, TULIP-SHAPED GLASSES.

AH, THOSE VERE THE GOOD OLD DAYS, WHEN MY LIFE WAS ALL AHEAD OF ME. IT VAS A TIME VHEN YOU COULD DREAM!

HEY, WHERE'S LILLIAN?

SHE STARTED A NEW JOB VORKING FOR THIS *HACK ACTOR*, BRIAN DONLEVY. SHE IS HIS "ASSISTANT."

*DONLEVY...*THAT SOUNDS FAMILIAR. OH YEAH, I'VE SEEN HIM IN *IMPACT*--HE WAS VERY GOOD!

VERY GOOD? HE COULDN'T *ACT* HIS VAY OUT OF A BOX.

THE FILM WAS OKAY.

THE DIRECTOR--ARTHUR--VE HAVE VORKED TOGETHER.

WELL, IT'S GOOD THAT SHE'S WORKING. YOU CAN SURE USE THE CASH.

YES. BUT I DO NOT TRUST HER. I CALL EVERY DAY TO HER OFFICE. I CALL *MANY TIMES.* I MAKE SURE I KNOW VHERE SHE IS, ALVAYS.

THERE'S SOMETHING HAPPENING BEHIND MY BACK, I KNOW IT!

I VISH I VAS LIKE THE VAMPIRE. I TURN INTO A LITTLE BAT AND *CATCH THEM* AT THEIR KRIME!

TFOO! I PUT A GYPSY CURSE ON THAT DONLEVY!

WHAT'S THIS?

IT'S FOR THE NEXT MOVIE I'M IN.

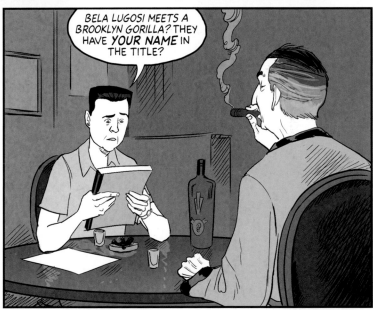

BELA LUGOSI MEETS A BROOKLYN GORILLA? THEY HAVE *YOUR NAME* IN THE TITLE?

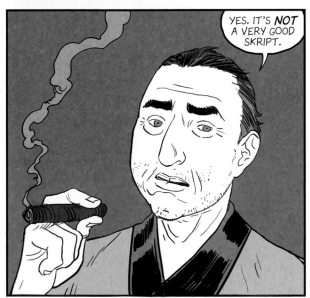

YES. IT'S *NOT* A VERY GOOD SKRIPT.

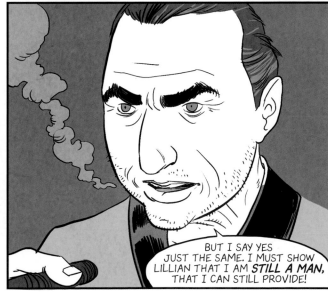

BUT I SAY YES JUST THE SAME. I MUST SHOW LILLIAN THAT I AM *STILL A MAN*, THAT I CAN STILL PROVIDE!

METROPOLITAN STATE HOSPITAL

HOW'S IT GOING, PAL?

EDDIE!

THE ONE AND ONLY!

BELA, YOU LOOK FANTASTIC! I'M SO HAPPY TO SEE YOU LOOKING SO WELL.

BAH, FLATTERY VILL GET YOU NOVHERE. SIT, SIT!

HOW DID THE PREMIERE OF *BRIDE OF THE MONSTER* GO? VAS THE THEATER PACKED?

VERE THERE BEAUTIFUL VOMEN ASKING FOR ME?

EH...NOT REALLY.

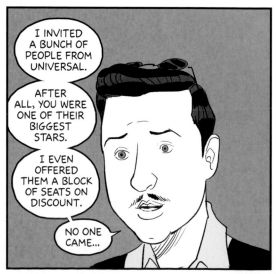

I INVITED A BUNCH OF PEOPLE FROM UNIVERSAL.

AFTER ALL, YOU WERE ONE OF THEIR BIGGEST STARS.

I EVEN OFFERED THEM A BLOCK OF SEATS ON DISCOUNT.

NO ONE CAME...

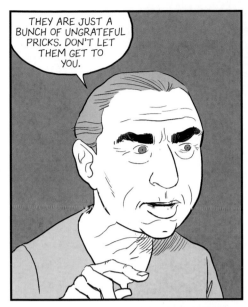

THEY ARE JUST A BUNCH OF UNGRATEFUL PRICKS. DON'T LET THEM GET TO YOU.

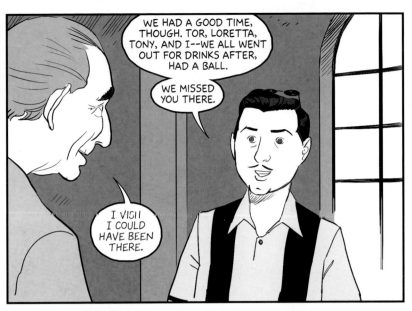

WE HAD A GOOD TIME, THOUGH. TOR, LORETTA, TONY, AND I--WE ALL WENT OUT FOR DRINKS AFTER, HAD A BALL.

WE MISSED YOU THERE.

I WISH I COULD HAVE BEEN THERE.

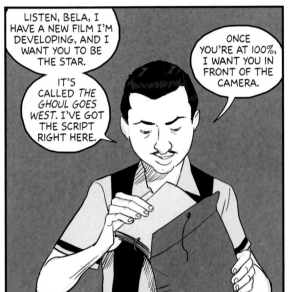

LISTEN, BELA, I HAVE A NEW FILM I'M DEVELOPING, AND I WANT YOU TO BE THE STAR.

IT'S CALLED *THE GHOUL GOES WEST*. I'VE GOT THE SCRIPT RIGHT HERE.

ONCE YOU'RE AT 100%, I WANT YOU IN FRONT OF THE CAMERA.

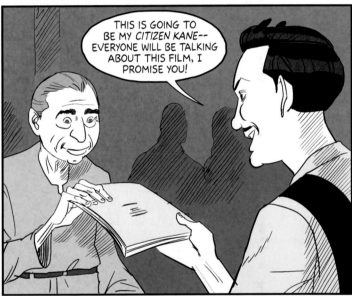

THIS IS GOING TO BE MY *CITIZEN KANE*-- EVERYONE WILL BE TALKING ABOUT THIS FILM, I PROMISE YOU!

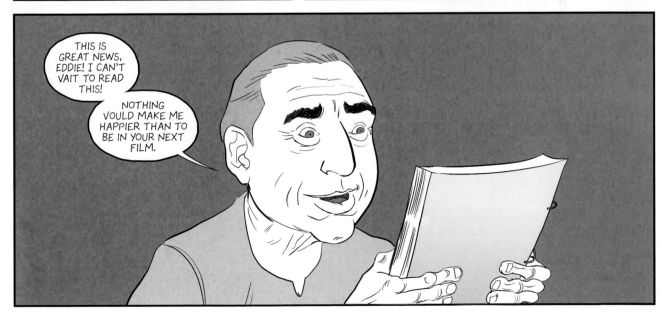

THIS IS GREAT NEWS, EDDIE! I CAN'T WAIT TO READ THIS!

NOTHING WOULD MAKE ME HAPPIER THAN TO BE IN YOUR NEXT FILM.

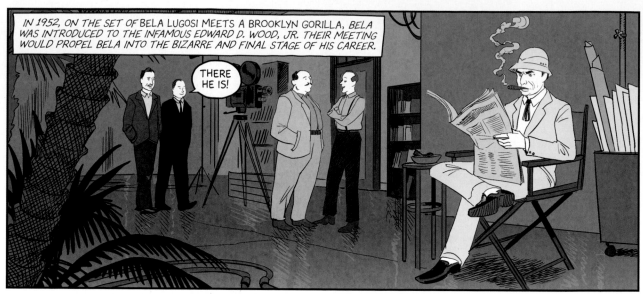

IN 1952, ON THE SET OF *BELA LUGOSI MEETS A BROOKLYN GORILLA,* BELA WAS INTRODUCED TO THE INFAMOUS EDWARD D. WOOD, JR. THEIR MEETING WOULD PROPEL BELA INTO THE BIZARRE AND FINAL STAGE OF HIS CAREER.

THERE HE IS!

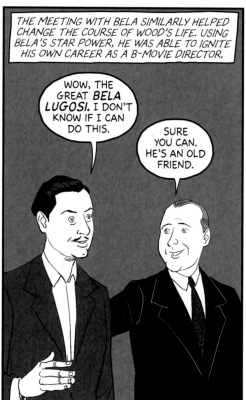

THE MEETING WITH BELA SIMILARLY HELPED CHANGE THE COURSE OF WOOD'S LIFE. USING BELA'S STAR POWER, HE WAS ABLE TO IGNITE HIS OWN CAREER AS A B-MOVIE DIRECTOR.

WOW, THE GREAT *BELA LUGOSI.* I DON'T KNOW IF I CAN DO THIS.

SURE YOU CAN. HE'S AN OLD FRIEND.

IN THE SIXTIES, WHEN HIS DREAMS OF BECOMING A FILMMAKER WERE SHUTTERED, WOOD BECAME A PORNOGRAPHER AND PULP NOVELIST. HE WOULD CONTINUE HIS WORK 'TIL 1978--WHEN HE DIED DRUNK AND PENNILESS.

WOOD GREW IN NOTORIETY ONLY IN THE LATE 20TH CENTURY, AFTER BEING CROWNED BY THE GOLDEN TURKEY AWARDS AS "THE WORST DIRECTOR OF ALL TIME."

ALRIGHT! HERE GOES NOTHING!

BELA, I WOULD LIKE TO INTRODUCE YOU TO A VERY SPECIAL FRIEND OF MINE.

HIS NAME IS *EDWARD D. WOOD.* HE'S A VERY PROMISING YOUNG DIRECTOR. WE USED TO BE ROOMMATES WHEN I FIRST ARRIVED IN L.A.

ED VOODS, HUH?

MR. LUGOSI, IT IS *SUCH A PLEASURE* TO MEET YOU IN PERSON. I'VE BEEN A FAN FOR *SO MANY YEARS.*

PLEASED TO MEET YOU, MR. VOODS. A FRIEND OF ALEX IS A FRIEND OF MINE.

SO VHAT FILMS HAVE YOU MADE THAT I MIGHT KNOW?

EHHMM, THERE ISN'T ANYTHING OUT THERE RIGHT NOW, BUT I HAVE A FEW PRODUCTIONS COOKING IN VARIOUS STAGES OF COMPLETION.

ONCE MY *NEXT* FILM IS OUT, YOU AND EVERYONE ELSE IN THIS TOWN WILL KNOW WHO I AM!

VELL, I VISH YOU THE VERY BEST OF LUCK WITH YOUR PRODUCTIONS, MR. VOODS.

WAIT, NOW THAT I THINK OF IT... THERE IS ONE FILM I'M WORKING ON THAT YOU WOULD BE *PERFECT* FOR!

IS THAT SO?

IT'S THE STORY OF A TRANSVESTITE WHO IS TORMENTED BY HIS DESIRE TO WEAR WOMEN'S CLOTHES.

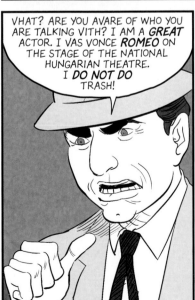

VHAT? ARE YOU AVARE OF WHO YOU ARE TALKING VITH? I AM A *GREAT* ACTOR. I VAS VONCE *ROMEO* ON THE STAGE OF THE NATIONAL HUNGARIAN THEATRE. I *DO NOT DO* TRASH!

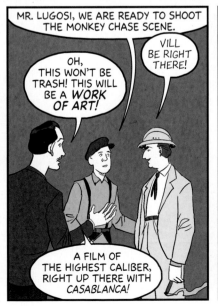

MR. LUGOSI, WE ARE READY TO SHOOT THE MONKEY CHASE SCENE.

VILL BE RIGHT THERE!

OH, THIS WON'T BE TRASH! THIS WILL BE A *WORK OF ART!*

A FILM OF THE HIGHEST CALIBER, RIGHT UP THERE WITH *CASABLANCA!*

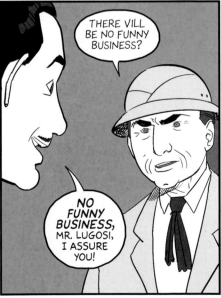

THERE VILL BE NO FUNNY BUSINESS?

NO FUNNY BUSINESS, MR. LUGOSI, I ASSURE YOU!

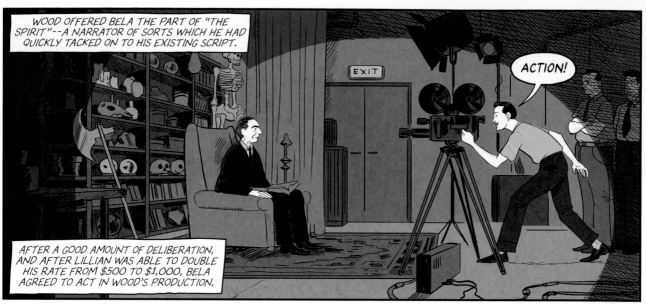

WOOD OFFERED BELA THE PART OF "THE SPIRIT"--A NARRATOR OF SORTS WHICH HE HAD QUICKLY TACKED ON TO HIS EXISTING SCRIPT.

ACTION!

AFTER A GOOD AMOUNT OF DELIBERATION, AND AFTER LILLIAN WAS ABLE TO DOUBLE HIS RATE FROM $500 TO $1,000, BELA AGREED TO ACT IN WOOD'S PRODUCTION.

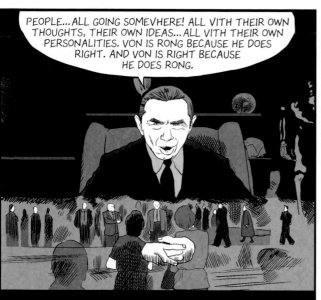

PEOPLE...ALL GOING SOMEVHERE! ALL VITH THEIR OWN THOUGHTS, THEIR OWN IDEAS...ALL VITH THEIR OWN PERSONALITIES. VON IS RONG BECAUSE HE DOES RIGHT. AND VON IS RIGHT BECAUSE HE DOES RONG.

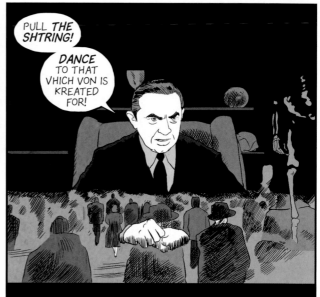

PULL *THE SHTRING!*

DANCE TO THAT VHICH VON IS KREATED FOR!

TELL ME! TELL ME, DRAGON!

DO YOU EAT LITTLE BOYS, PUPPY DOG TAILS, AND BIG, FAT SNAILS?

LATER.

EXIT

DIRECTOR ON SET!

LET'S HAVE THE CAMERA THERE!

AND MOVE THAT LIGHT HERE.

BELA! WHEN DID YOU GET HERE?

I KREPT IN AVHILE AGO.

SO WHAT DO YOU THINK SO FAR?

IT SEEMS A VERY INTERESTING FILM, EDDIE.

CERTAINLY LIKE NOTHING I'VE EVER PARTICIPATED IN.

THAT'S MUSIC TO MY EARS! AND THANK YOU FOR NOT JUDGING. SOME MEN WOULD HAVE HAD A HARD TIME SEEING THEIR DIRECTOR IN THIS GETUP.

VHY WOULD I JUDGE? VHATEVER MAKES YOU HAPPY. AS LONG AS YOU ARE NOT HURTING NOBODY, THERE IS NOTHING TO BE BOTHERED BY.

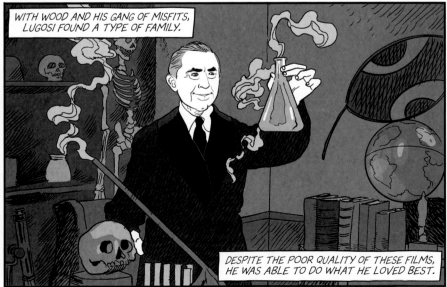

WITH WOOD AND HIS GANG OF MISFITS, LUGOSI FOUND A TYPE OF FAMILY.

DESPITE THE POOR QUALITY OF THESE FILMS, HE WAS ABLE TO DO WHAT HE LOVED BEST.

SADLY, THIS WAS BUT A SILVER LINING IN WHAT PROVED TO BE THE LOWEST POINT IN BELA'S LIFE.

OH GOD! YOU GAVE ME *SUCH* A SCARE.

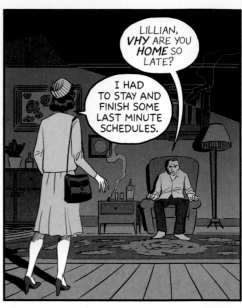

LILLIAN, *VHY* ARE YOU *HOME* SO LATE?

I HAD TO STAY AND FINISH SOME LAST MINUTE SCHEDULES.

I DO NOT *BELIEVE* YOU.

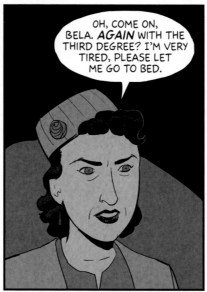

OH, COME ON, BELA. *AGAIN* WITH THE THIRD DEGREE? I'M VERY TIRED, PLEASE LET ME GO TO BED.

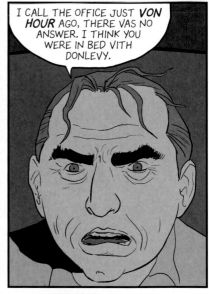

I CALL THE OFFICE JUST *VON HOUR* AGO, THERE VAS NO ANSWER. I THINK YOU WERE IN BED VITH DONLEVY.

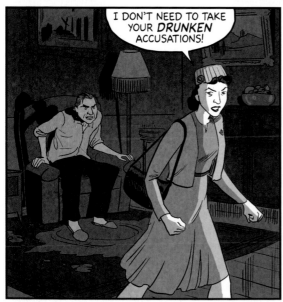

I DON'T NEED TO TAKE YOUR *DRUNKEN* ACCUSATIONS!

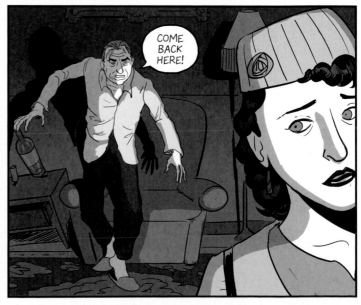

COME BACK HERE!

138

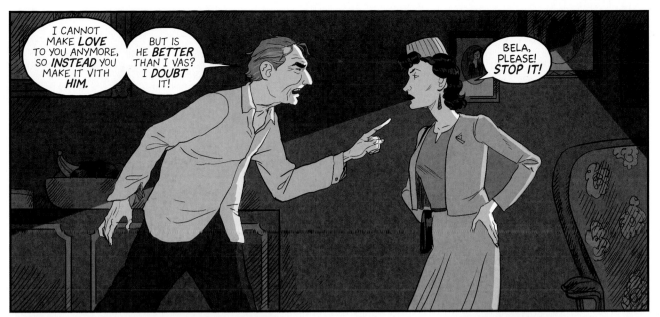

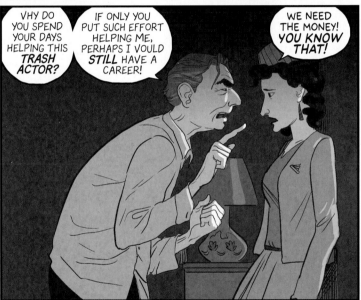

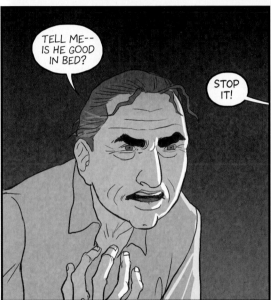

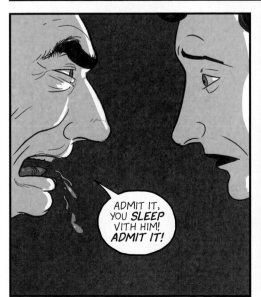

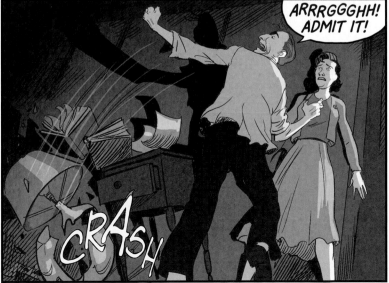

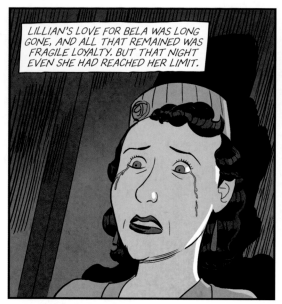

LILLIAN'S LOVE FOR BELA WAS LONG GONE, AND ALL THAT REMAINED WAS FRAGILE LOYALTY. BUT THAT NIGHT EVEN SHE HAD REACHED HER LIMIT.

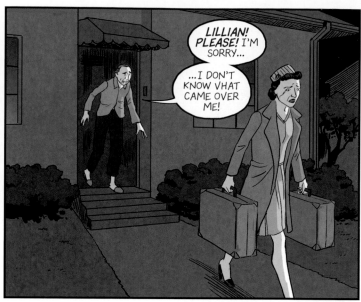

LILLIAN! PLEASE! I'M SORRY...

...I DON'T KNOW WHAT CAME OVER ME!

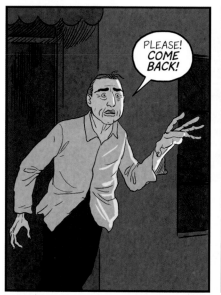

PLEASE! COME BACK!

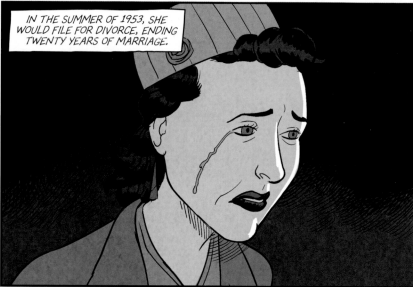

IN THE SUMMER OF 1953, SHE WOULD FILE FOR DIVORCE, ENDING TWENTY YEARS OF MARRIAGE.

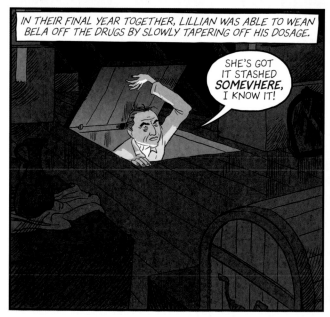

IN THEIR FINAL YEAR TOGETHER, LILLIAN WAS ABLE TO WEAN BELA OFF THE DRUGS BY SLOWLY TAPERING OFF HIS DOSAGE.

SHE'S GOT IT STASHED SOMEVHERE, I KNOW IT!

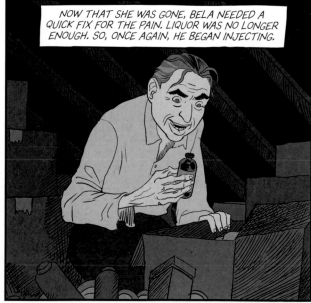

NOW THAT SHE WAS GONE, BELA NEEDED A QUICK FIX FOR THE PAIN. LIQUOR WAS NO LONGER ENOUGH. SO, ONCE AGAIN, HE BEGAN INJECTING.

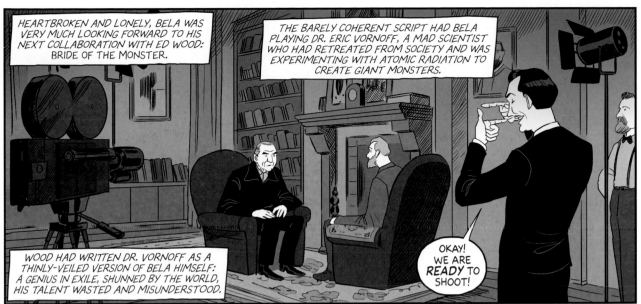

HEARTBROKEN AND LONELY, BELA WAS VERY MUCH LOOKING FORWARD TO HIS NEXT COLLABORATION WITH ED WOOD: BRIDE OF THE MONSTER.

THE BARELY COHERENT SCRIPT HAD BELA PLAYING DR. ERIC VORNOFF, A MAD SCIENTIST WHO HAD RETREATED FROM SOCIETY AND WAS EXPERIMENTING WITH ATOMIC RADIATION TO CREATE GIANT MONSTERS.

OKAY! WE ARE *READY* TO SHOOT!

WOOD HAD WRITTEN DR. VORNOFF AS A THINLY-VEILED VERSION OF BELA HIMSELF: A GENIUS IN EXILE, SHUNNED BY THE WORLD, HIS TALENT WASTED AND MISUNDERSTOOD.

EDDIE, MAY I TALK VITH YOU FOR A MOMENT?

THIS PART HAS MANY LINES. I AM AN OLD MAN, EDDIE. MY BRAIN IS NOT AS SHARP AS IT VONCE WAS.

I'M VORRIED I VILL NOT BE ABLE TO GET IT RIGHT...

YOU KNOW I CAN'T AFFORD SECOND TAKES.

WE ARE ON A TIGHT SCHEDULE BELA, I'M TRYING TO SHOOT 25 SCENES TODAY.

PLEASE, EDDIE, IS THERE NOTHING YOU CAN DO?

WAIT A SECOND! HOW ABOUT WE USE CUE CARDS? THEN YOU *CAN'T* GET IT WRONG.

THAT VOULD BE GREAT.

THANK YOU, EDDIE!

LATER.

OKAY, *ACTION!*

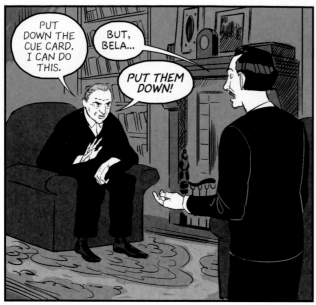

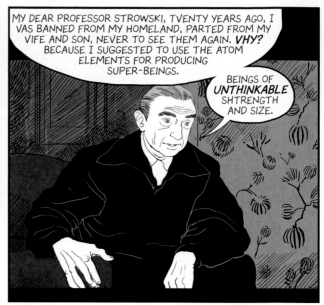

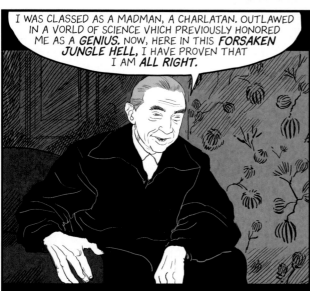

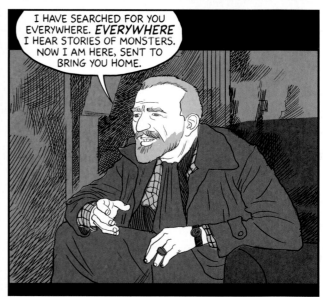

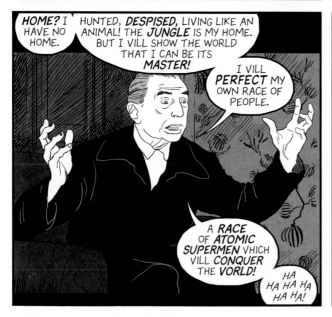

142

THE FOLLOWING WEEK.

RRRINGGG

HELLO?

EDDIE, I NEED YOU TO BRING ME A BOTTLE OF SKOTCH.

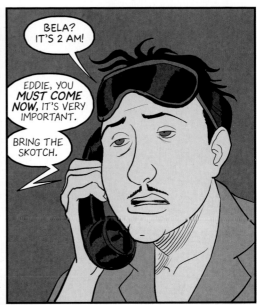

BELA? IT'S 2 AM!

EDDIE, YOU **MUST COME NOW,** IT'S VERY IMPORTANT.

BRING THE SKOTCH.

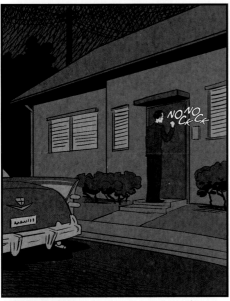

NO NO CK CK

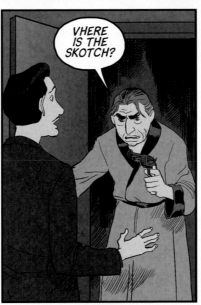

VHERE IS THE SKOTCH?

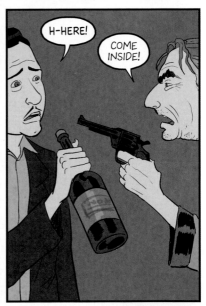

H-HERE!

COME INSIDE!

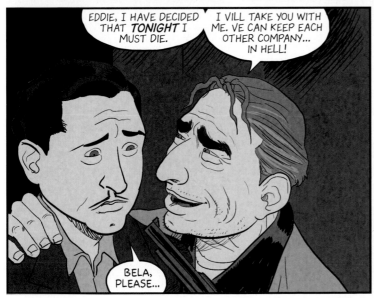

EDDIE, I HAVE DECIDED THAT **TONIGHT** I MUST DIE.

I VILL TAKE YOU WITH ME. VE CAN KEEP EACH OTHER COMPANY... IN HELL!

BELA, PLEASE...

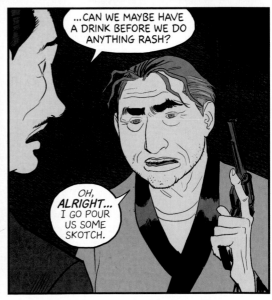

...CAN WE MAYBE HAVE A DRINK BEFORE WE DO ANYTHING RASH?

OH, **ALRIGHT**... I GO POUR US SOME SKOTCH.

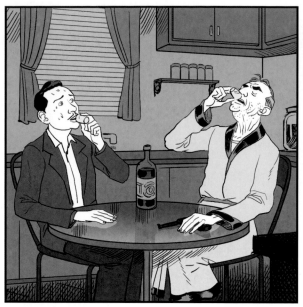

=SOB=

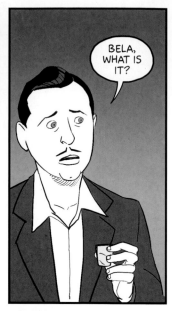

BELA, WHAT IS IT?

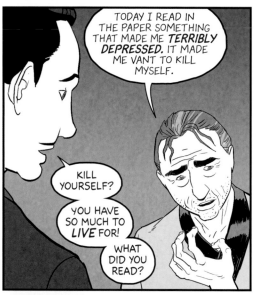

TODAY I READ IN THE PAPER SOMETHING THAT MADE ME *TERRIBLY DEPRESSED.* IT MADE ME VANT TO KILL MYSELF.

KILL YOURSELF?

YOU HAVE SO MUCH TO *LIVE* FOR!

WHAT DID YOU READ?

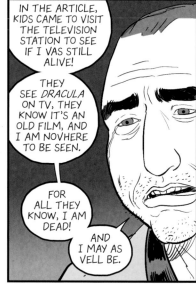

IN THE ARTICLE, KIDS CAME TO VISIT THE TELEVISION STATION TO SEE IF I VAS STILL ALIVE!

THEY SEE *DRACULA* ON TV, THEY KNOW IT'S AN OLD FILM, AND I AM NOVHERE TO BE SEEN.

FOR ALL THEY KNOW, I AM DEAD!

AND I MAY AS VELL BE.

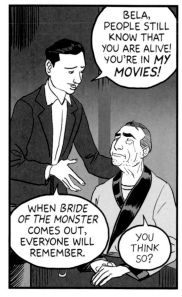

BELA, PEOPLE STILL KNOW THAT YOU ARE ALIVE! YOU'RE IN *MY MOVIES!*

WHEN *BRIDE OF THE MONSTER* COMES OUT, EVERYONE WILL REMEMBER.

YOU THINK SO?

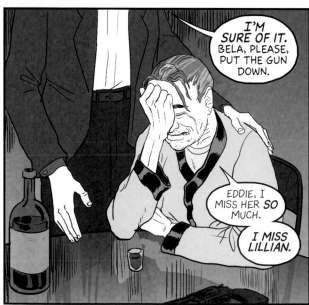

I'M *SURE OF IT.* BELA, PLEASE, PUT THE GUN DOWN.

EDDIE, I MISS HER *SO* MUCH.

I MISS LILLIAN.

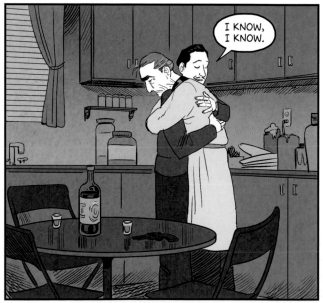

I KNOW, I KNOW.

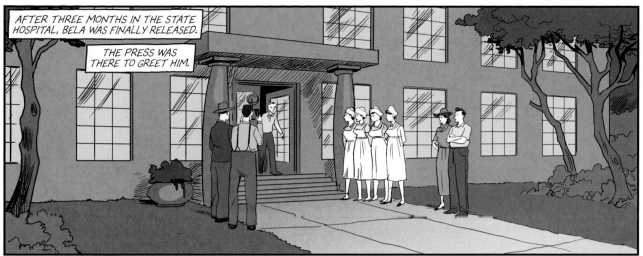

AFTER THREE MONTHS IN THE STATE HOSPITAL, BELA WAS FINALLY RELEASED.

THE PRESS WAS THERE TO GREET HIM.

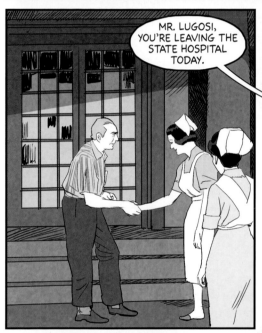

MR. LUGOSI, YOU'RE LEAVING THE STATE HOSPITAL TODAY.

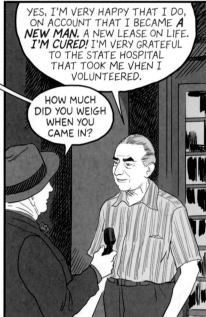

YES, I'M VERY HAPPY THAT I DO, ON ACCOUNT THAT I BECAME *A NEW MAN.* A NEW LEASE ON LIFE. *I'M CURED!* I'M VERY GRATEFUL TO THE STATE HOSPITAL THAT TOOK ME VHEN I VOLUNTEERED.

HOW MUCH DID YOU WEIGH WHEN YOU CAME IN?

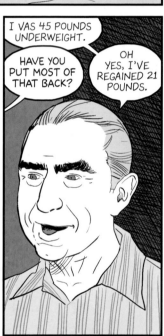

I VAS 45 POUNDS UNDERWEIGHT.

HAVE YOU PUT MOST OF THAT BACK?

OH YES, I'VE REGAINED 21 POUNDS.

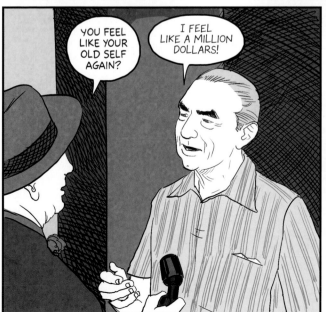

YOU FEEL LIKE YOUR OLD SELF AGAIN?

I FEEL LIKE A MILLION DOLLARS!

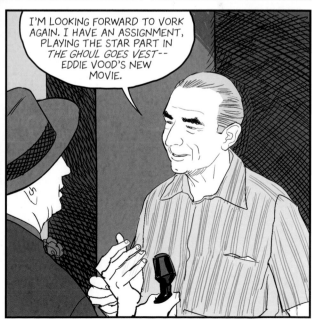

I'M LOOKING FORWARD TO VORK AGAIN. I HAVE AN ASSIGNMENT, PLAYING THE STAR PART IN *THE GHOUL GOES VEST*-- EDDIE VOOD'S NEW MOVIE.

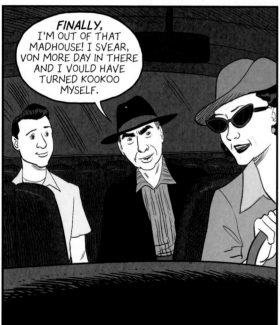

FINALLY, I'M OUT OF THAT MADHOUSE! I SVEAR, VON MORE DAY IN THERE AND I VOULD HAVE TURNED KOOKOO MYSELF.

SO WHAT NOW, BELA?

TAKE ME TO THE CLOSEST BAR!

OH, PLEASE...

I VAS JOKING!

IT'S NICE TO SEE YOU IN A GOOD MOOD AGAIN, UNCLE.

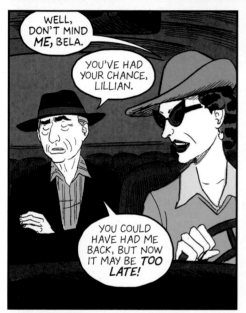

147

EPILOGUE

A FEW WEEKS AFTER BEING DISCHARGED, BELA MARRIED HIS SECRET ADMIRER, HOPE LOUISE LININGER.

HOPE WAS AN RKO STUDIO CUTTING ROOM CLERK AND A LONG-TIME LUGOSI FAN.

THE COUPLE WOULD SEE ED WOOD OFTEN. HE HAD YET TO ABANDON HIS DREAM OF HAVING BELA STAR IN HIS NEXT EPIC.

BEEP BEEP

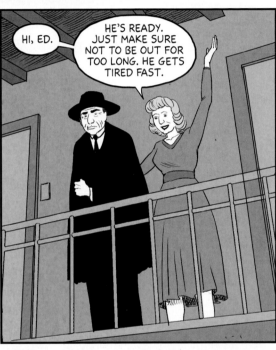

HI, ED.

HE'S READY. JUST MAKE SURE NOT TO BE OUT FOR TOO LONG. HE GETS TIRED FAST.

NO WORRIES, HOPE. I'LL RETURN HIM TO YOU IN ONE PIECE, I PROMISE!

DID YOU BRING THE CAPE?

YES, IN THE BAG.

VHAT IS GOING ON HERE? CAN SOMEVON PLEASE TELL ME?

IT'S A SURPRISE, BELA.

BAH, YOU *KNOW* I HATE SURPRISES!

EDDIE, VHERE ARE YOU TAKING ME? IS IT ANOTHER PREMIERE WHERE I'LL BE HOLDING A GORILLA ON A LEASH?

I VON'T BE HUMILIATED LIKE *THAT* AGAIN.

NO, NO, NOTHING LIKE THAT.

HERE WE ARE.

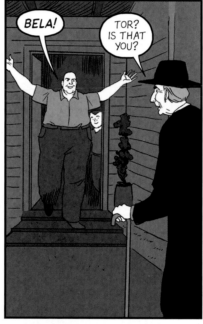

BELA!

TOR? IS THAT YOU?

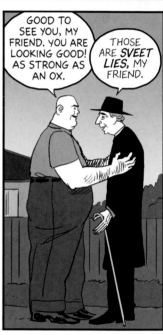

GOOD TO SEE YOU, MY FRIEND. YOU ARE LOOKING GOOD! AS STRONG AS AN OX.

THOSE ARE *SVEET LIES*, MY FRIEND.

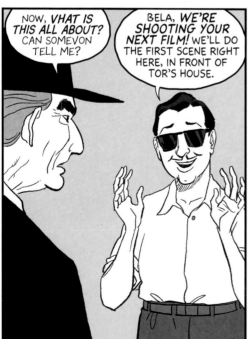

NOW, *VHAT IS THIS ALL ABOUT?* CAN SOMEVON TELL ME?

BELA, *WE'RE SHOOTING YOUR NEXT FILM!* WE'LL DO THE FIRST SCENE RIGHT HERE, IN FRONT OF TOR'S HOUSE.

FILM? VHERE IS THE SKRIPT?

EHH...NO SCRIPT QUITE YET.

AH...I SEE THIS IS VON OF THOSE NEW *ART FILMS* THE YOUNG KIDS ARE MAKING?

YES, *YES!* EXACTLY.

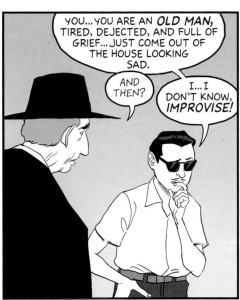

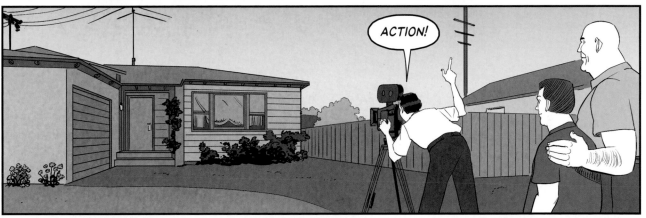

AAND-- CUT!

clap clap clap

DID I DO GOOD, EDDIE?

YOU WERE INCREDIBLE!

LATER.

IT'S GOOD TO SEE THAT I STILL "HAVE IT!"

VHERE ARE VE GOING NOW?

OUR NEXT SCENE. OVER HERE, THIS IS PERFECT.

VHAT ARE ALL THESE FOR?

IT'S MY PORTABLE CEMETARY!

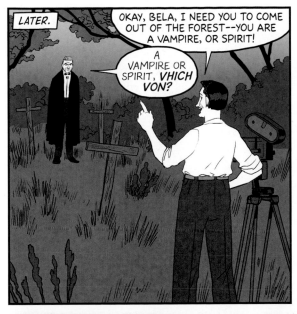

LATER.

OKAY, BELA, I NEED YOU TO COME OUT OF THE FOREST--YOU ARE A VAMPIRE, OR SPIRIT!

A VAMPIRE OR SPIRIT, *VHICH VON?*

UMM, YOU PICK! YOU ARE THE SAME OLD MAN FROM BEFORE. YOU'VE COME BACK TO HAUNT THOSE WHO HAVE MADE YOUR LIFE MISERABLE.

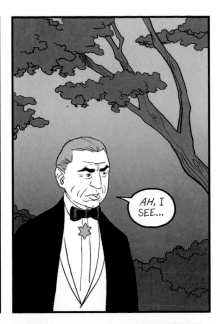

AH, I SEE...

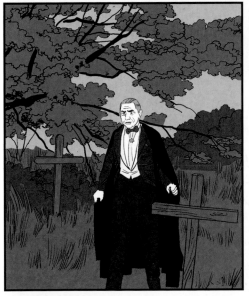

TAKE HEED!

CUT! FANTASTIC, FANTASTIC!

EDDIE, I'M GETTING TIRED.

OF COURSE, OF COURSE.

LET'S TAKE YOU HOME.

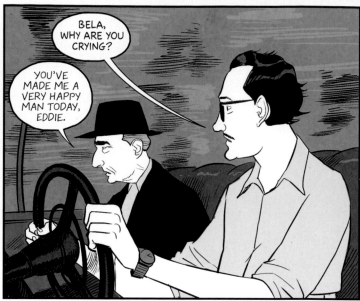

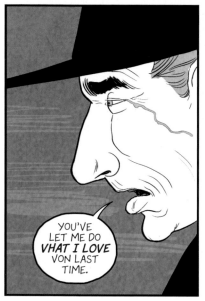

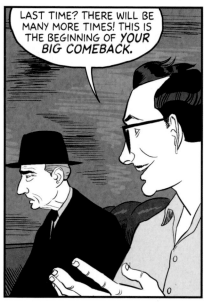

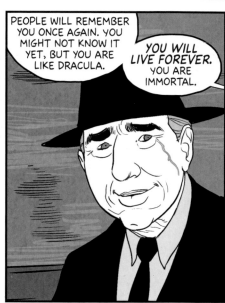

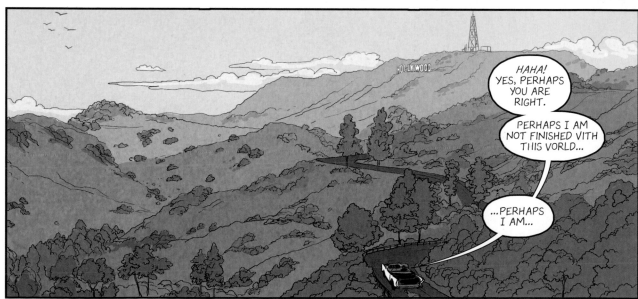

...IMMORTAL.

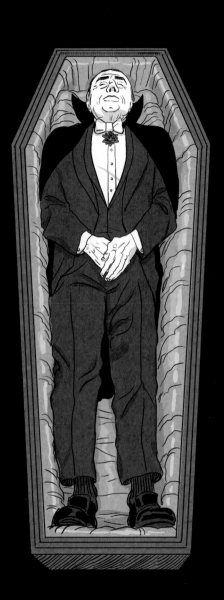

Afterword by Gary D. Rhodes

Koren Shadmi's graphic novel about the life and lore of Bela Lugosi is tremendous. If I might be allowed to offer another adjective, I'd be tempted to say--to screech, even, with appropriate background music and tremulous voice--"tremonstrous," a term that Universal Pictures invented to publicize the Karloff-Lugosi movie *The Black Cat* (1934).

And Shadmi's description of Lugosi as Hollywood's Dracula is particularly apt. My own documentary film about the actor was titled *Lugosi: Hollywood's Dracula* (1997). We have jointly seized upon the phrase for the same reason: through film Lugosi and Dracula became inseparable, and the connection seems only to deepen as the decades pass, from Lugosi's life and death through the twentieth and now twenty-first centuries, despite so many other wonderful actors who have starred in so many other memorable Dracula films.

Before sitting down to pen these words, I noticed pre-orders for yet another Lugosi-as-Dracula action figure. During the next week, I'll be recording a new audio commentary for a forthcoming Lugosi Blu-ray. And within a month stores will be selling Halloween masks that look an awful lot like Lugosi's awfully-awful-and-yet-awfully-handsome face, seductive vampire that he was. Lugosi's Dracula was, of course, as sexual as he was sinister.

As the author (in many cases co-author) of eleven books about Lugosi and his films, my enthusiasm for his biography and his screen presence remains undiminished. I have traveled the globe in search of any scrap of information, spending so much time in Canada, Germany, Hungary, and Romania on the trail of the most famous of film vampires. At this point, after a pursuit that has lasted for four decades, I know more than a little bit about his bite.

That's why I believe I can make a firm and honest declaration about Koren Shadmi's graphic novel. While I spend time as something of a grave robber in archives and libraries, he soars above like a bat, artfully and artistically flying through the high--and, necessarily, the low--points -of Lugosi geography. His version of Lugosi is worthy and worthwhile, beautifully horrifying and horrifyingly beautiful.

Lugosi's Hollywoodland was Draculand, just as it remains to the present day. But as Shadmi addresses with such intellectual and aesthetic insight, Lugosi was also much more than Dracula. He

rose to fame in Hungary, before forging a second and fascinating career in Germany, before making his way in American ethnic theater, before achieving success on Broadway, before becoming immortal in Tinseltown, where some of that wonderful shining tinsel came from his gleaming, hypnotic eyes.

Lugosi was a romantic, in both the Germanic and American connotation of the term. He was a lover, a connoisseur, a pleasure-seeker and a pleasure-giver. He was at home at home, and a foreigner amid the bright lights of Universal Pictures. Lugosi had his rise--more than one of them, to be sure--just as he had his fall, which also could be understood in the plural.

The same actor known as Dracula was once known as Jesus Christ in a Passion play. The same actor renowned for Shakespeare's *Romeo and Juliet* in 1910 became renowned for Ed Wood's *Bride of the Monster* in 1994, thanks to Tim Burton's film *Ed Wood*.

Put another way, Lugosi was definitely and definitively Hollywood's Dracula, at this point the world's Dracula. But he was so much more.

As of 2022, some of us know Lugosi well. Others only by his voice and appearance, recognizing them as Dracula even if unaware of the actor behind the vampire. Indeed, even if the name Lugosi becomes largely forgotten, even if it becomes something more akin to Lu-ghost-i, his Dracula will endure. No stake can destroy him. No sunlight can fade him to black.

Lugosi's Dracula will be out at night, always out at night. He may never drink wine, but he will always be passing through cobwebs, out a creaking castle door, into the clouds as they snake across the moon, to commune with the children of the night before sinking his teeth into the next neck. The evening air chills, as do our spines.

I will always be a fan of Bela Lugosi, just as I will always be a fan of Koren Shadmi. The two go together as fantastically well as did Bela Lugosi and Boris Karloff, or Bela Lugosi and Ed Wood. Here's to Hollywood's Dracula, meaning Lugosi's and also Shadmi's.

Gary D. Rhodes, Ph.D., is a film historian and filmmaker. In addition to his work on Bela Lugosi, he has published extensively on American cinema and horror movies.

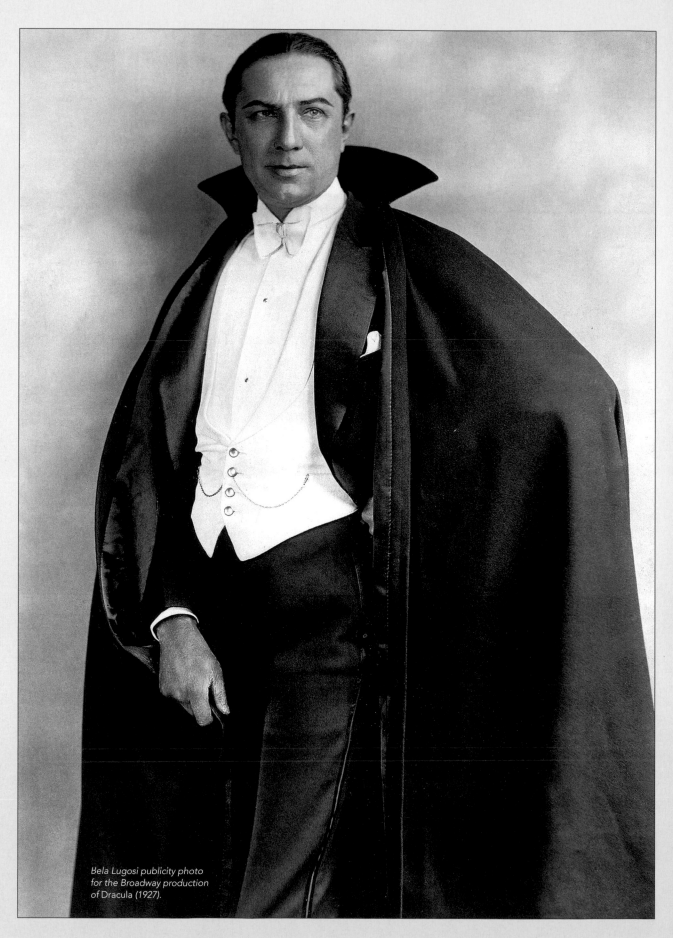

Bela Lugosi publicity photo for the Broadway production of Dracula (1927).

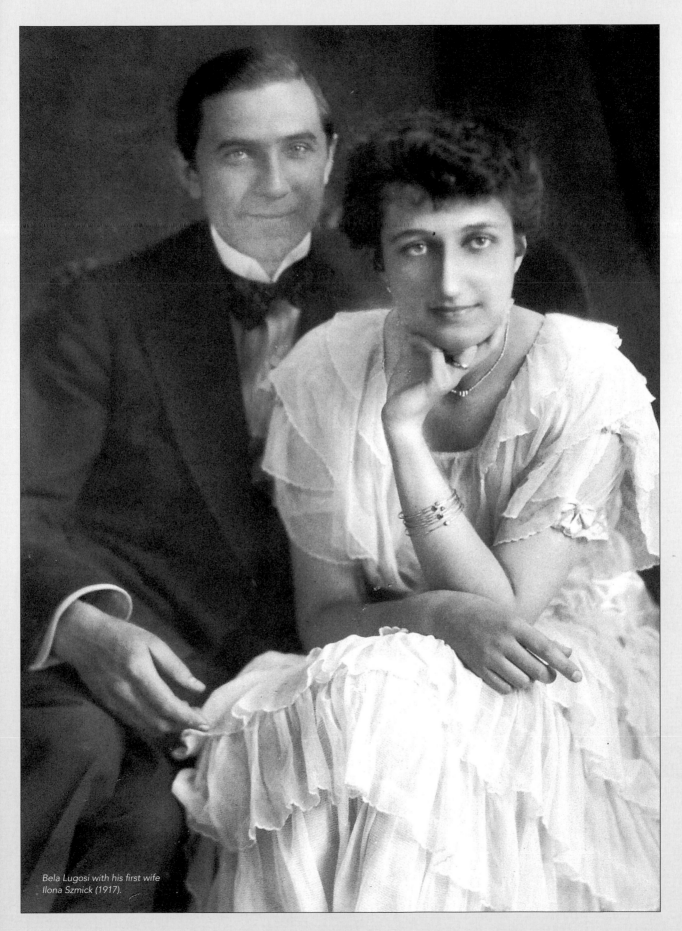

Bela Lugosi with his first wife Ilona Szmick (1917).

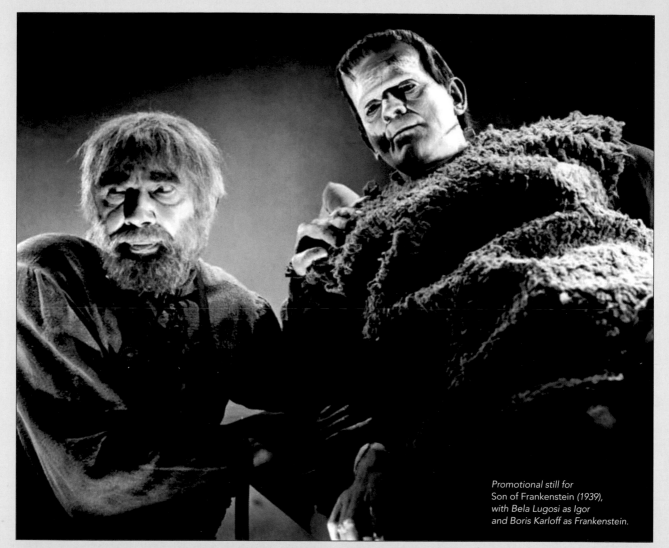

Promotional still for
Son of Frankenstein (1939),
with Bela Lugosi as Igor
and Boris Karloff as Frankenstein.

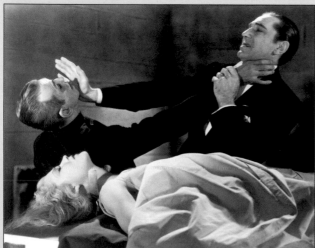

Bela Lugosi and Boris Karloff fighting over Lucille Lund in their first
collaboration, The Black Cat (1934).

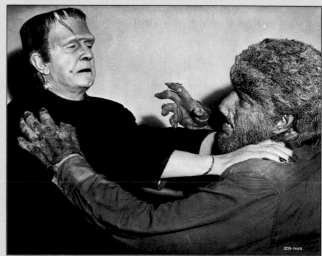

Promotional still for Frankenstein Meets the Wolf Man (1943), with
Bela Lugosi as Frankenstein and Lon Chaney, Jr. as Larry Talbot
(a.k.a. the Wolf Man).

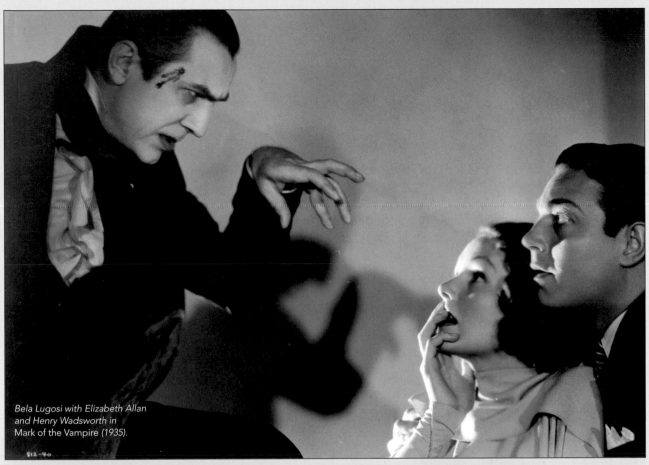

Bela Lugosi with Elizabeth Allan and Henry Wadsworth in Mark of the Vampire *(1935).*

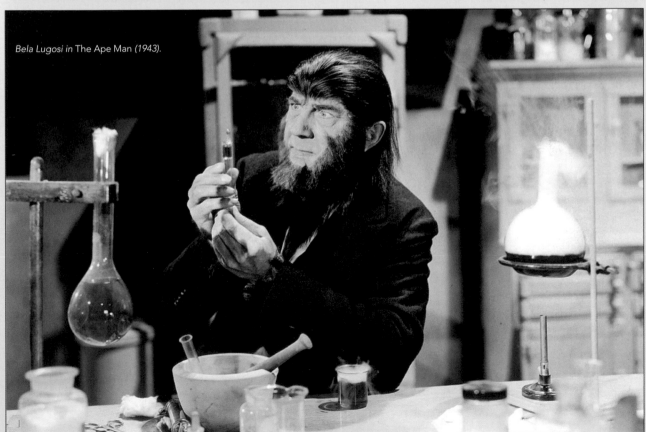

Bela Lugosi in The Ape Man *(1943).*

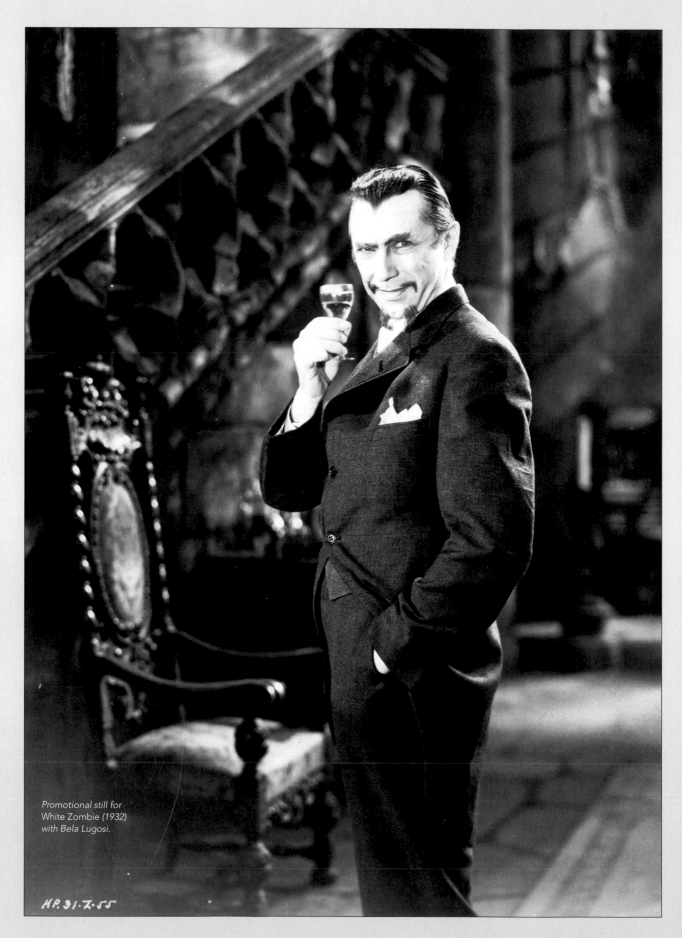

*Promotional still for
White Zombie (1932)
with Bela Lugosi.*

H.P. 31·7·55

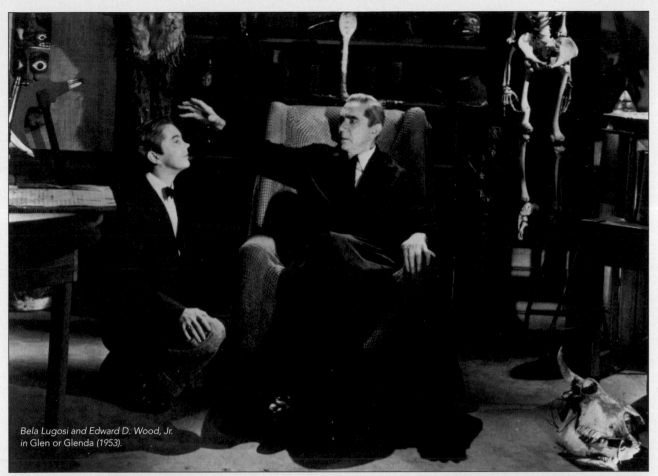

Bela Lugosi and Edward D. Wood, Jr.
in Glen or Glenda *(1953).*

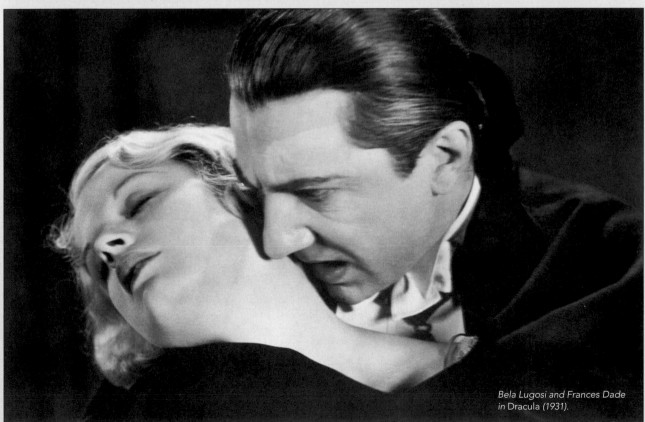

Bela Lugosi and Frances Dade
in Dracula *(1931).*

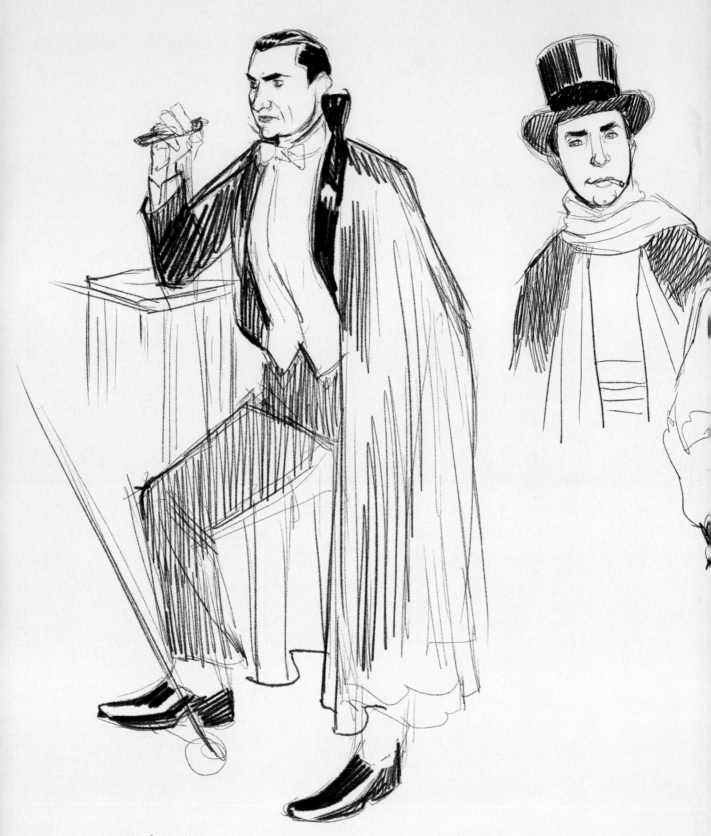

Koren's first take on Lugosi in his most iconic role.

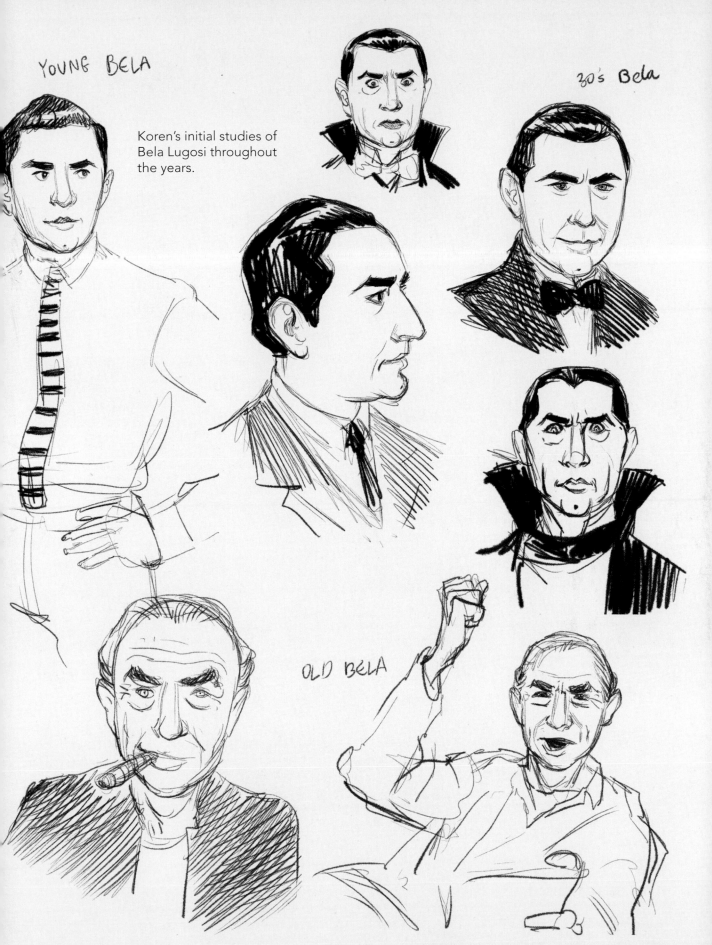

YOUNG BELA

30's Bela

Koren's initial studies of
Bela Lugosi throughout
the years.

OLD BELA

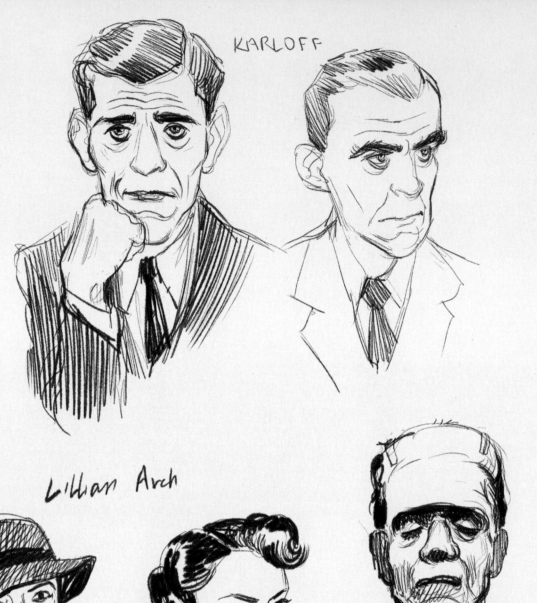

KARLOFF

Lillian Arch

Koren's studies of Lugosi's
fourth wife, Lillian,
and Hollywood rival,
Boris Karloff.
Next page, his cover sketches.

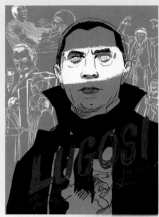
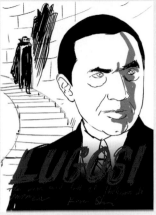

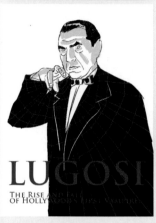
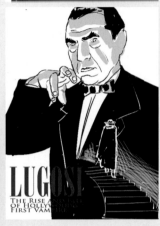

Bibliography

Barry, Barbara. "Meet the Vampire." *The New Movie Magazine*, January 1933.

"Bela Lugosi 'Sweet,' Despite Horror Roles, Wife Insists." *The Seattle Times*, March 13, 1945.

"Bela Lugosi Tells Long Dope Ordeal." *Los Angeles Times*, April 23, 1955.

The Bela Lugosi Blog. https://beladraculalugosi.com/

Bojarski, Richard. *The Films of Bela Lugosi*. Citadel Press, 1980.

Cremer, Robert. *Lugosi: The Man Behind the Cape*. Henry Regnery Company, 1976.

"Dracula Without His Cape." *The New York Times*, July 7, 1935.

Finn, Elsie. "Menace with Cold Feet—That's Bela Lugosi." *The Philadelphia Record*, May 19, 1943.
Hopper, Hedda. "Horror Men of Screen Just Pair of Home-Loving Folks, After All." *Los Angeles Times*, January 14, 1940.
Johnson, Fred. "'Dracula' Sees No 'Talkie' Future." *San Francisco Call Bulletin*, July 24, 1929.

Kimbrough, Mary. "Movie Monster." *St. Louis Dispatch*, January 21, 1954.

Laro, Frank. "Bela Lugosi to Wed Tonight." *Los Angeles Mirror-News*, August 24, 1955.

Lee, Stephen J. *European Dictatorships 1918-1945*. Routledge, 2008.

Lennig, Arthur. *The Immortal Count: The Life and Films of Bela Lugosi*. The University Press of Kentucky, 2013.

Longworth, Karina. (Host). "Bela and Boris" (Episode 4) [Audio podcast episode]. *You Must Remember This*. Nov 6, 2017.
http://www.youmustrememberthispodcast.com/episodes/2017/11/6/bela-and-boris-episode-4-bela-vs-boris

MacKey, Joe. "Big Bad Bela." *Picture Play*, July 1934.
Mank, Gregory William. *Bela Lugosi and Boris Karloff: The Expanded Story of a Haunting Collaboration*. McFarland & Company, 2009.

Mok, Michael. "Horror Man at Home." *The New York Post*, October 19, 1939.

Ray, Fred Olen. "So Just Who the Heck is Ed Wood, Anyway?" *Cult Movies Magazine* #11, January 1994.

Rees, Robert R. "The Vampira Chronicles." *Cult Movies Magazine* #11, January 1994.

Rhodes, Gary Don and Bill Kaffenberger. *No Traveler Returns: The Lost Years of Bela Lugosi*. BearManor Media, 2016.

Rhodes, Gary Don. *Lugosi: His Life in Films, on Stage, and in the Heart of Horror Lovers*. McFarland & Company, 2006.

Stenn, David. *Clara Bow: Runnin' Wild*. Cooper Square Press, 2000.

Stoker, Bram. *Dracula: The Vampire Play in Three Acts*. Dramatized by Hamilton Deane, John L. Balderston. Samuel French, Inc. 1933.

Sutherland, Henry. "Bela Lugosi Tells 20-yr Dope Horror." *Los Angeles Examiner*, April 23, 1955.

Wallace, Inez. "Dracula's Castle in Hollywood." *Cleveland Plain Dealer*, December 26, 1937.

Films

Beaudine, William, dir. *The Ape Man* [Film]. Banner Productions, 1943.

Browning, Tod, dir. *Dracula* [Film]. Universal Pictures, 1931.

Browning, Tod, dir. *Mark of the Vampire* [Film]. MGM, 1935.

Douglas, Gordon, dir. *Zombies on Broadway* [Film]. RKO Radio Pictures Corporation, 1945.

Florey, Robert, dir. *Murders in the Rue Morgue* [Film]. Universal Pictures, 1932.

Halperin, Victor, dir. *White Zombie* [Film]. Victor & Edward Halperin Productions, 1932.
Lee, Rowland V., dir. *Son of Frankenstein* [Film]. Universal Pictures, 1939.

Neill, Roy William, dir. *Frankenstein Meets the Wolf Man* [Film]. Universal Pictures, 1943.

Rosen, Phil, dir. *Return of the Ape Man* [Film]. Banner Productions, 1944.

Ulmer, Edgar G., dir. *The Black Cat* [Film]. Universal Pictures, 1934.

Whale, James, dir. *Frankenstein* [Film]. Universal Pictures, 1931.

Wood, Jr., Edward D., dir. *Glen or Glenda* [Film]. Screen Classics Productions, 1953.

Wood, Jr., Edward D., dir. *Bride of the Monster* [Film]. Rolling M. Productions, 1955.

Wood, Jr., Edward D., dir. *Plan 9 from Outer Space* [Film]. Reynolds Pictures, 1957.

Documentaries and Interviews

"Boris Karloff Vs. Bela Lugosi." *Hollywood Rivals*, Passport International Entertainment, 2001-2002.
Elliott, Grace, dir. *Intimate Interviews: Bela Lugosi* [Film]. Interview by Dorothy West. Talking Pictures Epics, 1931.

Gilman, Jr., Mark S. and Dave Stuckey, dir. *Lugosi: The Forgotten King*. Operator 13 Productions, 1985.

Lugosi, Bela. *Broadway Newsreel* [Film]. Interview by Hy Gardner, April 5, 1939. Transcription: http://www.collinsporthistoricalsociety.com/2015/05/bela-lugosi-they-wont-all-be-children.html

Lugosi, Bela. *MASTER OF HORRORS! Has Bela Lugosi Inherited the Mantle of Lon Chaney?* Interview by John Sinclair. Silver Screen, 1932. Transcription: https://beladraculalugosi.com/1932-2/

Nasr, Constantine, dir. *Lugosi, the Dark Prince*. New Wave Entertainment, 2006.

Rhodes, Gary D., dir. *Lugosi: Hollywood's Dracula* [Film]. Spinning Our Wheels Productions, 1997.

Also by Koren Shadmi: